The Photographer's Guide to
Portraits

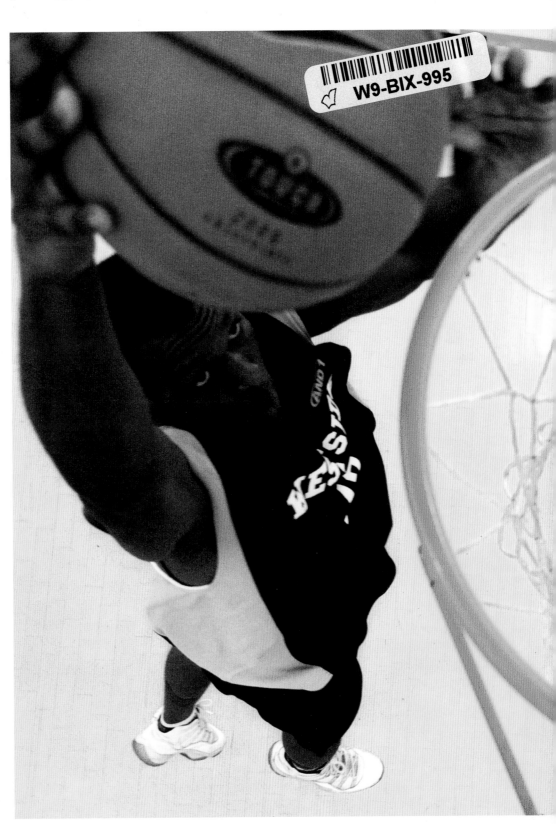

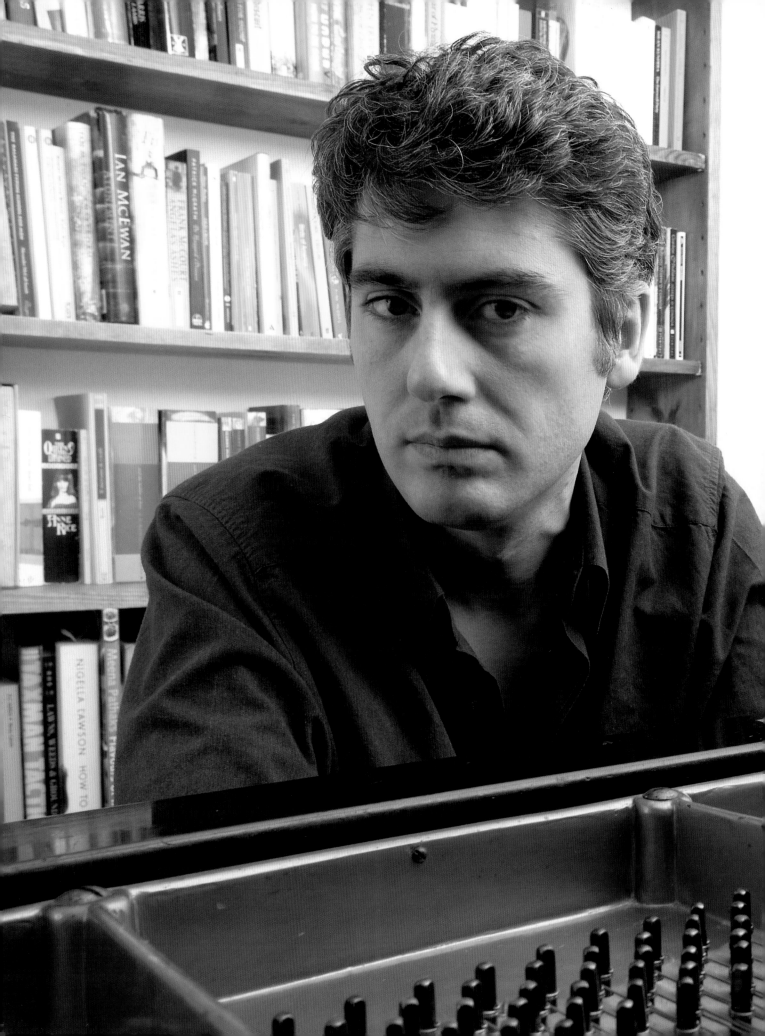

The Photographer's Guide to
Portraits

John Freeman

COLLINS & BROWN

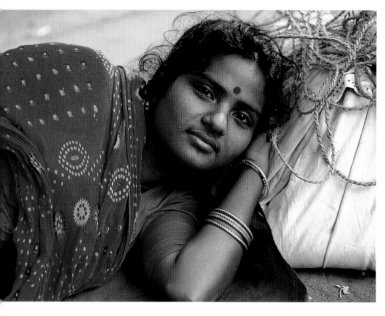

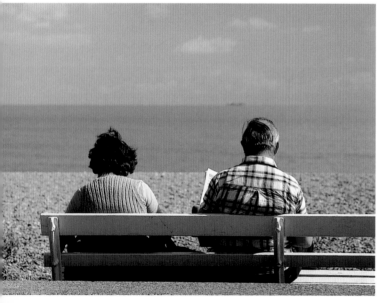

In memory of my sister, Ani

First published in Great Britain in 2004 by
Collins & Brown Limited

An imprint of **Chrysalis** Books Group

The Chrysalis Building
Bramley Road
London W10 6SP

Distributed in the United States and Canada by
Sterling Publishing Co., 387 Park Avenue South,
New York, NY 10016, USA

10 9 8 7 6 5 4 3 2 1

British Library Cataloguing-in-Publication Data:
A catalogue record for this book is available from the British
Library.

ISBN 1 84340 175 4

Commissioning Editor: Emma Baxter
Copy Editor: Ian Kearey
Design: Grade Design Consultants
Digital Systems Operator: Alex Dow
Project Editor: Serena Webb

Reproduction by Mission Productions Ltd, Hong Kong
Printed and bound in Times Offset (M), Sdn. Bhd, Malaysia

Contents

Introduction

From the moment that people discovered the art of drawing and painting, they used their surroundings for inspiration. Many of the earliest recorded examples, such as cave paintings, depicted basic survival, with fire and hunting being recurring themes. Among all these examples one subject stands out above all others, and that is the depiction of human beings. As civilization advanced and techniques for recording images became more sophisticated, the portrayal of people remained the number one theme. And so it is with photography. Since the early days, when pioneering photographers such as Julia Margaret Cameron first chose photography as the medium for creating and recording an image, the portrait in all its forms and variations, has remained the most popular and enduring of all photographic subjects.

This is hardly surprising, as from the moment we are born we are surrounded by other human beings. Nowadays the first portraits that are taken of a person are at their birth, and from then on, there is hardly an event or an occasion that is not recorded by a photograph – first birthday, first day at school, sports day, graduation, marriage and so on. With so much new technology available it is possible that a record of our lives can now be documented on film, or more likely as an electronic image, from birth to death and all that goes on in between. This record can then be viewed by successive generations for many years to come. This is astounding when you think that it was only a few generations ago when a photograph of a family member was something to be looked on in wonderment and was far from commonplace.

From its early images, reproduced as Daguerrotypes, prints or lantern slides, photography has progressed at an astonishing pace, and now it is rare to find a Western family that does not have a camera; many even have several cameras, which might include the latest digital version, a compact and a one-use model. The one thing that all these cameras have in common, apart from the ability to record images of varying quality, is that they are only as good as the person behind them. No amount of sophisticated equipment is going to turn a poorly composed, badly exposed and poorly lit photograph of the most beautiful person, in the most attractive setting, into an attractive portrait.

What counts with many aspects of photography – and portrait photography is no exception – is the ability to see a good photographic opportunity and then to have the skill to turn it into a stunning photograph that stands out from the huge amount of shots that are taken every day. Becoming familiar with your camera and accessories is the first step in getting that stunning image. There is no point in having the ability to see the potential of a good portrait, only to fumble with the controls and not understand how to get the exposure right. Even with the simplest camera, it is possible to obscure the lens or flash with your own hands when holding it incorrectly.

As you become more knowledgeable and the equipment that you use becomes more sophisticated – with, perhaps, a range of interchangeable lenses – it becomes essential to learn the correlation between aperture and depth of field, shutter speed and image sharpness, ISO and grain or noise. When you have gained this technical knowledge, the next step is to frame your shots for maximum impact. Many people only ever hold their cameras in the horizontal or landscape

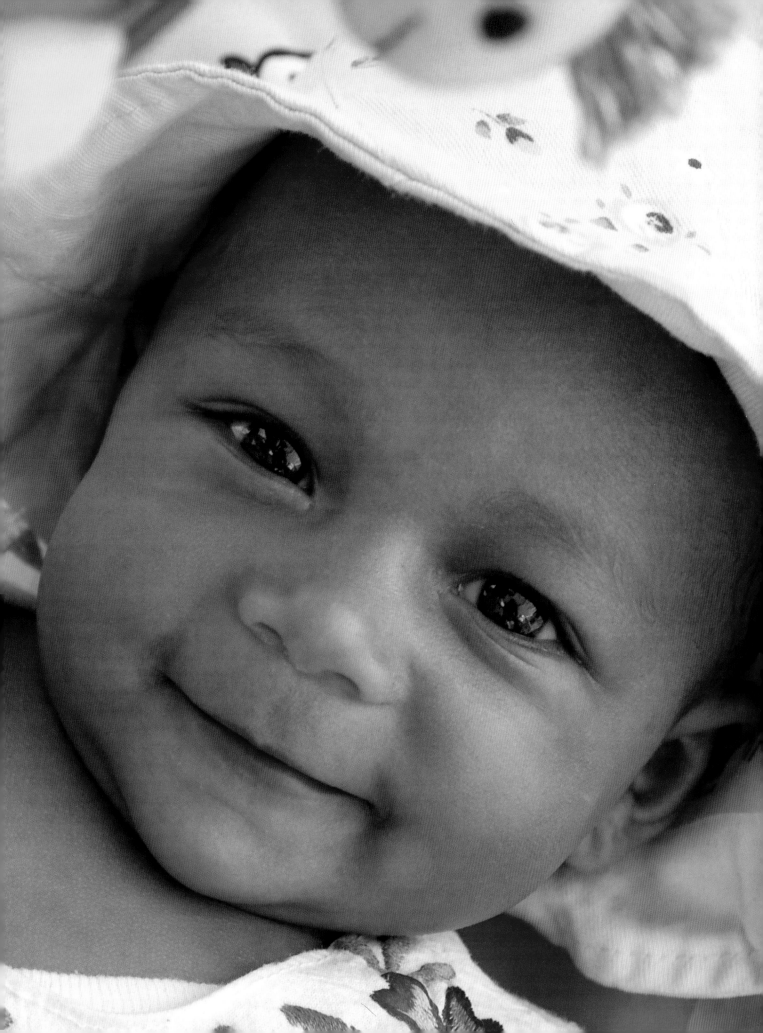

position. This is quite extraordinary when you think that when the average camera is held in the vertical or portrait position, the human face fills the frame naturally. In addition to basic framing, viewpoint can make all the difference to how the frame is filled – a high viewpoint foreshortens the body but can put great emphasis on the face, while a low viewpoint can make even the shortest person look taller. The viewpoint you select can also change the ambience of the picture by making your subject look more vulnerable or more confident.

Understanding the nature of light is another key area to creating good portraits. Whether you are working with daylight, available light, flash or tungsten, knowing how to get the best from any light source is essential. All types of light can be manipulated with the aid of reflectors and flags, to create soft or harsh light, high or low key, rim or backlight and so on.

However, without your unique observation and way of seeing, no amount of technical knowledge can get the shot that everyone will wish they had taken themselves. This book is designed to help you understand how your equipment works, improve your picture-taking in a variety of different situations, develop your own style and get the best portrait every time.

1 The Essentials

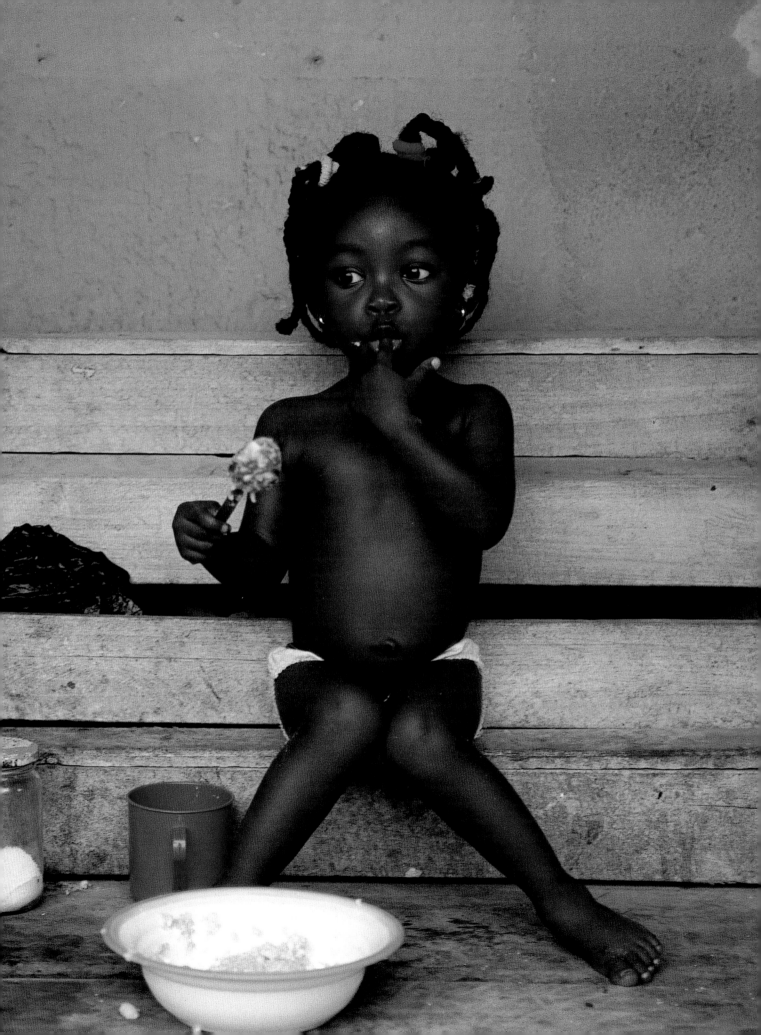

Basic Equipment

There is no one piece of equipment that will give you the ability always to get a stunning portrait, but there are certain key items of kit that will enhance your portrait photography. When it comes to cameras, the single lens reflex (SLR) camera is virtually unbeatable. With this camera and its extensive range of lenses and accessories, you can shoot in virtually any situation. The ability to see your subject through the taking lens gives you an unparalleled control over composition, framing, depth of field preview and accurate close-up control. Of course, many of these features are applicable to non-SLR digital cameras by viewing the image on the LCD screen at the rear of the camera body. However, the majority of these cameras are not backed up by the range of accessories and lenses offered by the SLR. It is because SLRs are so versatile that they are sometimes referred to as "system" cameras.

For portrait photography you might want to consider a system that consists of the camera body, a range of lenses such as wide-angle, normal and telephoto, a set of extension rings or tubes, a lens extender to increase the focal length of your basic lenses, and a dedicated flash. Of course, you might want to limit the bulk of your kit to a single zoom lens such as a 28–70mm, which will enable you to take portraits from a reasonable wide-angle field of view to a short telephoto when set on 70mm. Alternatively, three zoom lenses – 17–35mm, 28–70mm and 70–200mm – will give you the focal lengths for just about any shooting situation. If you add a 2x extender, your 200mm lens will in effect become a 400mm.

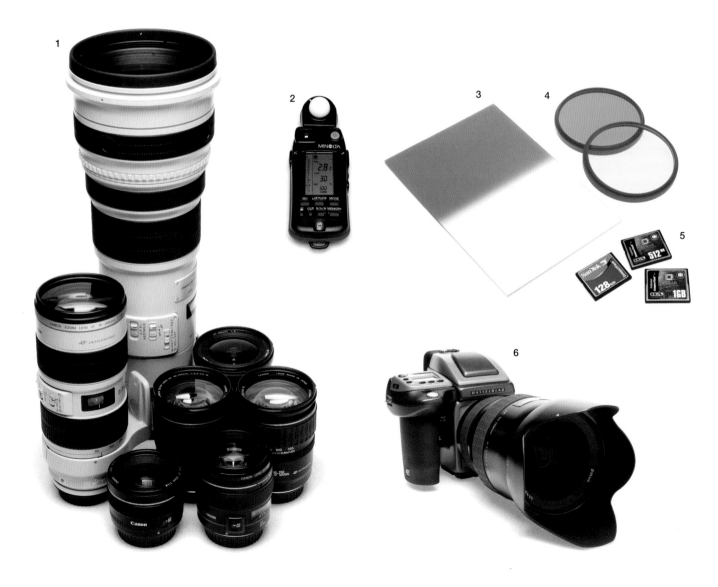

Digital cameras

When purchasing a digital camera, always try to buy a model that gives you at least 4 megapixels. This enables you to make prints up to A3 size without the pixels becoming noticeably visible. Even if you do not want to make prints this size, you may find that after you have cropped into your image and produced an A5 size print, the overall image size might well have been the equivalent of A3.

Beware of the term "digital zoom" when buying a digital camera, and look for "optical zoom" instead. The former only enlarges a part of the image, whereas an optical zoom actually brings your subject closer. Once it has been downloaded into your computer you can then crop into this image (which is what a digital zoom does) without the same loss of definition. If your budget is more modest, many compact digital cameras now accept telephoto and wide-angle converters. These are screwed on to the front of the camera's lens, and either increase the focal length for a telephoto effect or decrease it for a wide-angle view. While these lenses are never going to be as good as a top-quality lens, only a critical eye will see the difference.

1. Interchangeable lenses.
2. Exposure meter.
3. Graduated neutral density filter.
4. Screw-in filters.
5. Compact flash cards.
6. Medium-format camera.
7. Tripod.
8. Monobloc flash unit.

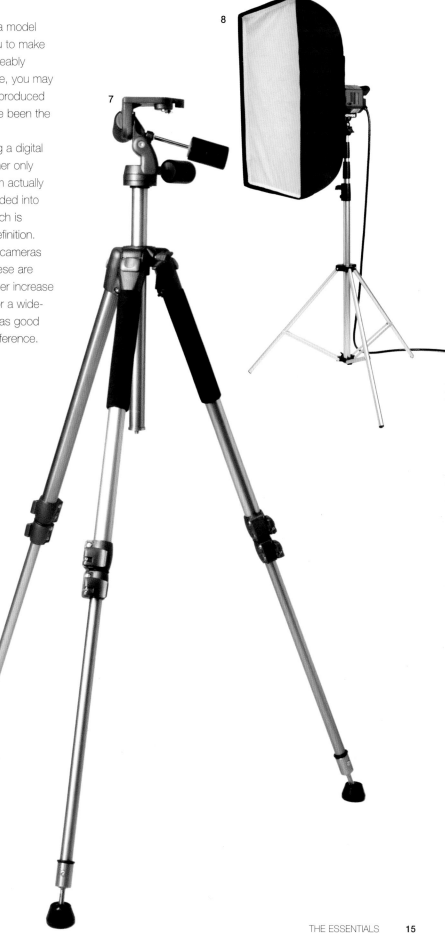

Basic Equipment Continued

Film cameras

With film cameras the range starts with the one-use camera, which comes complete with film and built-in flash, and in some models can be used underwater. Although these cameras have only a fixed-focus standard lens made of plastic, it is surprising how good some of the results can be; carrying a one-use camera as an emergency backup in case your main camera gets forgotten, broken or stolen, can help you get an acceptable shot rather than no shot at all!

Compact film cameras were until recently the most popular types of camera, but their sales are dropping in favour of digital compact cameras; the same is true of APS (Advanced Photo System) cameras. However, the higher up the range you go with these models, the more impressive their sophistication becomes. You can even buy SLR APS versions, which come with an impressive variety of lenses and accessories.

Another camera that has fallen from favour over the years is the Rangefinder camera. When you look through the viewfinder of this camera, you see two images in the centre of the frame. As you turn the barrel of the lens to focus, these two images become one – at this point your shot will be pin-sharp. The most famous of these models is the Leica, which was used by Henri Cartier-Bresson, the famous French photographer noted for his spontaneous portraits. His technique became known as "the decisive moment".

Roll-film, or medium-format cameras take 120-size film. This comes on a spool, as opposed to the cassette which 35mm and APS films come in. Roll-film cameras are favoured by professional photographers because the bigger film format gives greater quality when enlarged. The models also come with an extensive range of lenses and accessories, which, like 35mm SLRs, makes them system cameras.

Medium-format cameras are also made with interchangeable film backs, which means that that you can go from black and white to colour film, or fast to slow film, even in mid-roll. You can fit a Polaroid back and shoot to check a set-up before finally taking it, and now you can fit digital backs to make the cameras truly versatile.

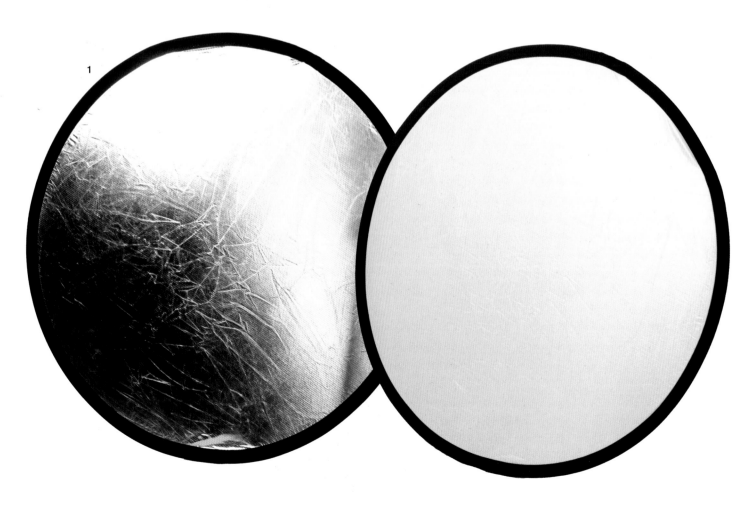

1

Other equipment

Another piece of equipment that is extremely useful in portrait photography is the extension tube or ring. This fits between the camera body and the lens, and allows you to get in closer than the minimum focusing distance of the lens by itself. Extension tubes come in different sizes and can be joined together for extreme close-up work.

A dedicated flashgun is also useful and far more effective than the built-in variety. Depending on the compatibility with your camera, most flashguns work with the camera's TTL metering systems. They give far greater control over that age-old problem "red eye", and you can adjust the head for different lighting, such as bounced flash.

The important point to remember when purchasing any photographic equipment is that no matter how sophisticated it is or how many gizmos it comes with, it is only going to be as good as you make it. This means that you need to understand the difference between what your eyes see and how the camera will interpret it. Remember the golden rule that no camera ever took a great picture. People take great pictures!

4

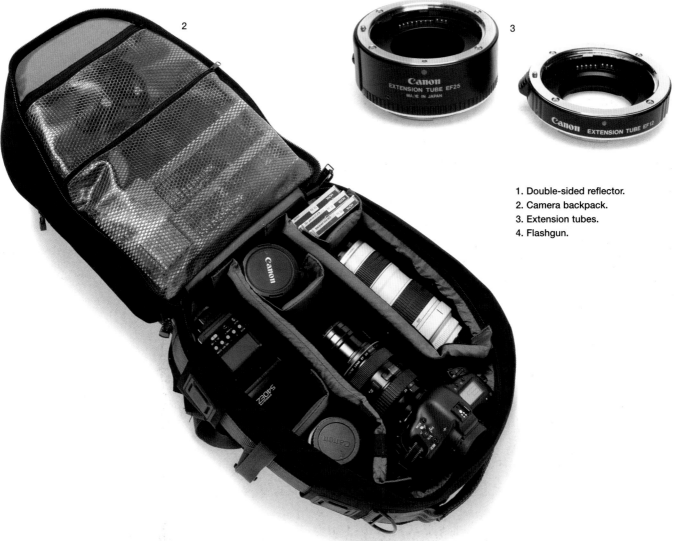

2

3

1. Double-sided reflector.
2. Camera backpack.
3. Extension tubes.
4. Flashgun.

Normal Lenses

One lens that is often much maligned and overlooked, when compared to the zoom lens, is the standard or normal lens. It is referred to in these terms because its angle of view gives roughly the same angle of view as the human eye. In 35mm photography the standard lens has a focal length of 45–50mm and records its image on a frame of film that measures 24 x 36mm. With a medium-format camera such as the Hasselblad, the film area is 6 x 6cm and the standard lens focal length is 80mm; with the Mamiya RZ, the image area is 6 x 7cm and the focal length is 110mm.

Because 35mm has become the most popular format, most camera manufacturers still refer to it as the norm, even with digital cameras. The problem here is that with 35mm the film area is 24 x 36mm, but the sensor that records the image on a digital camera is smaller. This means that a 50mm lens will be slightly telephoto on a digital camera, and a wide-angle of, say, 28mm on 35mm film, will only be equivalent to a 40mm lens on a 35mm camera, so the angle of view will not be so great.

Normal lenses usually have a reasonably large maximum aperture. With 35mm cameras this might be f1.8 or even f1.2, while with medium-format cameras it is probably f2.8. This is an important consideration, as a "faster" lens enables you to work in lower light conditions – without flash, for example – than a slower lens with a maximum aperture of f3.5 or f4.5.

If a 35mm camera has a zoom lens with a focal range of 35–105mm as standard, you can set it to 50mm to get the equivalent of the standard lens. This focal length has the advantage of giving you great scope for framing your picture. Although it might be true that filling the frame is important, it does not necessarily follow that this has to be with the main subject – for example, you might want the person you are photographing to be to one side of the frame so that other relevant detail can appear as well. This could be their house or an example of their work, or they could be in the foreground with an interesting view behind.

Left: With 35mm cameras the focal length of a normal lens is 50mm and gives a field of view roughly that of the human eye. It is ideal for portraits like this, as it is less likely to distort or foreshorten the subject's features, which might be the case with a wide-angle or telephoto lens.

Below: Whatever format you are using, the standard lens gives roughly the same field of view as the human eye.

Opposite: The normal lens lets you work at a comfortable distance from your subject. This is important in portrait photography, as it allows you to have a rapport with your subject without crowding and intimidating them.

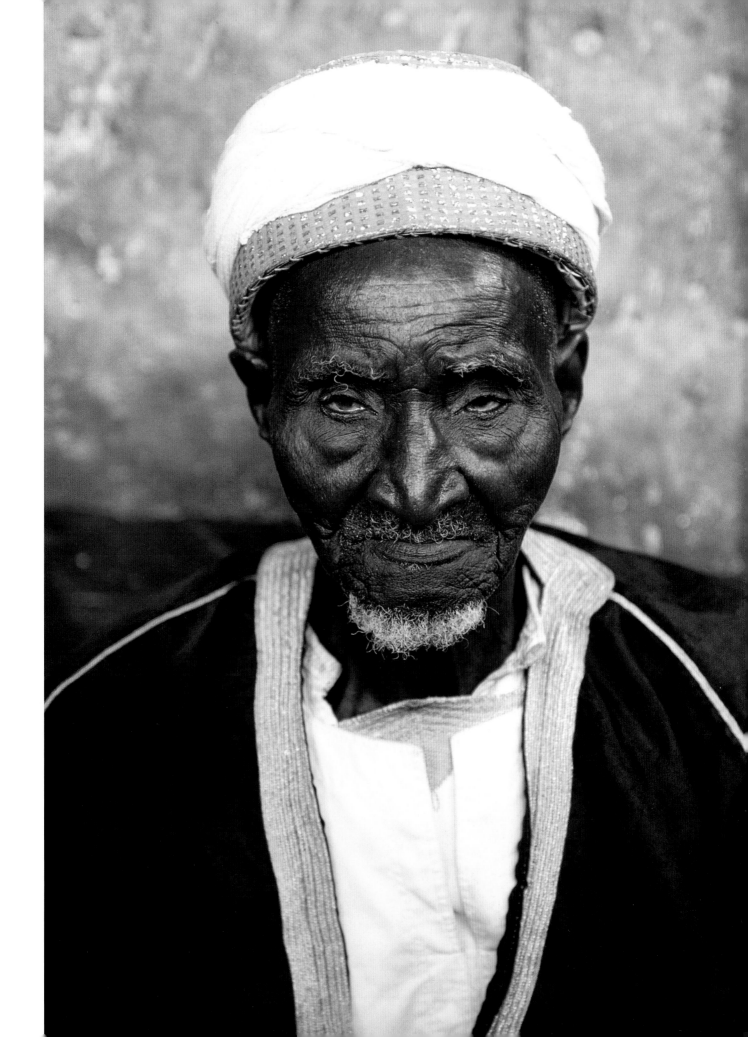

Right: Normal lenses are great for filling the frame. With a wide-angle lens, there is always the danger of getting a lot of unwanted detail in your picture that will need to be cropped at printing stage, whereas with a telephoto lens there is always the possibility of cropping out vital detail. Here, we can see the perfect balance in this portrait of a Cuban café owner.

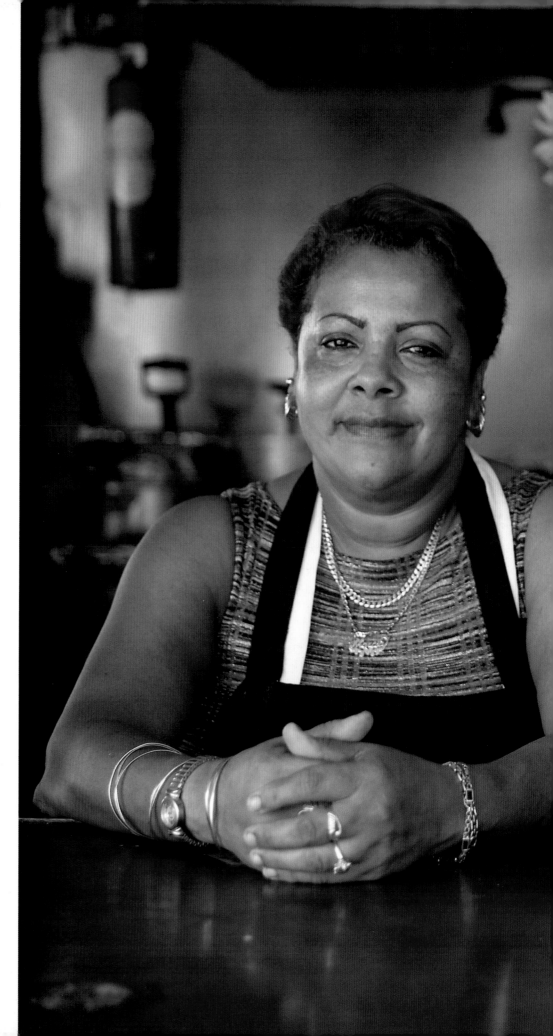

Wide-angle Lenses

If your camera has a zoom lens or can accept inter-changeable lenses, you can change to a wide-angle focal length or lens. **The term "wide-angle" refers to a focal length that gives a greater angle of view than the human eye.** This means that anything shorter than 35mm in focal length will be wide-angle. If you use a lens with a focal length of 24mm or shorter, this is referred to as ultra-wide-angle.

With these lenses comes greater depth of field (see pages 30–31), which can be used to your advantage, and you can also get more foreground and background in your shot. However, these lenses need to be used with more care than standard lenses, as distortion can easily become a problem. For example, when shooting in close to a person's face, the facial features can become distorted – noses can appear to be bigger than they really are and eyes can become bulbous. While some of these effects can be amusing, they are not particularly flattering – or accurate.

Similar care needs to be taken when working with the greater depth of field of these lenses. While it may be advantageous in certain situations to have everything in your shot sharp, in others it will be a distinct disadvantage, as this could detract from your subject and make the subject merge into the background.

This can also happen with such a wide angle of view, when so much more can be seen in the frame. Here, the problem is that your subject appears to be pushed further into the background, thus getting lost in the surrounding detail. However, with careful framing of foreground detail this wide angle of view, combined with greater than normal depth of field, can produce very effective portraits.

As with all aspects of photography, experimenting with your equipment and trying out new angles and ways of working, more than anything else, helps you to develop an individual and unique style.

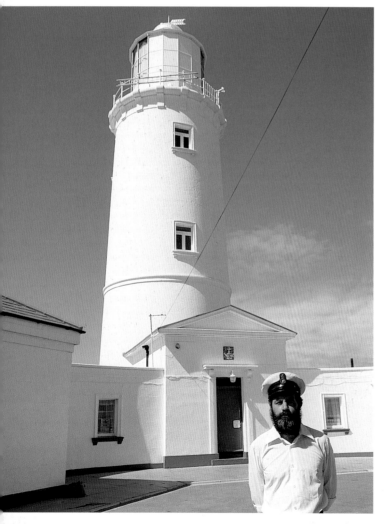

Left: The choice of a wide-angle lens enabled me to take this portrait of a lighthouse keeper and his lighthouse. Although the camera had to be pointed slightly upwards, the building does not suffer too much from converging verticals and the lighthouse keeper is completely free of any angular distortion.

Below: Wide-angle lenses have a far greater field of view than the human eye. For this reason they need to be used with extra care, as there is always a danger of including a lot of unwanted detail in your shot. Viewpoint and precise framing are crucial if this is to be avoided.

Opposite: Care needs to be taken when using a wide-angle lens in portrait photography, as it is easy to distort people's physical features. In this case, the choice of a high viewpoint together with a 28mm wide-angle lens created just the right balance in this intimate shot of a newborn baby and her mother.

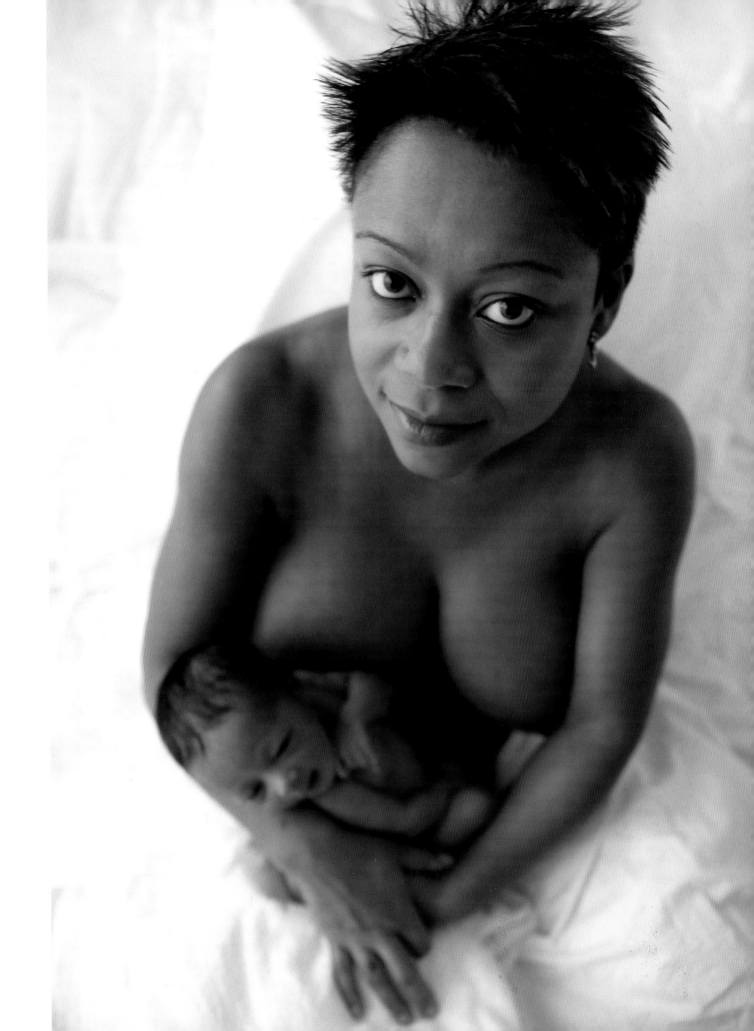

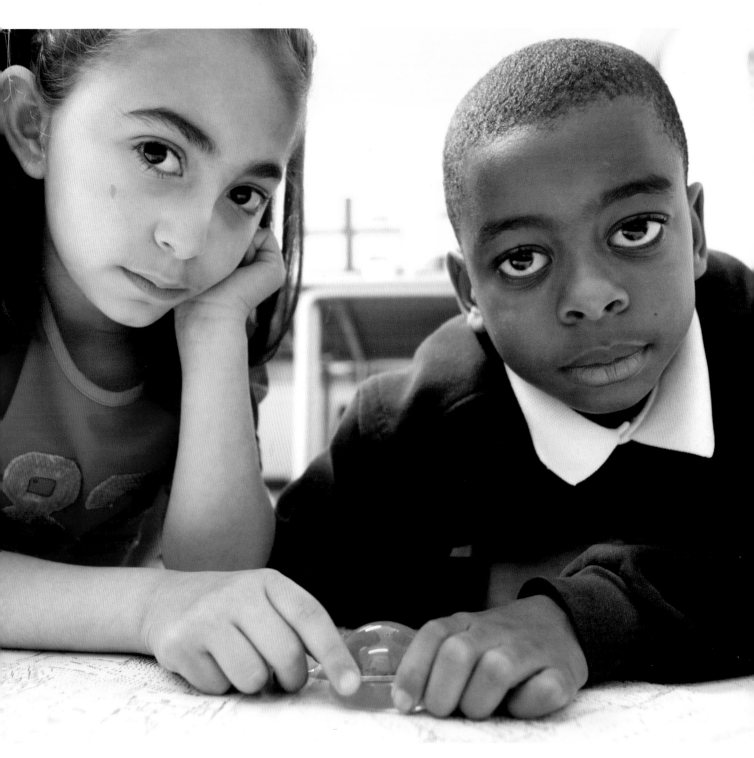

Above: An extremely low viewpoint, together with a 24mm wide-angle lens, was chosen when taking this portrait of two schoolchildren who were studying a map. It gives them an air of great confidence and allows the viewer the feeling of sharing in their activity. Always be on the lookout for different ways of looking at your subject.

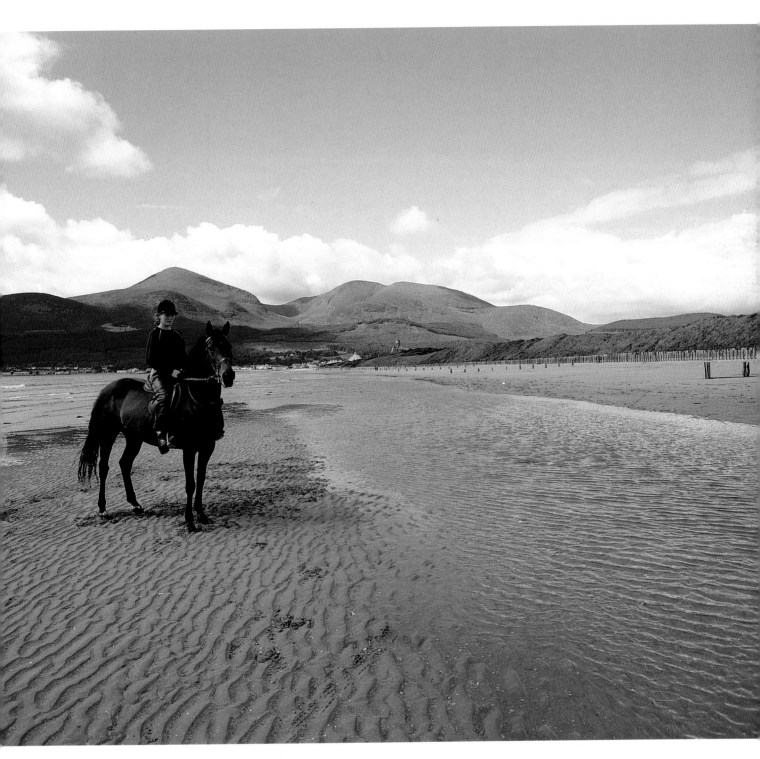

Above: Keeping the camera completely level has eliminated any potential for distortion in this portrait, even though the viewpoint was close to the rider and her horse. The use of a wide-angle lens means that enough of the landscape has been included, while the subject, positioned to one side of the frame, still holds centre stage.

Telephoto Lenses

When using a 35mm camera, the normal lens (see pages 18–21) has a focal length of 50mm. Any lens with a focal length lower than this, such as 35mm, is a wide-angle. However, when the focal length increases, to, say 70mm, then the lens becomes a telephoto lens. We can categorize these lenses into three distinct groups: up to 100mm short telephoto, up to 250mm medium telephoto, and, beyond this, ultra telephoto. The greater the focal length the heavier the lens, so support, such as a tripod or monopod, will be necessary.

Many portrait photographers favour these lenses. Their main advantage is that they have a far shorter depth of field than normal or wide-angle lenses (see pages 30–31). This means that you can make the background go out of focus and appear blurred while keeping your subject pin-sharp. This has the advantage of putting the person you are photographing very much to the fore of your finished image.

Another advantage that these lenses have is that they "compress" your picture. This can make people's facial features more attractive, as well as bringing background detail closer to the camera. The lenses also allow you to create physical space between you and your subject. When their portrait is being shot, people often become intimidated when a camera is almost on the end of their nose. With a 200mm lens, for instance, you can fill the frame with a person's face yet be perhaps 6ft (2m) away from them. This can make the subject feel far more comfortable and relaxed, and can ensure a successful outcome for your intended portraits.

If you are shooting on a camera that boasts a "digital" zoom, don't be fooled by the manufacturer's exaggerated claims of its ratio. All a digital zoom does is enlarge a part of the image, and this can be done once your shots have been downloaded into your computer. If you do it in camera and then again on the computer, the image will be of poor quality. When buying a digital camera, it is the "optical" ratio of the zoom lens that you need to take into consideration, as this truly does bring your subject closer.

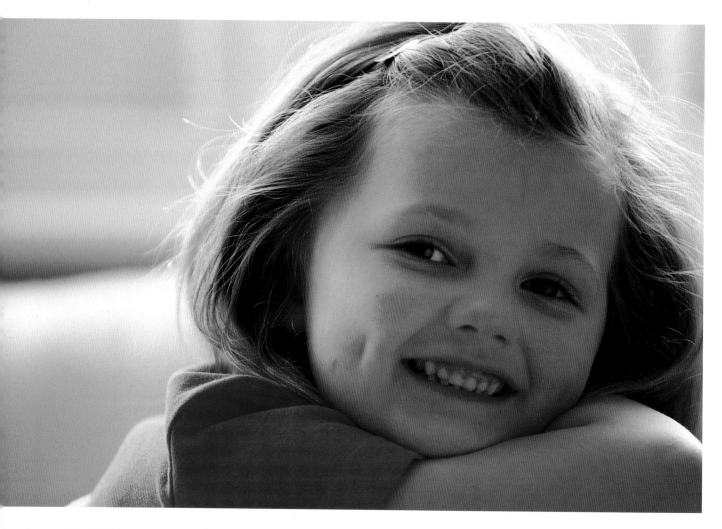

Opposite: The great thing about telephoto lenses is that they enable you to get in close to your subject without crowding them. This means that you can fill the frame and crop out unwanted detail, such as the reflector that was placed just to the right of the girl's face.

Below: In addition to putting the background out of focus, the shallow depth of field can also create interesting patterns in the background. In this shot, strong angular shapes have been formed from the buildings behind the subject, which adds interest to the shot while not drawing our attention away from the central figure.

Right: In comparison to normal or wide-angle lenses, the telephoto lens has an extremely narrow field of view. On a 35mm camera, the angle of view is roughly 40° across the horizontal plane with a normal 50mm lens. However, when fitted with a 300mm lens, the angle of view is reduced to just 6.5° on the horizontal plane.

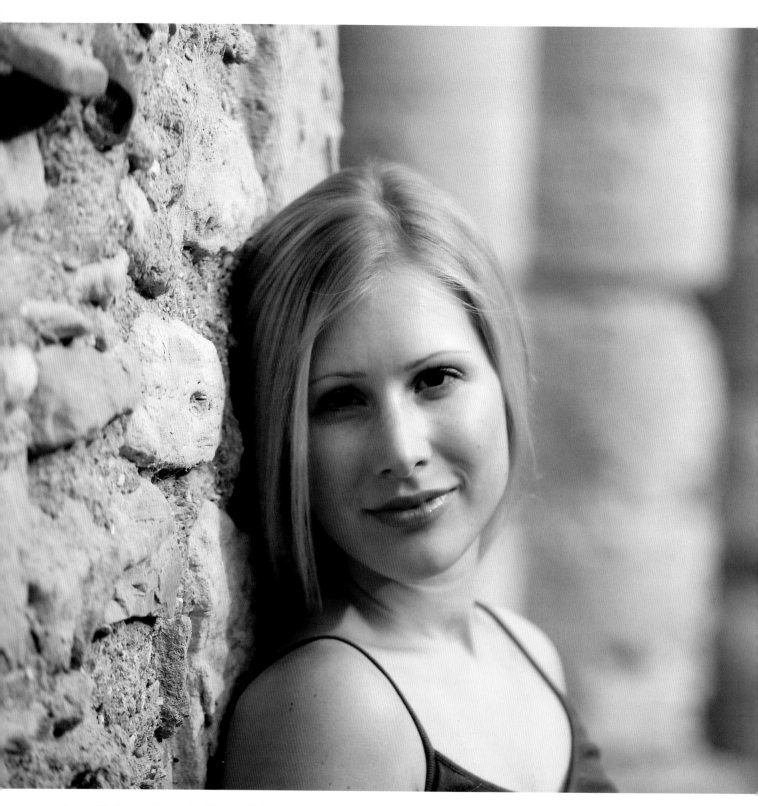

Above: This is a good example of how small the area of sharp focus is when working with telephoto lenses, in this case a 200mm set to its maximum aperture of f2.8. The background has gone completely out of focus, and all our attention is on the model. Professional photographers often use this technique so that a designer of a book or magazine can overlay type on the picture.

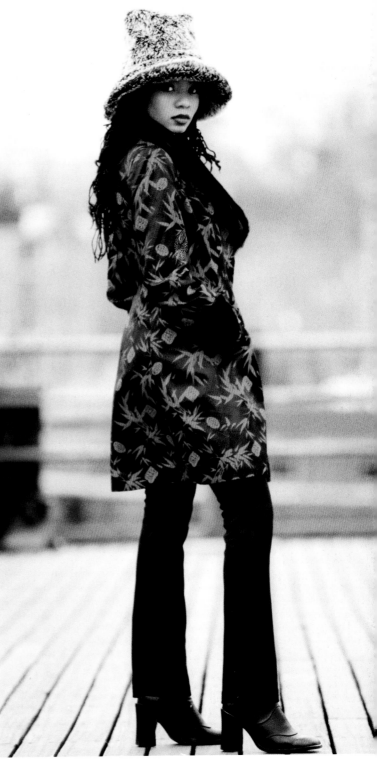

Above: Long telephoto lenses, such as the 300mm used to create this shot, are favoured by fashion photographers, as they can isolate the subject against the background. By using a wide aperture, such as f2.8, the area of sharp focus is extremely small and extends only a short way in front of and behind the model.

Depth of Field

Depth of field refers to the plane of sharp focus in front of and behind the subject on which the camera is focused. It is important to understand how depth of field is determined and how it varies with different focal length lenses. The depth of field you select can greatly add or detract from the overall composition of your photographs.

Imagine that your camera is fitted with a standard lens and is set to its widest aperture, f2.8. If you are shooting a subject that is 6ft (2m) away, very little behind and even less in front will be sharp. If the camera is set to an aperture of f8 in the same position, more that is behind and in front of the subject will be in focus. If the lens is stopped down even further, to f22 perhaps, all the scene behind the subject and a great deal in front will be in focus. If you are using a wide-angle lens, more of your picture will be in focus, even when using an aperture of f2.8, whereas the greater the focal length of a telephoto lens, the less will be in focus, even at apertures as small as f22.

Because the aperture or f stop determines how much light passes through the lens on to the film or sensor, an adjustment to the shutter speed has to be made. The wider the aperture, e.g. f2.8, the more light passes through the lens. The smaller the aperture, e.g. f22, the less light passes through the lens. So if a shutter speed of 1/000th second is required at f2.8, an equivalent shutter speed of 1/15th second will be required if the aperture is set to f22. Because very few people can hold a camera perfectly still at speeds of 1/30th second or slower, the camera should be supported on a tripod or some other firm surface.

If your camera has a metering mode called "aperture priority", this allows you to have complete control over the f stop while the camera selects the shutter speed. The diagram below illustrates how the area of sharp focus varies according to the size of the aperture.

Area of Sharp Focus

Aperture of f2.8　　Aperture of f8　　Aperture of f22

Distance from Subject
1 2 3 4 5 6 7 8 9 10 11 12 13 14 15 ∞

Left: This shows the scale of sharp focus when the lens is stopped down. The wider the aperture, the less of the picture is sharp, whereas the smaller the aperture, the greater the area of sharp focus. This is seen in the pictures opposite.

1 A 28mm wide-angle lens was used with an aperture of f2.8. A great deal of the picture is in focus, with only a slight fall-off on the very front and in the far distance.

2 When the lens is stopped down to f8, more of the picture is in focus, or sharper.

3 When the lens is stopped right down to f22, all the foreground and the background are in focus.

4 When the lens is changed to a 50mm standard lens and an aperture of f2.8 is used, it can be seen that far less of the picture is sharp than with the equivalent aperture used in 1.

5 As the lens is progressively stopped down, first to f8 and then to f22 (6), more of the picture becomes sharp but it still doesn't compare to the sharpness of the wide-angle lens.

7–9 When using a long lens such as a 200mm, very little is sharp on either side of the model, even with the lens stopped down to f22 (9).

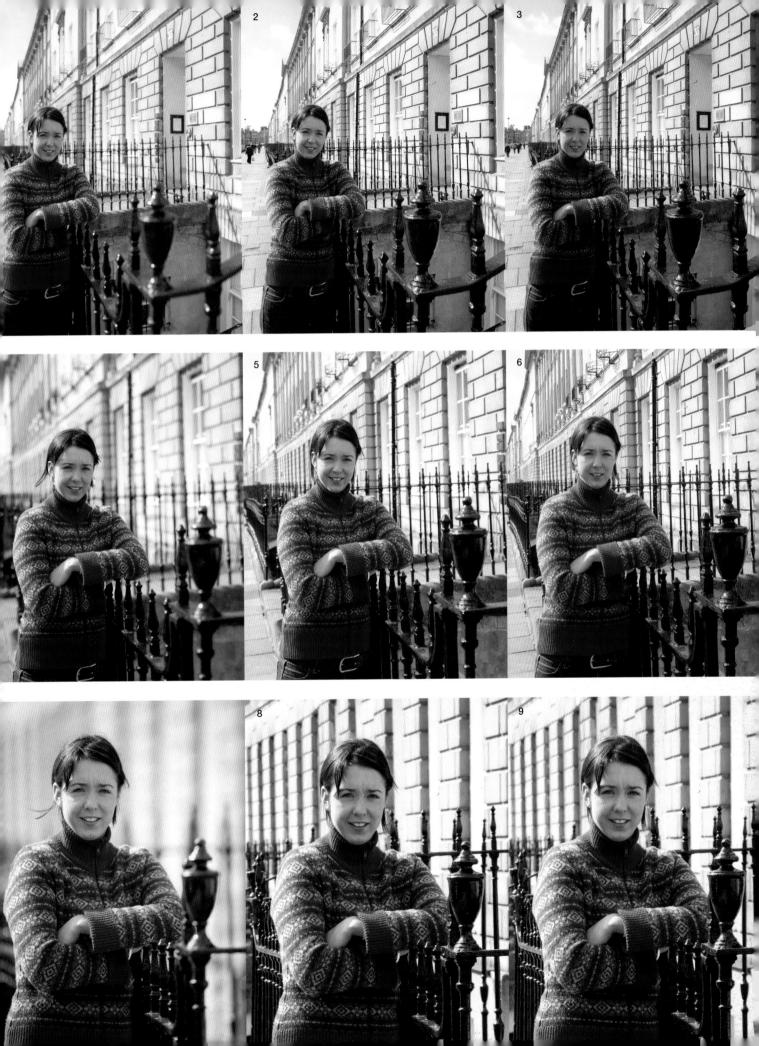

Exposure

Except for cheap one-use cameras or basic point-and-shoot compact models, nearly all cameras come with some sort of built-in metering system; the further up the range, the more sophisticated these systems are.

Many manufacturers would have you believe that their system is foolproof and that you will get a perfectly exposed shot every time. However, even the most advanced metering system can be fooled, and the way you first saw that potential shot can come out looking totally different once the camera has interpreted the scene.

One of the benefits of digital cameras is that once you have taken your shot you can see the image on the camera's LCD and examine the histogram. This shows how the exposure levels are spread over a scale like a graph. If the levels are bunched towards the left of the scale and blocking in, this shows underexposure. If the levels are bunched towards the right of the scale, this indicates overexposure. However, if there is an even spread of levels throughout the scale, this means the shot is correctly exposed. Of course, even if there is no time to repeat the shot to get it correctly exposed, a certain amount of correction can be made once the image has been downloaded into the computer – but only a certain amount.

When using film, especially colour reversal film, which produces colour transparencies, getting the right exposure is much more critical. If your shots are badly overexposed, the detail is lost forever. If they are underexposed, no amount of burning in will bring detail back into the shadow areas. Many professional photographers take a Polaroid before shooting on film to check for such things as correct exposure, but most photographers do not have this luxury, so getting it right is crucial to a successful shot.

As with so many aspects of photography, getting to know how your equipment works, and its limitations, can assist you in getting your shots correctly exposed every time.

Overexposure
1 The exposure data of a digital image is displayed as a histogram on the camera's LCD. The levels in this image are bunched towards the upper end of the histogram, or to the right in the LCD. This indicates that the brighter parts of the image are burning out and overexposing.

Normal Exposure
2 The levels are spread through the histogram evenly, showing an even spread of tones. The levels bunched in the middle shows a good exposure for an average image.

Underexposure
3 In this example the levels are bunched to the left and blocking in, showing underexposure.

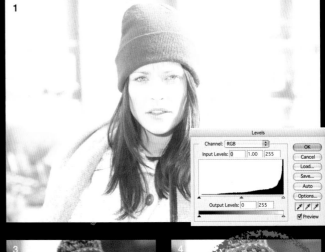

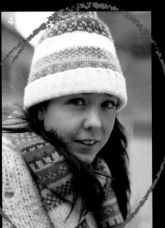

Right: This girl was photographed against a very light background and came out too dark because the camera's built-in meter took its reading predominantly for the background and not for her.

Far Right: I took a reading from the model's face using the camera's spot metering mode. This has correctly exposed the shot for her and not the background, which is now overexposed. If your camera doesn't have a metering mode, try moving in close to take the reading, but try not to cast your own shadow over the subject.

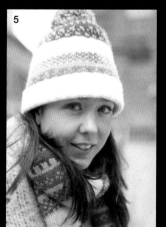

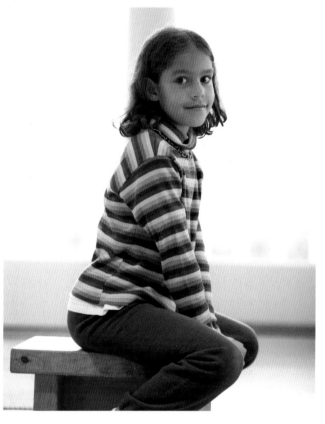

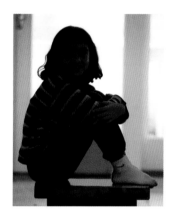

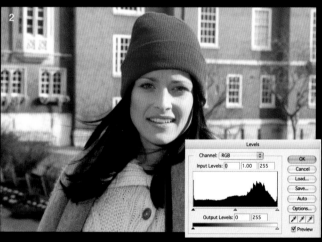

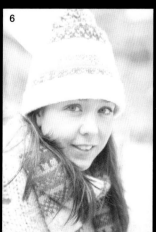

Left: In this series of pictures you can see the effect of bracketing the exposures.
1 The shot is too dark and underexposed. By gradually increasing the exposure, the shot becomes lighter.
4 Correct exposure.
7 Increasing the exposure further results in overexposure.

ISO

ISO stands for International Standards Organization, and is the rating given to the speed of film, indicating the sensitivity to light of a particular film. Every film you buy is marked with the ISO rating. Most often this is 100 or 200 ISO, but the range extends from 12 ISO to beyond 1600 ISO. A lot of people are unaware that with 35mm film the rating is DX-coded – there is a bar code on the cassette, and once it has been loaded the camera reads the information and adjusts the metering system accordingly. Films with a low ISO are called slow films, and those with a high ISO number are referred to as fast films.

Film with a higher ISO is more sensitive to light than one with a lower rating, so it is better suited to low-light conditions or where you need to use fast shutter speeds to freeze action. The problem with fast film is that grain can become more noticeable, although manufacturers have reduced this effect considerably. However, grain can be put to use creatively, especially in portrait photography. It can emulate the style of painting known as pointillism, in which the painter applies small dots of pure colour, which, when viewed from a distance, combine together to give increased luminosity. The most famous exponent of this style was the French painter, Georges Seurat, whose picture, *Bathers at Asnières* can be found in print shops all over the world. In fact, studying the work of painters, as well as photographers that you admire, can be a useful exercise, not just for seeing different styles but also for learning about composition and posing.

More advanced digital cameras also have a facility for adjusting the ISO. Just as with film, the higher the ISO you set your camera to, the grainier the image appears. The difference is that in digital photography this grain is referred to as noise, and it can cause problems in the shadow areas at print stage. Noise can also be added to a fine-grain shot in the computer using a program such as Photoshop. Even a fine-grain film negative or transparency can have this effect added when it has been scanned into the computer.

Fine Grain
When the chosen ISO is 100, photographs have fine grain or noise, and even when the shot is enlarged (right) and the grain increases and the sharpness begins to suffer, the result is still acceptable.

Coarse Grain
With the ISO at 1250, the grain or noise increases dramatically and the overall sharpness of the shot begins to diminish (right). In certain situations this would be unacceptable, but, as in the shot on the opposite page, the spontaneity of the picture outweighs any concerns about the fineness of the grain.

Colour Balance

When we look at a scene, we tend to assume that the colours we are seeing are "natural". To a certain extent this is true, as our brain adjusts the different levels of light to what it thinks are natural.

Although we perceive daylight as white light, it is, in fact, made up of all the colours of the rainbow or spectrum, ranging from red to violet, with five other distinct bands in between: orange, yellow, green, blue and indigo. These colours do not stop rigidly next to one another, and we can divide them into three main colour bands – red, green and blue. If we projected them in equal intensity on to the same spot, the result would be an area that appeared white.

Throughout the day the quality of light changes. On a clear day, when the sun rises it can be quite red, or, in photographic terms, "warm" in colour. The same is true at the end of the day, when the sun is setting. At midday, when the sun is at its highest, the light is cooler, or "bluer". This variation in the appearance of light is measured on a scale known as

degrees Kelvin. These degrees range from approximately 3,000 degrees Kelvin (K), the output of an average domestic tungsten light bulb, through to about 8,000 degrees K in the shade under hazy or overcast skies.

When we use colour film that is balanced for daylight and flash in tungsten light, the resulting picture has an orange cast. If we use colour film that is balanced for tungsten light in daylight or with flash, it appears with a blue cast. With digital photography, you need to set the "white balance" to get a true representation of colour, otherwise your shots will come out with a distinct cast, just like film. More advanced digital cameras have settings for different lighting conditions, such as daylight, tungsten and fluorescent, and with a colour temperature choice in degrees K. There is also an auto white balance setting, where the camera determines the colour temperature and adjusts to its own settings – much like the human brain.

Colour Balance

Below: This diagram shows the colour temperature of light as measured in degrees Kelvin. It ranges from a candle, which has an orange/reddish light of about 2,000°K, through to clear blue skies, which measure about 10,000°K.

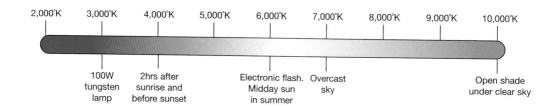

2,000°K 3,000°K 4,000°K 5,000°K 6,000°K 7,000°K 8,000°K 9,000°K 10,000°K

100W tungsten lamp 2hrs after sunrise and before sunset Electronic flash. Midday sun in summer Overcast sky Open shade under clear sky

Right: In the shot near right, daylight balanced film was used in predominantly tungsten light. This caused the shot to come out with a distinct orange cast to it. To correct this cast an 80A colour correction filter, which is bluish in colour, was used (far right). Alternatively, you can use tungsten-balanced film. The same problems occur when shooting digitally if you have not set the correct white balance.

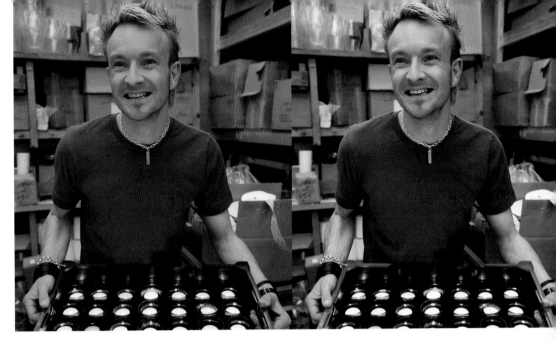

Right: One of the problems with shooting in fluorescent light is that fluorescent tubes come in many different varieties: daylight, warm light, cool light, etc. Choosing the correct filter to remove the green cast (near right) can be a hit-and-miss affair unless you have a colour temperature meter and a range of different colour correction filters. Using a 40CC magenta together with a 10CC blue filter works well under most fluorescent lighting conditions (far right).

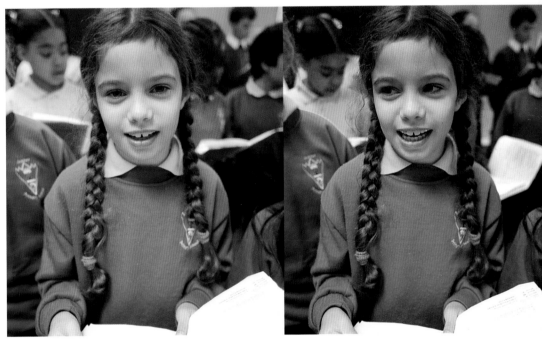

Right: In the picture near right, tungsten-balanced film used in daylight caused the shot to come out with a blue cast. To correct this, you can use an 85B colour correction filter (far right) or use daylight-balanced colour film.

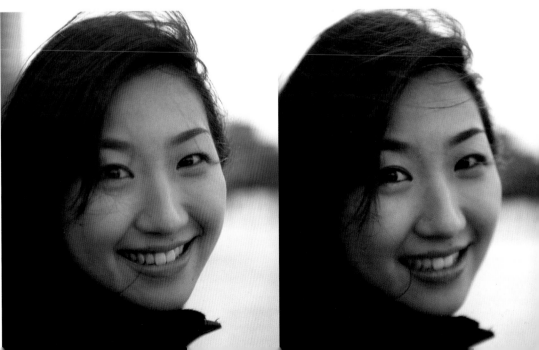

Viewpoint

The angle of view, or viewpoint, that you choose when taking your portrait shots can have considerable bearing on their success or failure. Many people take their shots from their normal standing height and don't stop to think of the many other possibilities that are on offer. For example, if you are taking a full-length portrait and choose a low angle – perhaps lying on the ground so that the camera is slightly tilted upwards – the person that you are photographing appears to be much taller, and, depending on what they are wearing, seems to have much longer legs than in reality. This can produce a much more flattering effect than if you were to take the same shot from a standing position. If you were to go even higher this could have the effect of shortening the person's legs, which might not be very flattering.

Another example of the importance of viewpoint is when moving in close to a face. If you take the shot from a low angle, this can give the appearance of the subject being in control, and can make them look far more confident. If you take the shot from a higher viewpoint, looking down, the subject can look far more diminutive and have a certain vulnerability.

However, it is not just the expression or look that can change with the viewpoint. How often, when looking at photographs, have you seen a really good portrait ruined because a tree or electricity pylon appears to be growing out of the subject's head? If only the viewpoint had been altered by even a few inches or centimetres, the unsightly intrusion would not have occurred.

One reason why this can happen when shooting with an SLR is that you are seeing the view with the camera's lens wide open. This means that the background might be out of focus. However, when the shot is taken the lens stops down automatically, and if a small aperture has been chosen, such as f16, then the background will come into focus (see Depth of Field, pages 30–31).

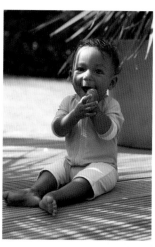

Left: These two pictures illustrate the difference a small shift in viewpoint can make. In the top picture, the decking that the baby is sitting on is quite visible and is a distraction to the eye. This means that the emphasis, which should be on the baby, is diminished. By taking a lower viewpoint of only a few inches or centimetres, so that the camera is virtually at ground level, the whole emphasis is on the baby, and the decking that she is sitting on is hardly visible.

Opposite: In these three pictures, all taken within seconds of one another, the change of viewpoint has altered the mood of the model. In the picture above left, the camera is looking down on her and her expression is direct yet matter-of-fact. In the picture above right, the low viewpoint creates an aura of dreaminess, and there is a greater feeling of being involved with her thoughts. When the camera viewpoint is moved to a position of direct eye contact, as in the picture below, the emotion changes again, and now we feel that the mood is far more suggestive. By exploring several different viewpoints you can build a series of pictures that can be edited to convey many emotions.

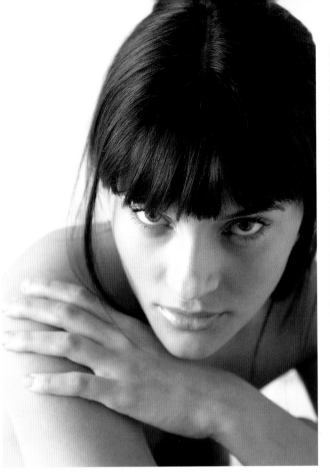
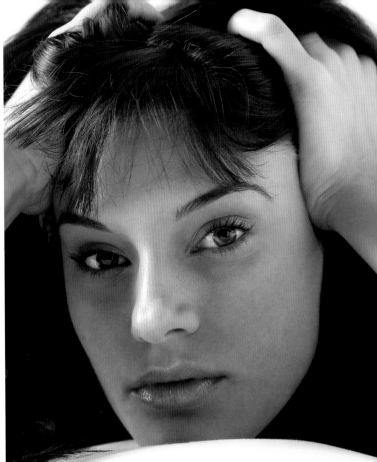
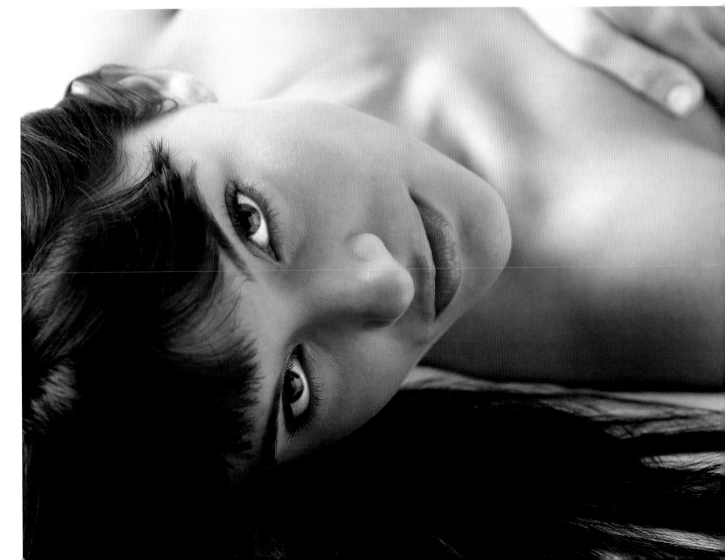

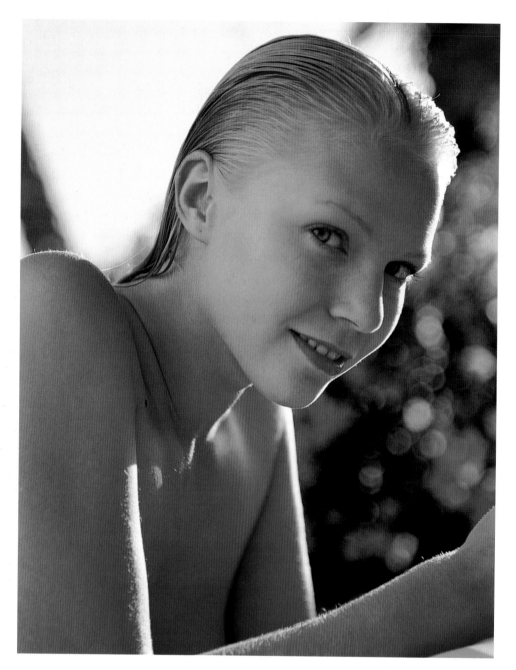

Above: In the picture of a girl lying on a sunbed, the camera was looking up from the ground. This has meant that she is back-lit against the sky which creates a pleasant halo of light on her hair and skin.

Opposite: By contrast, this picture was taken from a high viewpoint with a wide-angle lens. This puts the emphasis directly on the girl's face, and the shallow depth of field creates a striking composition.

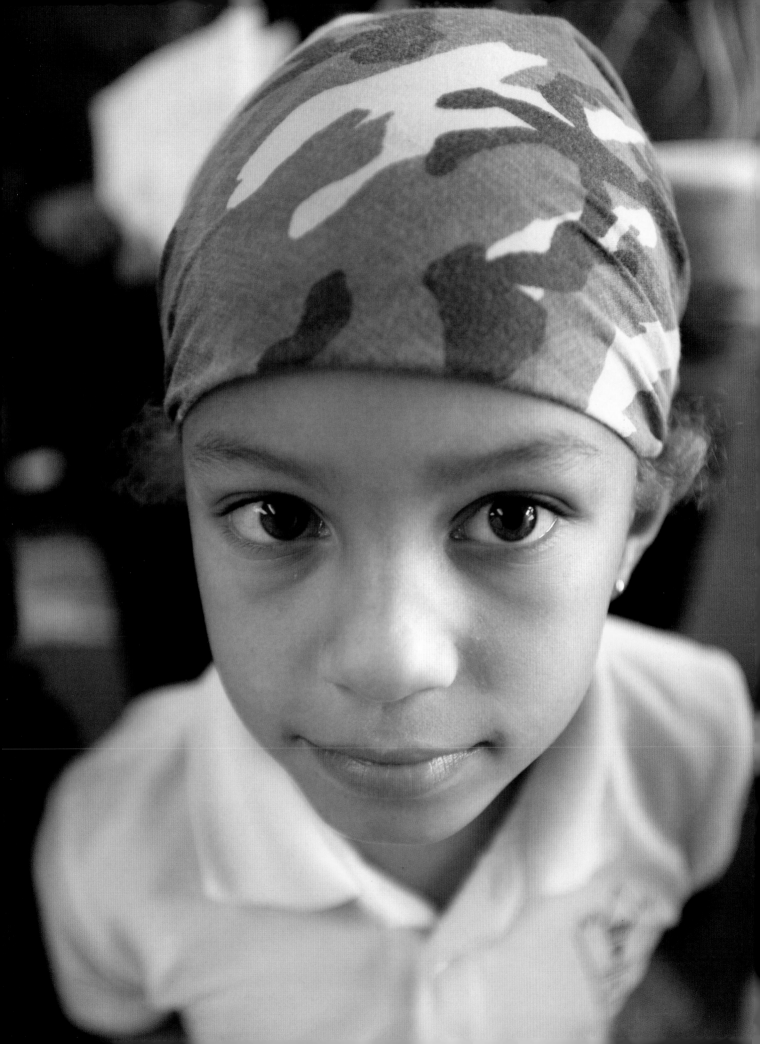

Basic Composition

If choosing the right viewpoint can alter the ambience of your portrait photographs then correct framing and composition will enhance them even further. There has been a rule that artists have followed since the Egyptians built the pyramids or the Greeks built the Acropolis. This rule is known as the, "Golden section". It means that the subject should stand at the intersection of imaginary lines drawn vertically and horizontally a third of the way along the sides of the picture. Naturally there are photographs that completely reject this rule and are still fine photographs. What you should aim for is to draw the viewer's eye to the main subject by using strong perspective, or the contrast of the person with the background, or – in colour – the distribution of various hues. Of course you could use a combination of all of these.

The most obvious way of filling the frame is to move in close. It is interesting, therefore, that most people seem to move backwards when taking their shot. You can crop out unwanted detail at a later date to make your subject more prominent in the frame, but this could be at the expense of increased grain or noise.

If it is not possible to get closer to your subject, try changing the lens or zooming in to fill the frame. If that doesn't work, consider changing position to include some compositional detail. Can your subject use a tree, for example, to lean against? This will add a more natural feel to the shot as well as filling an area of the frame.

Another way of filling the frame is to decide whether your shot would look better as a landscape or a portrait. It is amazing that so many people seem to think that photographs can only be taken when the camera is held in the horizontal position. After all, most people's faces fit neatly into the frame of the camera when it is being held in the portrait or vertical position.

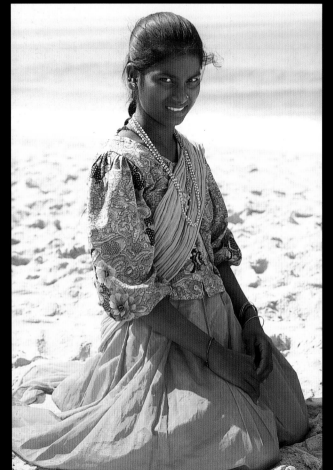

Framing Your Shot

This young Indian girl was photographed on the beach and at first I photographed her full length with the sea as a backdrop. I then decided to move in closer and concentrate on her face. At first I wasn't that happy with the results, but when I came to print them I cropped in tightly. This made all the difference, and the final version below right, where her face completely fills the frame, is very enigmatic. Many shots that at first look mediocre can benefit from this approach, so always study each one carefully before dismissing it out of hand.

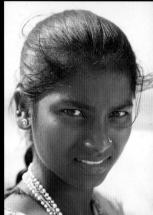

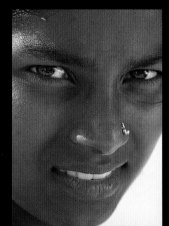

Right: Not all portraits need to have the subject facing the camera. This shot has all the elements of a strong composition: the horizon, wall and bench divide it into specific geometrical areas that frame the subject. The lady is slumped slightly forward, adding to the lonely, despairing feel of the portrait, while her red scarf and the handle of her umbrella are almost metaphors for the dangers that can exist in the world.

Below: This is another portrait that uses all the elements of the surroundings to frame the subject. I placed him on a fire escape, where the weathered look of the metal is strong in texture and angularity. I stood two floors down and used a telephoto lens to get in close and placed the subject to one side of the frame so that he was against the sky. Try to develop a keen eye to see what potential there may be in mundane surroundings.

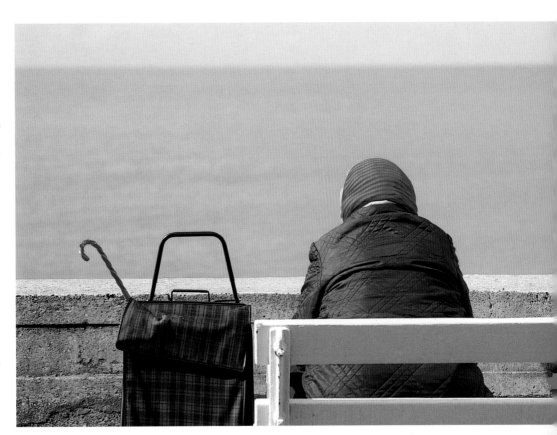

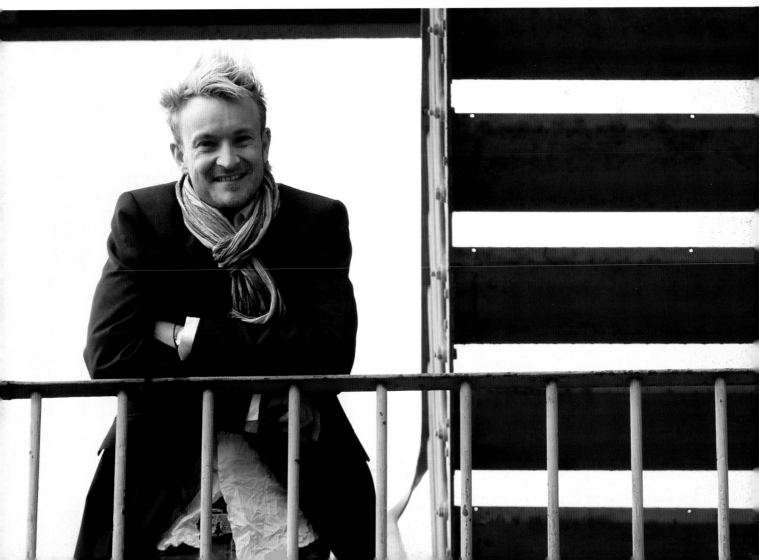

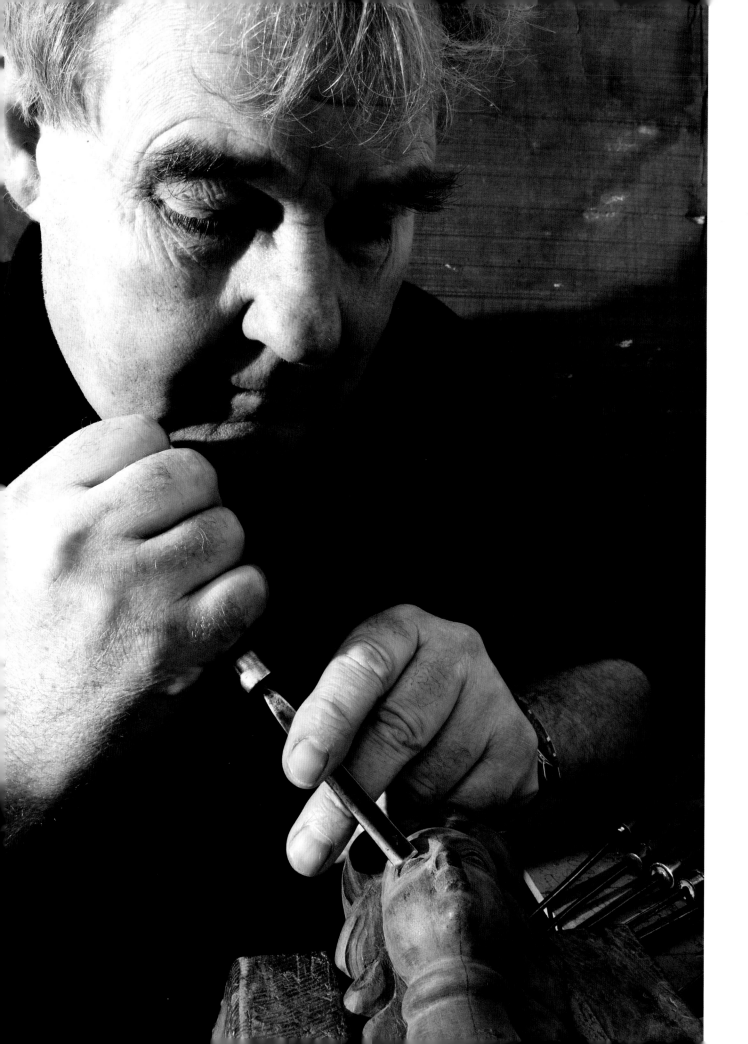

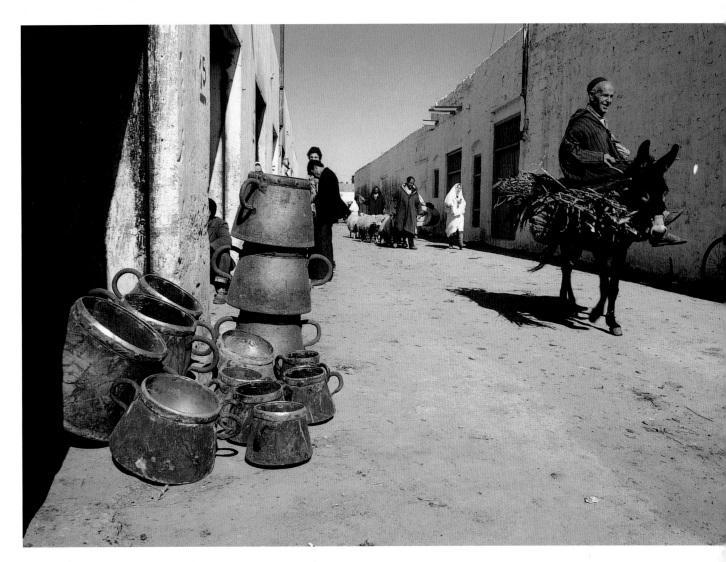

Opposite: This photograph of a master carver at work has all the elements of a good composition. The shot is close enough for us to see the intricacies of his work, while at the same time showing his absolute concentration. His hands and chisel form an interesting shape in the bottom half of the picture, while his face dominates the remaining area.

Above: In composition there is a rule known as the Golden Section, which states that your subject should be placed at the intersection of imaginary lines drawn vertically and horizontally one third of the way along each side of your picture. This portrait of a man on a donkey has all these ingredients, with each element perfectly placed.

Daylight

Because we take daylight for granted, it is often the light source that we pay the least attention to. This can present several problems when taking portrait pictures. For instance, as the colour temperature of daylight varies throughout the day (see pages 36–37), so the cast caused by this variation affects the overall colour and becomes apparent in the skin tones of your subject, making them look warmer or cooler.

Bright sun in the middle of the day can create harsh shadows, particularly under the eyes, nose and chin of your subject, and can make the person squint and screw up his or her eyes. If this is the case, try to move the subject to an area of overall shade so the light is more even and more comfortable to pose in. Another way is to turn the subject round so that his or her back is to the sun, which can create a pleasant backlight through the hair.

Remember to compensate in exposure, as your camera meter may read for all the light coming from behind and not the light falling on the face. If you don't compensate, your subject may be underexposed and appear as a silhouette. Many cameras have a built-in backlight compensation setting that calculates the exposure automatically for this technique. Alternatively, you could use a reflector to bounce light back into the face, or use fill-in flash (see pages 140–41). On the other hand, if you have placed your subject against a very dark background, the meter may read primarily for this and the image will come out overexposed.

If the day is very overcast, the light will be quite cool and could make the skin tones of your model look bluish. You could use a warm-up filter, such as an 81A, or correct the tones once the image has been scanned into your computer. Another form of daylight that can look attractive on skin is dappled light. This happens when the sun is filtering through the branches of a tree, creating little pools of light. Care needs to be taken in this case so that the contrast between light and shade is not too harsh.

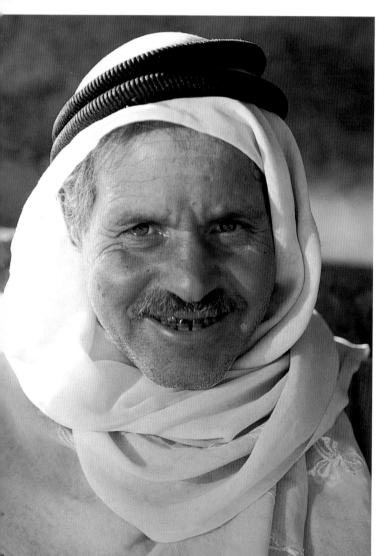

Left: The sun was shining so brightly at the time I took this portrait that I had to move the man into an area of relative shade. You can see the sun coming from behind one side of his headdress. Fortunately I placed him facing a white wall, which I used as a reflector, and it bounced just enough light back into his face to give an even exposure for his skin tones.

Opposite: By contrast, this girl had her back to the early evening summer sun that was beginning to get quite low in the sky and bathed her hair and shoulders in a subtle halo of light. I took a reading for her skin tones with the camera's spot meter mode, and the result is an evenly lit portrait set against a muted background.

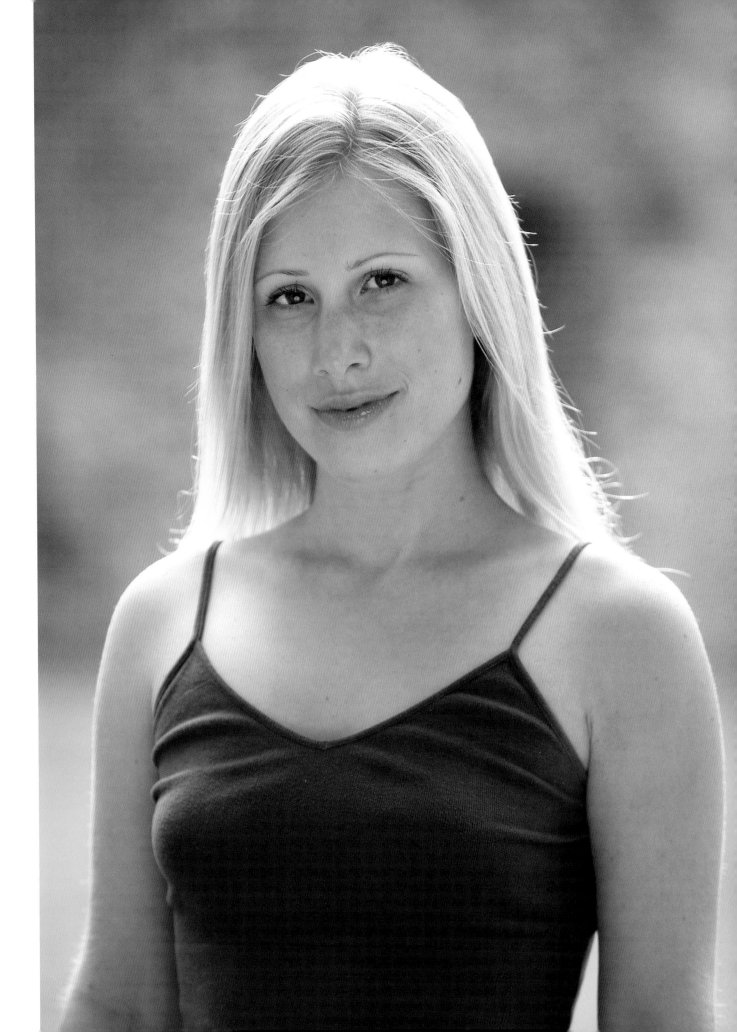

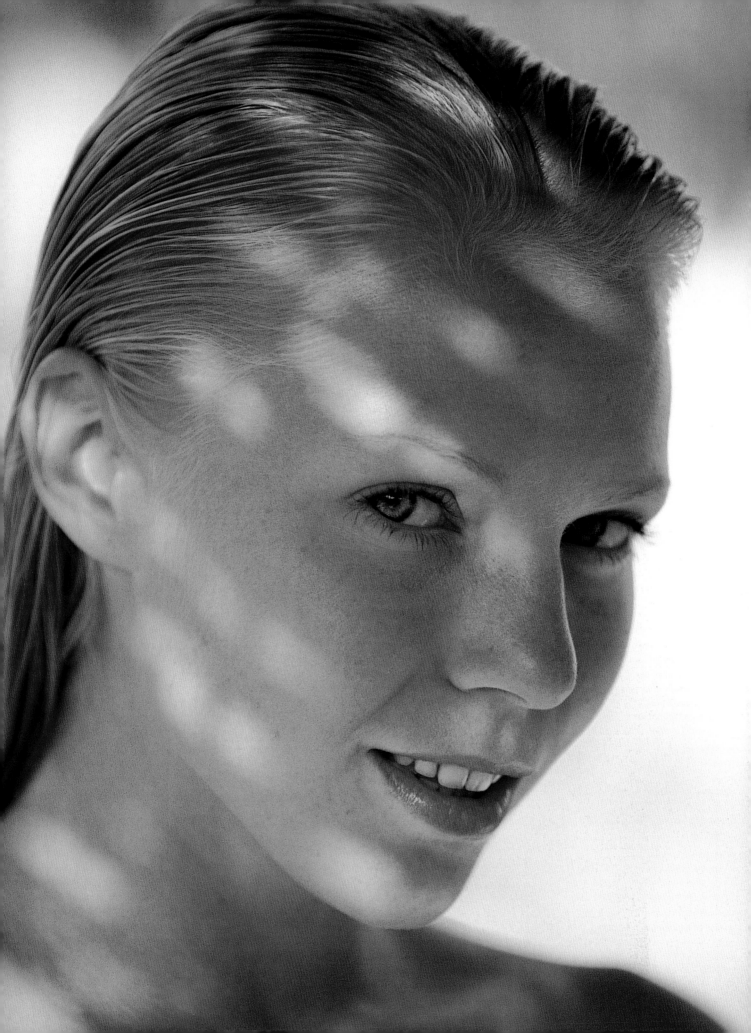

Opposite: Bright daylight can create attractive light patterns, but because it is continually on the move, you need to act quickly to get the shot that first attracted you. The light falling on this girl's face was filtering through the leaves of a tree. In situations like this, you need to make sure that the pools of light are not so harsh that they burn out the skin tones.

Below: This portrait of the Chief Yeoman Warder at the Tower of London was taken early in the morning, when it was slightly overcast. However, I used this to my advantage because if the sun had been shining brightly it could have caused problems with shadows under his hat. The result is an evenly lit portrait that makes him look confident and relaxed.

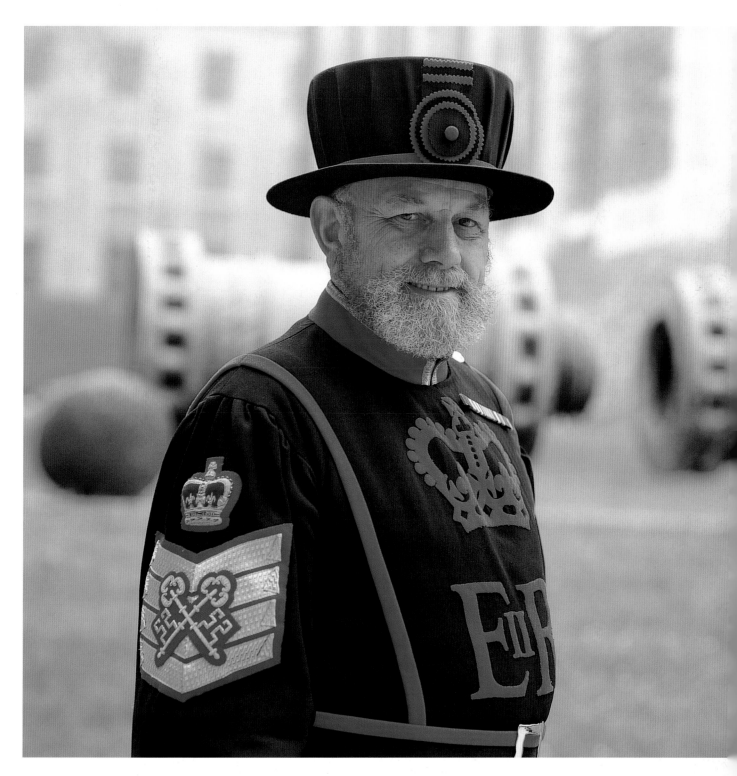

Available Light

In photography we refer to available light as the light that exists without our having to add an artificial light source, such as flash or photofloods. This could be daylight coming in through a window or doorway, normal domestic lighting, such as light bulbs or fluorescent tubes, or even light from a candle, lighter or match.

If you are using light coming in through a window, look carefully at how it falls on the person's face. Is it bright and harsh, causing one side of their face to fall into deep shadow? If this is the case, it can be beneficial to use a reflector to soften this shadow. Another technique is to soften the light. This could be done by hanging a piece of white muslin material over the window or diffusing it with tracing paper. In either case, you are cutting down the amount of light that is available, and have to choose either a wider aperture or a slower shutter speed. If it is the latter, you may have to use a tripod or find some means of support for your camera to keep it steady.

When using artificial light indoors, such as standard domestic tungsten bulbs, you need to use tungsten-balanced film or to set the white balance on your digital camera to tungsten. (Even when set on auto white balance, some cameras still produce over-warm pictures that need to be corrected at a later stage.) If your camera is already loaded with daylight-balanced film, you could use a colour-balancing filter – this is usually an 80A, which is dark blue. The problem in this situation is that the filter is quite dark and cuts down the amount of light passing through the lens, so an increase in exposure is almost certain to be required.

With fluorescent light, your pictures come out with a green cast, whether you are using daylight- or tungsten-balanced colour film. There is a range of different filters available to correct this cast, but because there are so many different types of fluorescent tubes, you only know what is the right filter by testing them or by using a colour temperature meter.

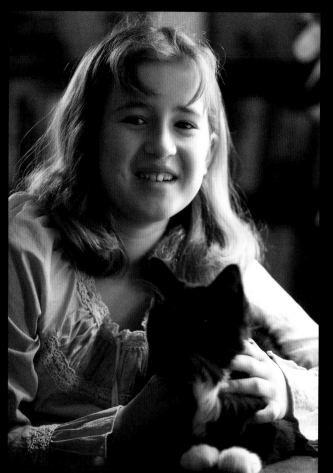

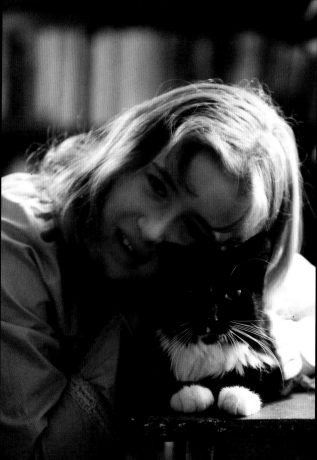

Opposite far left: I placed this young girl and her pet cat next to a window and used the available daylight as the main light source. Although there was enough light to get the shot I was unhappy with the overall quality of the picture. I thought the shadow area on the left side of her face was unflattering and did not create the mood I was after.

Opposite near left: I then positioned a white reflector to her left so that the daylight was bounced back into the shadow areas. This created a far better feel to the shot, and the overall light is far more flattering. If you do not have a custom-made reflector, one can easily be improvised by using a piece of

Above: This girl was photographed between two illuminated walls of light. Because I did not have a colour temperature meter and I had no idea what the light source was I set the white balance on my digital camera to auto. This has ensured that the final result is perfectly acceptable and the girl has near perfect skin tones.

Overleaf left: The candle that this girl was holding was the only light source in this picture. I placed a reflector above her head to bounce some light back into her hair. As the exposure required was 1/4 second I had to have the camera on a tripod to keep it steady.

Overleaf right: I took the portrait at night in a bar in New Orleans with a mixture of available light. There were tungsten lights in the ceiling, a fluorescent light over the bar, and the remains of the daylight coming in through a doorway to his right. I placed a white reflector to his left, as this was in quite harsh shadow, and decided to shoot it in black and white so that there would not be

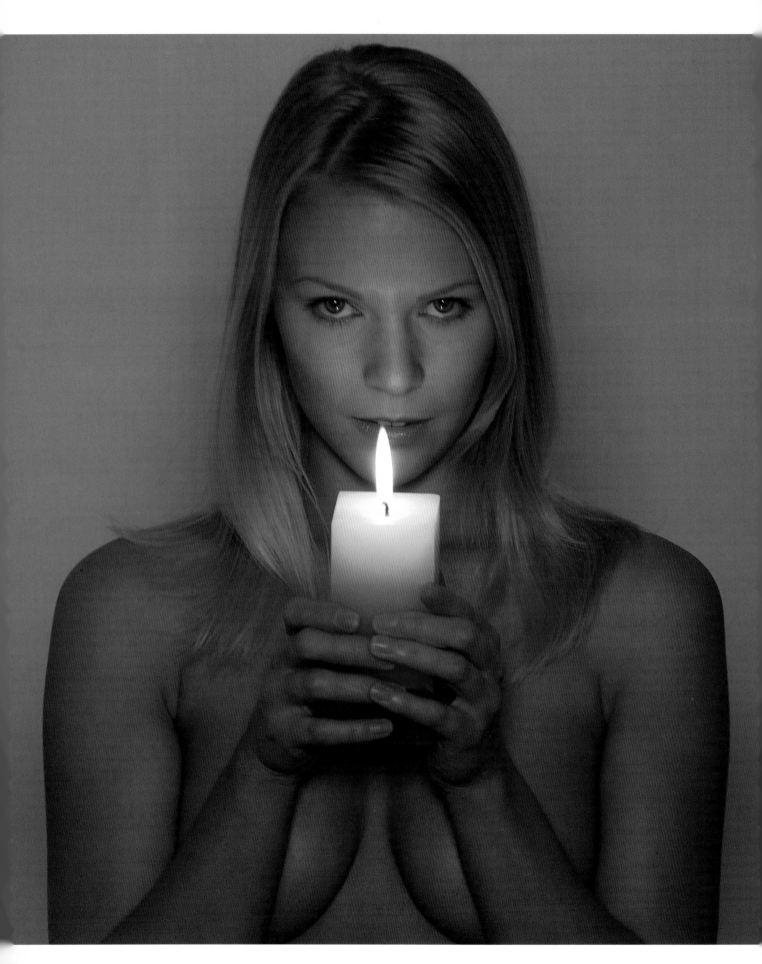

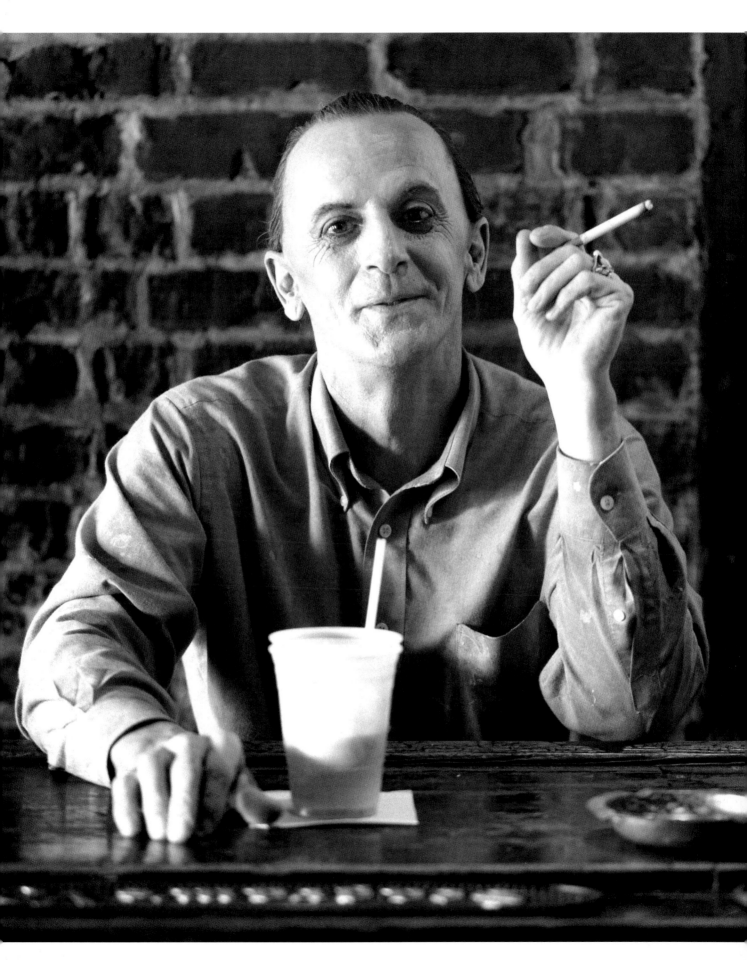

Flash

Most cameras come with some sort of built-in flash, usually positioned on the camera body, next to or near the viewfinder, or as a pop-up unit on the top of the camera. The exceptions to this are the professional cameras at the more expensive end of the market – and it is the absence of flash in these models that gives us an idea of the worth, or otherwise, of built-in units.

A common problem with built-in flash is "red eye". In low light conditions the eyes' pupils dilate or become larger; this causes the flash, at the moment the shot is taken, to enter the subject's eyes and reflect off the red blood vessels at the back of the eye. While many camera models have what the manufacturers call "anti-red eye" or "red-eye reduction mode", these features do not give particularly good results. They nearly all work by firing a series of small flashes before the shot is actually taken, to reduce the amount of the eye's dilation. However, because with this system there is a delay between

you seeing the shot and the camera actually taking it, the moment can pass and the fleeting facial expression, which looked so animated just a few seconds ago, can be lost.

The only effective way to eliminate red eye is to have a separate flash unit that can be held further away from the camera so that the direction of the flash is not on the same axis as the camera's lens. Another benefit of separate flash units is that they are far more powerful than the built-in type. Many are of the dedicated variety so that your camera will be able to read exactly the amount of flash required through its TTL metering system. You can swivel and tilt the flash head, which enables you to "bounce" the flash off the ceiling or other white surface to give a softer, more diffused light than direct flash. This method makes for far more flattering portraits, although you need to be careful that it does not lead to shadows under the eyes. Many flashguns have a small fill-in flash window just under the main flash head to help eliminate this problem.

Bounced Flash
If your subject is close to the background and you photograph with direct flash, an unattractive shadow can appear on the background (below). The best way to eliminate this is to bounce the flash by angling the flash head so that the light is reflected (bounced) off the ceiling or some other suitable neutral surface. This produces a far more flattering light (right).

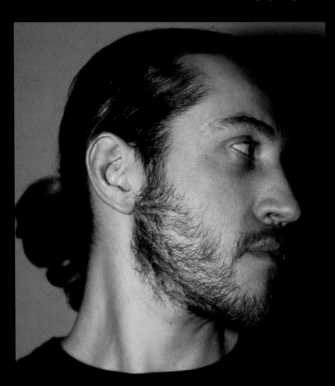

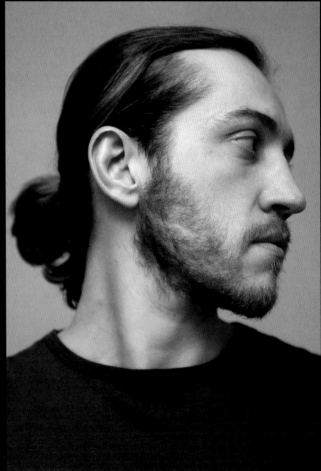

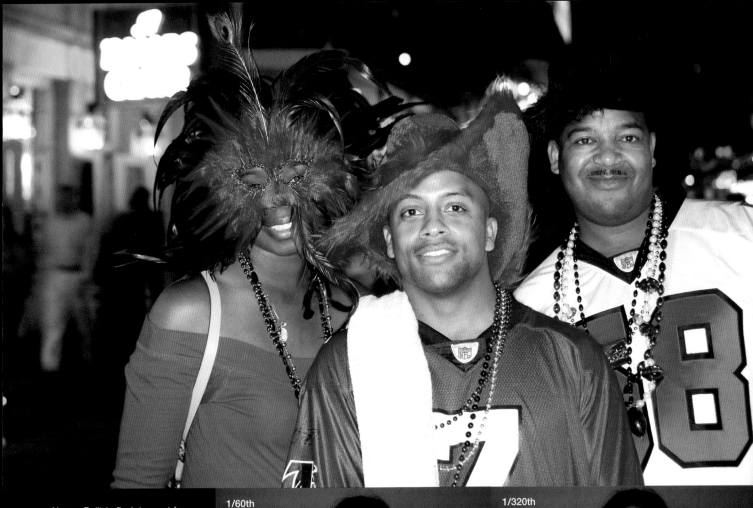

Above: Built-in flash is great for spontaneous shots. However, with many cameras this type of flash is very weak, so you need to be sure that you are shooting well within the camera's range. This usually means that anything further than 10ft (3m) away will be underexposed.

Right: When using SLR cameras, there is a maximum shutter speed at which the flash will synchronize, usually around 1/125 second. If you choose a shutter speed that is faster than this, only some of your picture will come out correctly exposed. The faster the speed, the less this will be, as shown here.

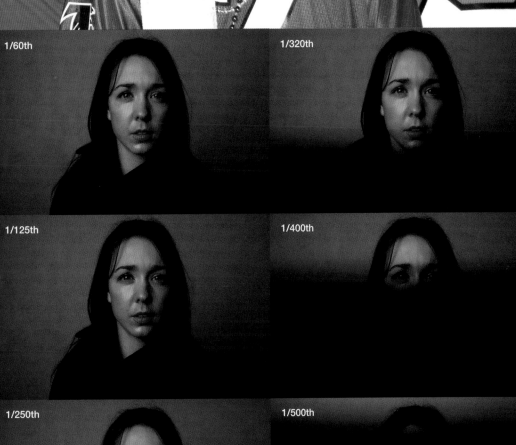

1/60th

1/320th

1/125th

1/400th

1/250th

1/500th

Top left: A common mistake when taking portraits indoors is to rely on the camera's exposure meter to determine the correct settings. Often what happens is that the meter reads the brightest part of the subject – in this case the window – and underexposes the subject.

Top right: To correct this, you need to introduce a certain amount of flash to balance the background with the subject. However, even this can create problems with flare, and here the flash has reflected badly in the window.

Above: By turning the flash so that it is now at a slight angle to the window, the reflection has been eliminated and the picture is evenly balanced, with both the background and the subject correctly exposed.

Top left: In overcast weather skin tones can look flat and dull, and the final portrait can lack life, as seen here.

Above left: If you add flash when shooting outdoors, you need to take care that the auto flash sensor reads for the main subject. In this case it has taken its reading from the background, which is some way away, and overexposed the girl's face.

Above: In this shot the amount of flash is just right and is balanced for the surroundings. It has given vitality to the girl's face and lifted the gloom of the dull weather.

Backgrounds

The background to a portrait photograph can often determine whether the shot is going to be a success or a failure. If the background is very busy, it can become a distraction from the person you are photographing and absorb them so that they lose their importance. On the other hand, the background can be put to good effect in the sense that it can tell us something about the person's work, environment or interests. In both cases, you need to achieve a subtle blend between background and subject.

When shooting portraits indoors with available light, the chances are that the light will be quite low in intensity. This means that you can use a wider aperture, which reduces the depth of field, making the background go out of focus and giving a blurred backdrop. Of course, you can use this technique outdoors in daylight. It is especially effective when using a long telephoto lens, as the depth of field is even less; with practice, it can look quite painterly. In addition, a background shot in this way without a subject can always be stored on your computer and used at a later date.

Long rolls of background paper, known as coloramas, are often used in photographic studios. These rolls of paper come in a range of colours, and although they could be seen as quite bland because they are simply flat colour, they can be lit in such a way as to give them depth. The other great thing about shooting in a controlled space like a studio is that you can create virtually any background you want, using wood, stone, plastic or woven materials, to name but a few examples.

The sun may create the background you are looking for by shining through the branches of a tree or doorway, making a dappled light pattern or strong geometric shapes on a wall. You can then place your subject against these, remembering that time is of the essence – unlike controlled light in the studio, the sun is constantly on the move, and the effect you first saw will soon change.

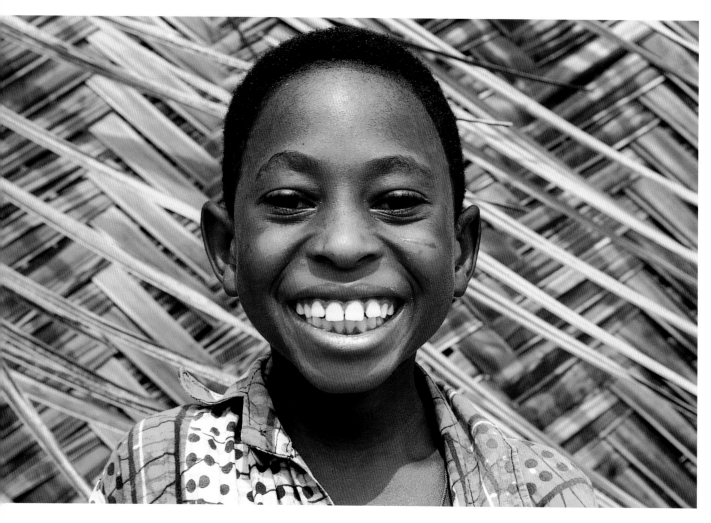

Opposite: I used a wall of palm leaves as a background for a young boy in Ghana, West Africa. Its attractive textures and shapes complement the picture while not dominating it. The boy stands out well, and the emphasis is very much on his exuberant smile.

Right: In the studio photographers often use long rolls of background paper which come in a range of colours as well as black and white.

Below: The shot was taken in the mechanic's garage. I wanted to keep the ambience of the environment and lit it in the available light – one fluorescent strip light high on the ceiling – and used a reflector to his left. This created a slightly harsh light, but gave a gritty feel to the overall shot, and the pictures on the wall provided the perfect backdrop.

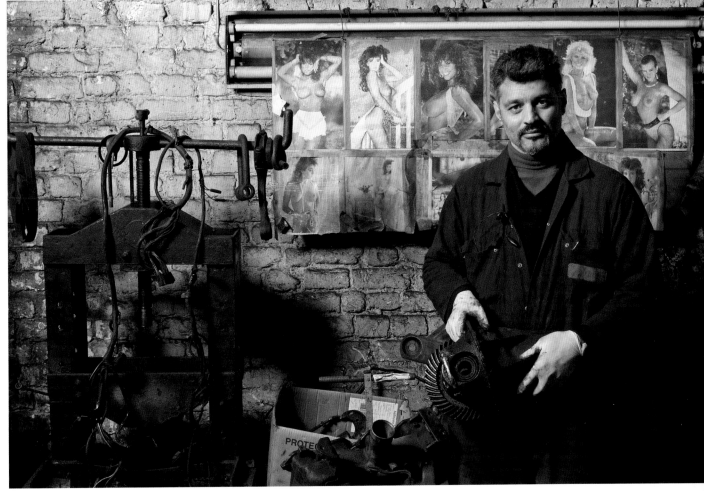

Left: The rocks provided the backdrop for this spontaneous portrait. I particularly liked the way they added a feeling of depth to the picture as they stretched behind in different layers. The high viewpoint means that the camera is looking downwards, which has cut out the sky so that the rocks are the only feature other than the girl, who stands out from them.

Opposite: I met this character in the street and immediately wanted to take his portrait. As there was no time to move him to another position, I chose the best background in the immediate vicinity. The red wall contrasts well with his yellow singlet, and the brickwork adds just enough interest to stop the background from being bland.

Using Props

One aid to composition in portrait photography is to add a prop, which can be something as simple as a hat, a musical instrument or a column that your subject can lean against. In other words, a prop is an item that complements your subjects – and if you give them something to hold, this can help them to feel and appear more relaxed and natural in front of the camera. Many professional photographers have prop stores or cupboards in their studios so that if they feel a shot needs some addition they can usually produce a suitable item. Some have built up a store of such props over a period of years, with no specific idea in mind for many of the items – but one day, just such an item may be exactly what is required.

If you use a hat as a prop, be careful that it does not cast an unsightly shadow across the subject's face, or you may need to use fill-in flash or a reflector. If neither of these is available, the hat must be placed in such a way as to minimize any shadow, or you will have to position the person so that the light is directly behind them.

When photographing a subject in their place of work, look out for the tools or means of their trade that could lend themselves to your shots; it could be that they have their back to their working environment but are holding an item that they have made or crafted.

Be on the lookout for the unusual placing of props, as an everyday object held or positioned in an original way can produce a really effective portrait. On the other hand, it could be the way you position your subject amongst various props that makes an eye-catching composition.

Photographers will often be on the lookout for props. These do not always have to be bought. For instance, a walk on the beach might uncover the most amazing piece of weathered driftwood. Depending on its size this could be used for a model to recline on or to lean against. Material or fabric shops are another great source for props. It is amazing what remnants of fabric can be used in portrait photography, from being draped around a model to being used as an entire background.

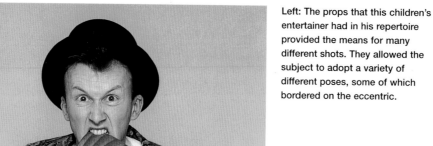

Left: The props that this children's entertainer had in his repertoire provided the means for many different shots. They allowed the subject to adopt a variety of different poses, some of which bordered on the eccentric.

Opposite above: The skateboard in this shot made the perfect prop for this young man. His choice of shades helps to convey a cool image, which was his intention. By letting the background go out of focus, the emphasis is very much on him and his guise, which convey to us the nature of the activity that he is involved with.

Opposite below: The props were deliberately placed in this portrait to create a feeling of early summer. The hats complement one another and generate the impression, as does the tray of drinks on the table, that the girl is about to be joined by someone else. The whole feel is of a shady area on a hot summer day where two people can have a lazy, intimate drink.

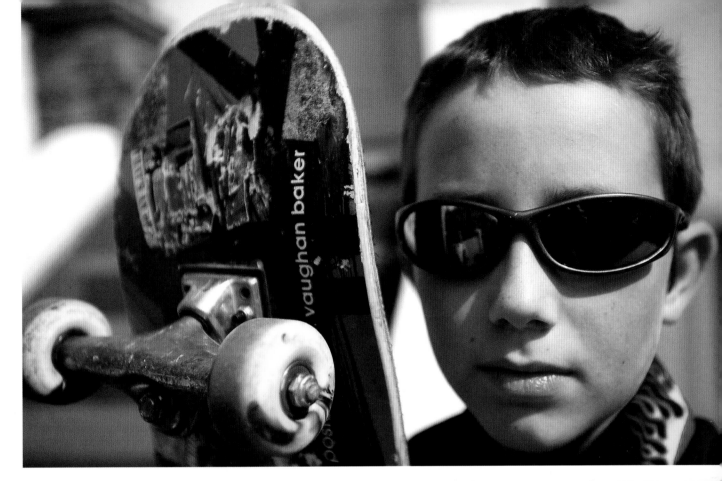

Overleaf: I liked the idea that these two people were both drinking but could not be more different. In the picture on the left, the man is holding an outsize mug, which looks even bigger due to the use of a wide-angle lens.

By contrast, the girl on the right was shot with a medium telephoto lens and is drinking from a normal mug. She is slim and perfectly made-up, and the mug adds the right amount of colour to the surroundings. Her smile contrasts well with his.

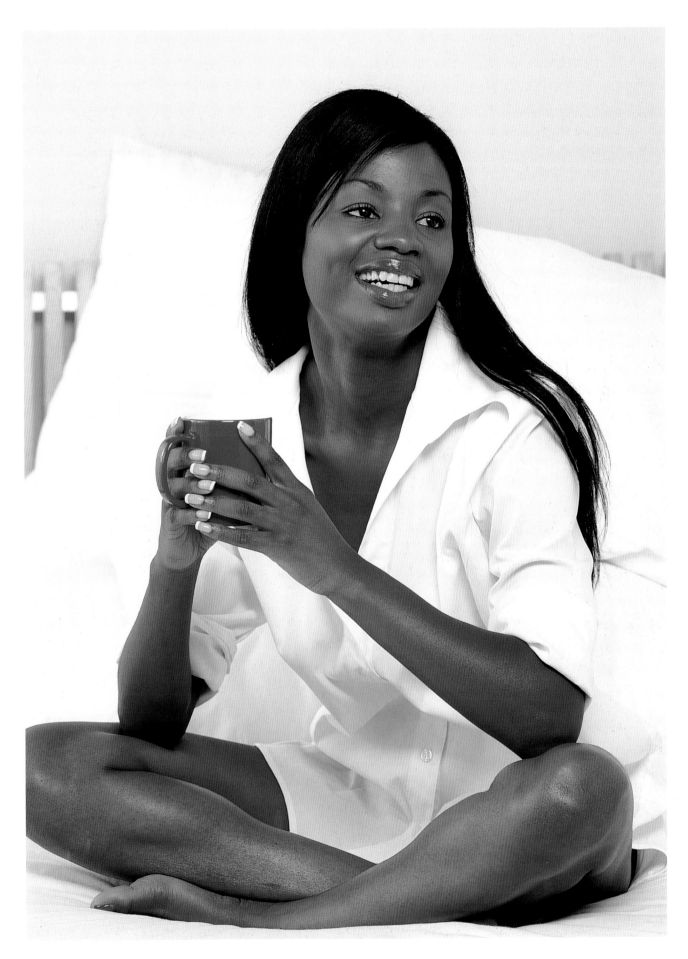

Using Colour

Because we live in a world where colour is all around us, most of us take it for granted and accept what we see every day as normal. It is only when something radically changes that we are shocked into noticing it. For instance, someone in your street suddenly paints their house deep purple; or the person you work with, who has blonde hair, arrives one day with it dyed bright green. Of course these are extremes, but it is surprising how drastic change needs to be before the majority of people take notice.

The same is true in photography, where lots of shots fail because the photographer didn't pay enough attention to the use of colour. Colour works because it complements or contrasts with another colour – after all, when you are going to decorate your home, you consult a colour chart to see what colour the walls should be, as opposed to the woodwork, which you might paint another shade.

A colour wheel is useful, as with it you can see which colours go well together and which don't. This doesn't mean that you have to carry a colour wheel with the rest of your photography kit, but studying it helps you to understand the meaning of colour, and to use it with greater confidence. Of course, every rule can be broken, sometimes to great effect. The important point to remember is that if the final result is eye-catching and effective, it has made its point.

It is also important to remember that photography is only a representation of what you saw at a particular time – poor film, faulty processing or even poor camera equipment can change the colour of what you thought you had perceived. This is why it is so important, when buying any kind of film, to make sure that it comes from a reliable source and is stored in the correct conditions. If film is not stored properly, a colour shift can happen, which will mean that it could reproduce with a magenta bias, for instance. You can't always be sure in hot countries that the film has been protected from heat, which is why it makes sense to buy more film than you need before travelling, and to store it as directed.

Right: A colour wheel is a useful device for seeing the relationship between colours. The three primary colours, red, yellow and blue, cannot be replicated by mixing other colours together. On the other hand, secondary colours are created by mixing two primary colours together: blue and yellow to create green, red and yellow to create orange, or blue and red to create violet. The colours opposite each other on the colour wheel are called complementary colours.

Below far left: Black skin contrasts well with almost any colour, such as this red backdrop. The other primary colours, yellow and blue, would have been equally as effective, as would their complementary colours.

Below near left: In this shot, the pink bikini top contrasts well with the blue of the swimming pool. This is because they are opposites. If the bikini had been blue, it would not have looked as effective in the blue of the pool as it does here.

Below left: In this picture of a father and son, the colours of their T-shirts contrast well, while the scarves they are wearing complement one another. I particularly like the relationship of their hands, which, together with tight framing, make a strong, colourfully composed portrait composition.

Below right: The green of this tropical background provides the perfect backdrop for the portrait of this girl in traditional African dress. Although the colours are not high in contrast, they do complement one another.

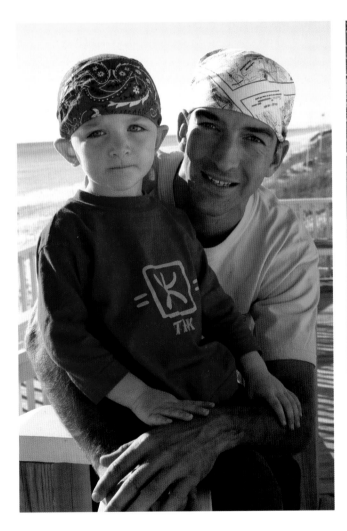

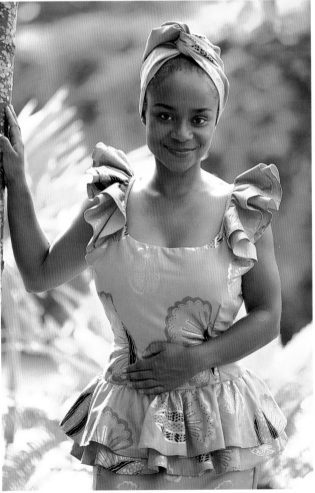

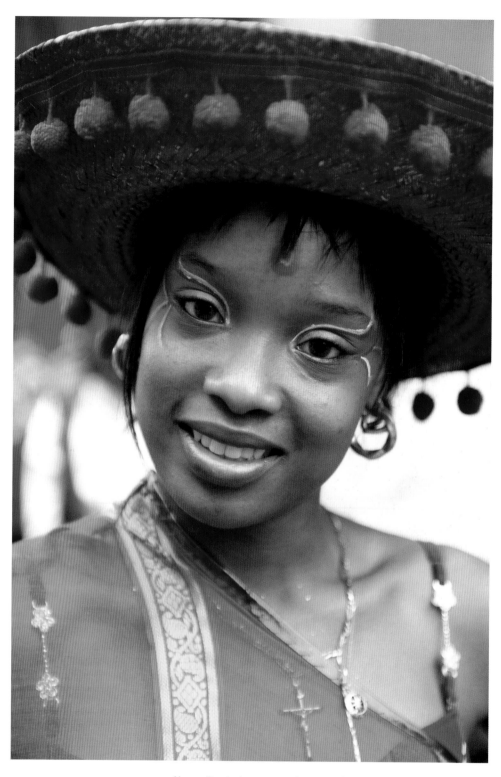

Above: Carnivals are great places
to find people wearing vibrant
colours. The intensity of this red
outfit perfectly frames the woman
so that the emphasis is drawn
immediately to her facial features.
An overcast sky prevented the
sun from causing a harsh shadow
from her hat to fall on her face.

Opposite: The field of lavender
provides a vibrant background
for this girl wearing typical
Provençal dress. Her skin
contrasts well with the flowers
as they stretch in rows into the
background behind her. The
bright sun also helps to intensify
the colour.

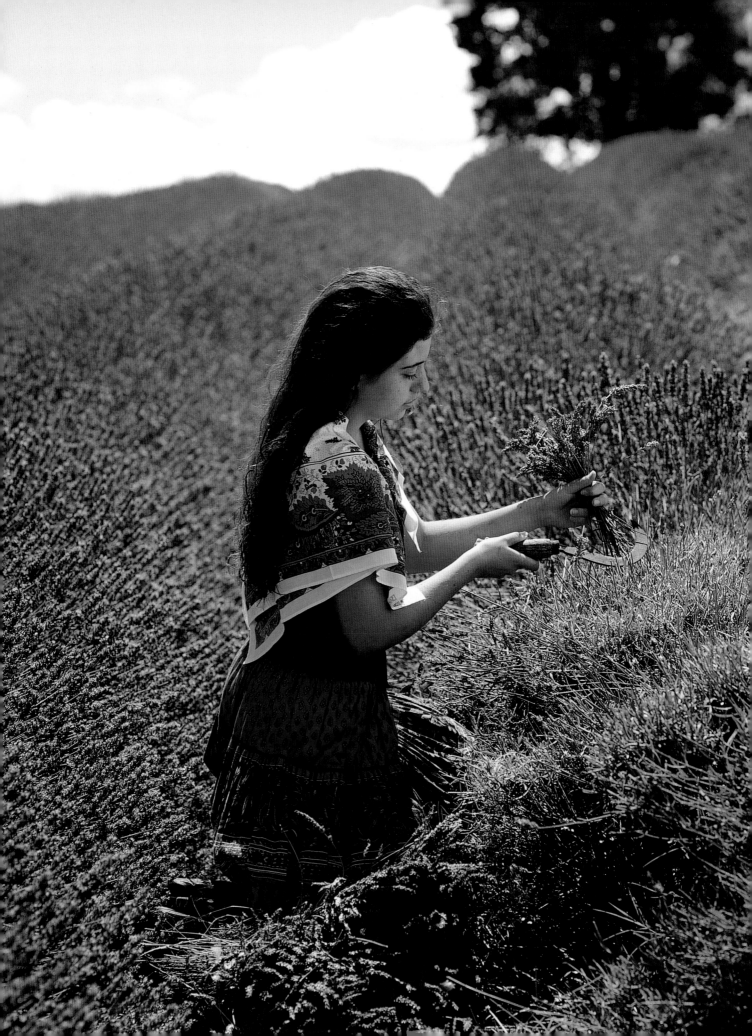

Black and White

For portrait photography, black and white is in many ways the perfect medium, as the eye concentrates much more on the subject, lighting, composition and tonal range, and is not distracted by bright colours. Black and white can be far more effective than colour in showing the lines and characteristics of a person's face. If you are shooting digitally you can always convert your colour shots to black and white once you have downloaded them on to the computer. The same is true for shots taken on film, which can be scanned from negatives or transparencies or prints.

When shooting with film, choose one to suit the situation. If you are using available light, it would be wise to use a fast film or up-rate a slower one. Although this will increase the grain, it should not necessarily detract from your finished print, and could well increase the atmosphere. If you are shooting digitally, it may be necessary to increase the ISO; this will increase the noise, but again this could be put to good effect.

When shooting indoors with artificial light at slow speeds, use a tripod. If you have lighting, such as electronic flash, start with just one light and build it up as necessary. If the flash is too powerful for the shot – for instance, when you want to use a wide aperture – you could use the flash unit's modelling lights as your light source. Most units have variable intensity and work like dimmer switches, so you can alter the intensity of the light without having to move them nearer or further from your subject. The great thing with black and white is that you do not have to worry about colour casts, as you would if shooting in colour. If you do change viewpoint, make sure that the light still looks appropriate.

Once you have shot your portraits and have had your film processed or scanned them into your computer, you can tone the images. As well as adding greater permanence, in the case of selenium toning to bromide prints, toning can create atmosphere, making it colder or warmer, or emphasize an aspect of the image (see pages 148–49).

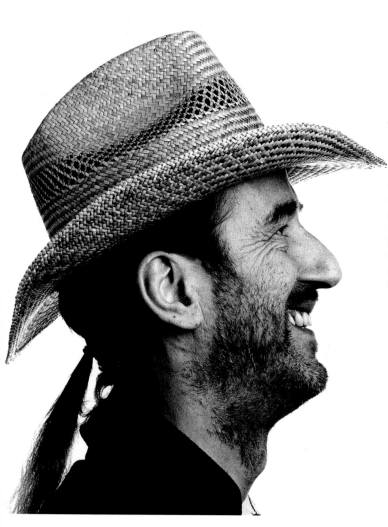

Left: Plain white backgrounds need not be boring and can often bring out the character of your subject more than when shot in colour. One only has to look at the work of the great American photographer Richard Avedon to see how effective they can be.

Opposite: This portrait works particularly well in black and white, as it displays a full range of tones. The lines in the woman's skin show up far better than they would have done had the shot been in colour. Far from being unattractive, the quality of her skin adds character to a face that is full of vitality for one so old.

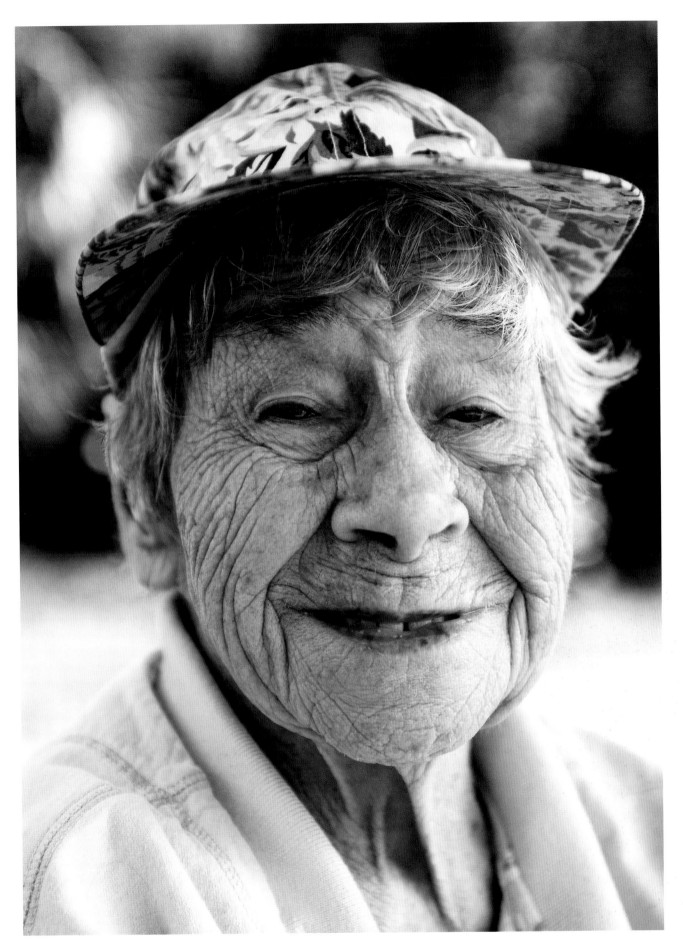

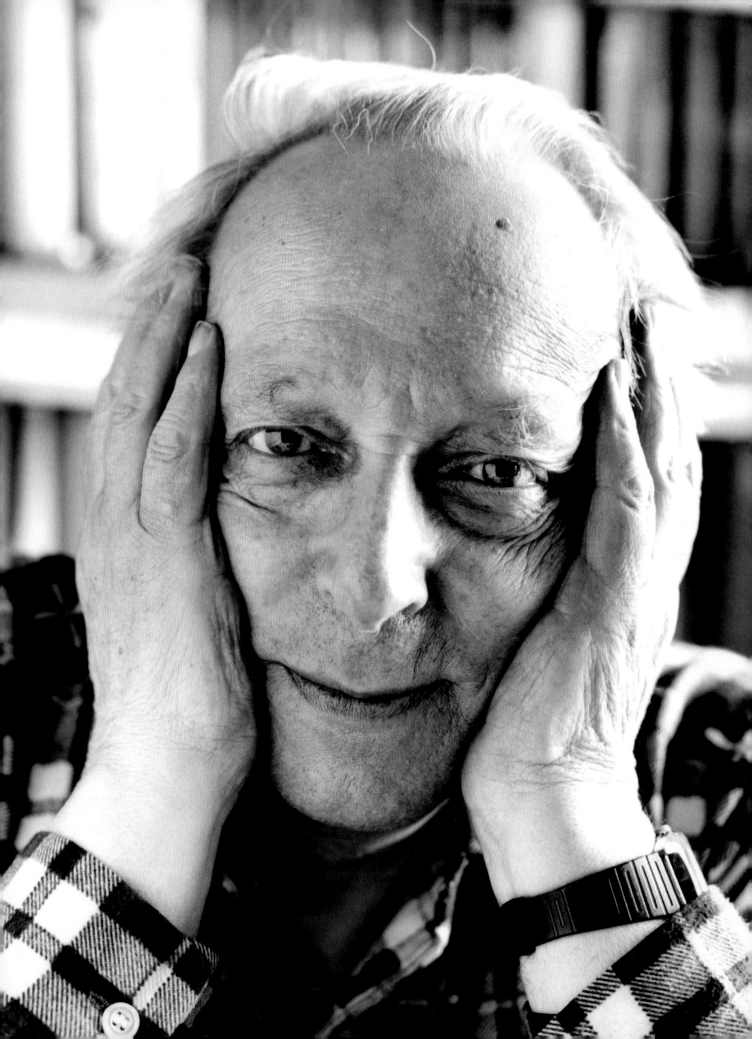

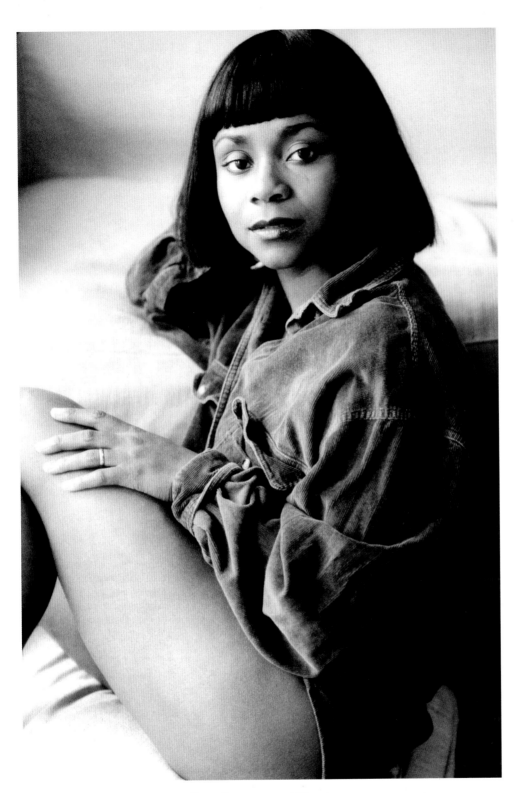

Opposite: Black and white is ideal for available light photography, especially when you are shooting in mixed lighting conditions. This is because you will not have to worry about colour balance. Black-and-white film can also be pushed to a greater degree than colour film and still produce acceptable results.

Above: There are many different black-and-white films on the market, each of which has its own characteristics. This shot was taken on black-and-white Polaroid instant film, which produces positive images and gives rich, inky-black results when printed.

Mood and Expression

More often than not, the first thing that attracts us to another person is their face. The ability to change facial expressions to convey a particular mood is unique to the human species. Faces, smooth and wrinkled, young and old, can show sadness and happiness, humour and despair, anger and joy, surprise and calm. It is this range of expressions and facial nuances that you need to exploit if your portraits are going to be successful.

With all portraits, you will get the best expressions from the person you are photographing if he or she feels relaxed and at ease with you. To create a sense of ease you need to be confident with yourself and in the equipment that you are using – nothing is more disconcerting to a subject than to have to wait while the photographer fiddles with a piece of kit or is indecisive over which lens to use.

The same is true when you first meet your subject – for example try to make a relaxed start by having a coffee with them first. This gives you the opportunity to talk about a variety of subjects and interests, while at the same time studying their face and range of expressions. It is at this time you might notice something about their face that was not apparent on previous meetings. Start thinking about the type of light you are going to use, and the situation you are going to put your subject in – different viewpoints can drastically alter the subject's relationship with the camera.

It is your ability to direct and inspire the subject that can make any session successful. When you take a shot, say how great they look to help them relax. Little movements – such as asking the subject to part his or her lips slightly, or look away from the camera and look back to it on the count of three – can dramatically change the range of mood and feeling.

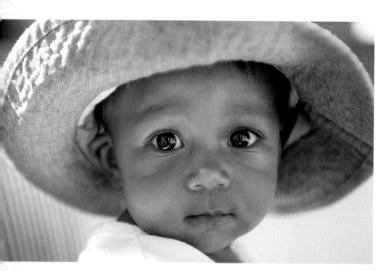

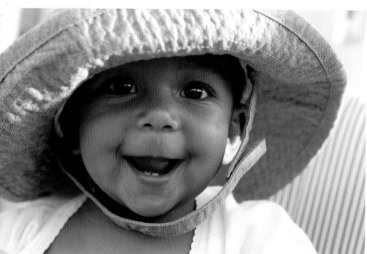

Left: Getting the right mood and expression takes time and patience. This is especially true when photographing very young children and babies, such as this six-month-old. These shots were taken on a 28–70mm zoom lens set on 70mm. I added a No.1 extension tube that enabled me to get in really tight on the subject. With an aperture of f2.8, depth of field was kept to a minimum so that the eyes are really emphasized. The sun was bright, so the baby was positioned with her back towards the sun so she didn't squint. A lens hood was essential to keep the sun out of the lens. Several shots were taken and edited at a later stage. The end result was a selection of crisp and sharp pictures featuring a good range of expressions.

Opposite: Gaining the confidence and respect of your subject is essential if you are going to capture the essence of his or her personality. The expressions of this teenage girl range from a slightly awkward, vulnerable young girl (top left), through to a self-assured, confident young woman whose expression belies her years (bottom right). This range of expressions just doesn't happen, it is a product of the rapport that the photographer must build with his subject. In the first picture, the hands are held together in a rather self-conscious manner, and the slightly high viewpoint increases the expression of apprehension. Her shoe is visible to one side of her face, which is not particularly attractive. With the final shot, which is taken a lot tighter in, she has let her hair down – which makes her look older; she is far more relaxed, and the lower viewpoint gives her an air of complete confidence and control.

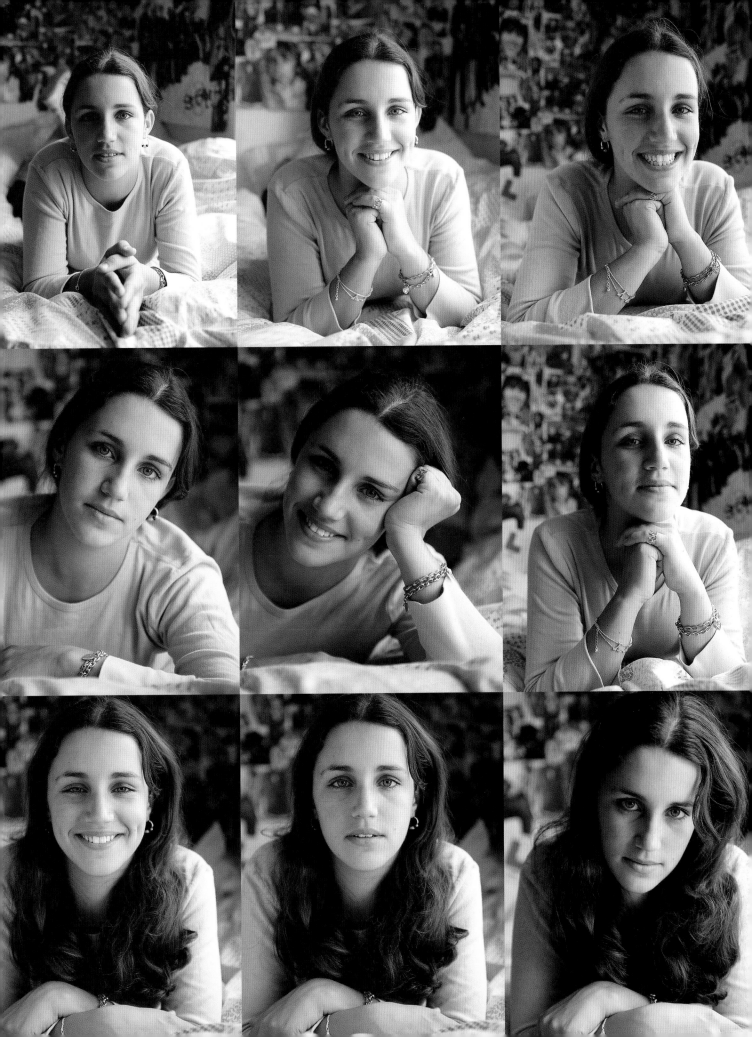

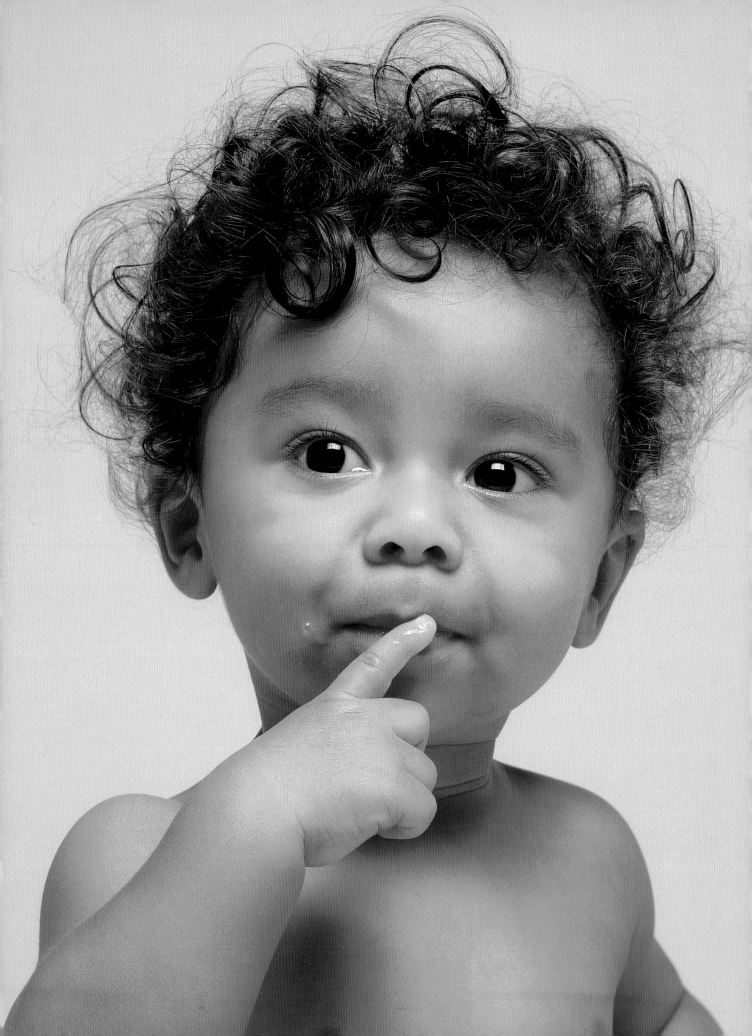

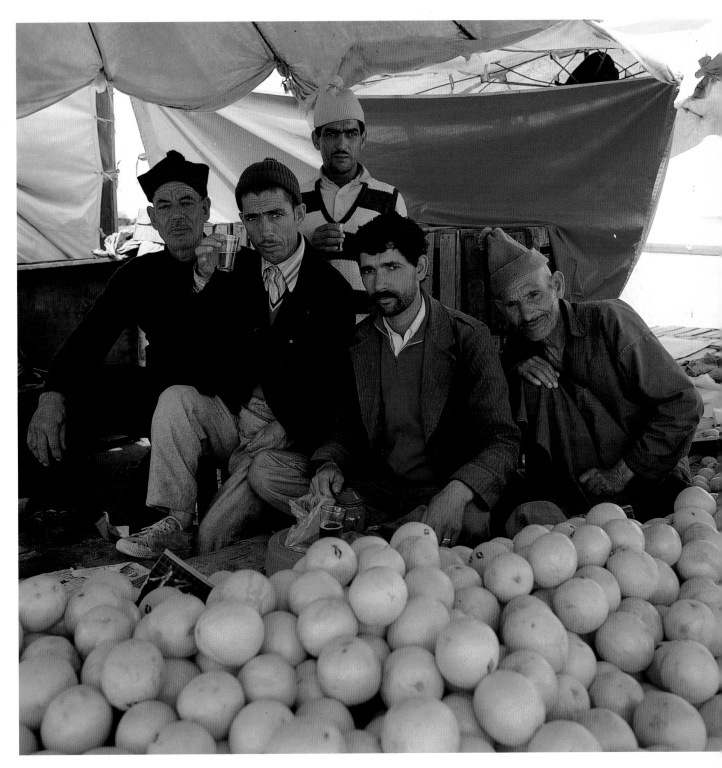

Opposite: Capturing a fleeting expression, especially with children, is an essential ingredient in portrait photography. Here, the young boy is caught in a moment of bemused fascination as he ponders what is going on around him. You need to be alert to get shots like this as they can be gone in a flash!

Above: These men worked in a souk in Morocco, and at first glance look intimidating to anyone who might ask to photograph them. Contrary to their appearance, however, they were only too willing to have their picture taken, and the result is a colourful group portrait.

2 The Subjects

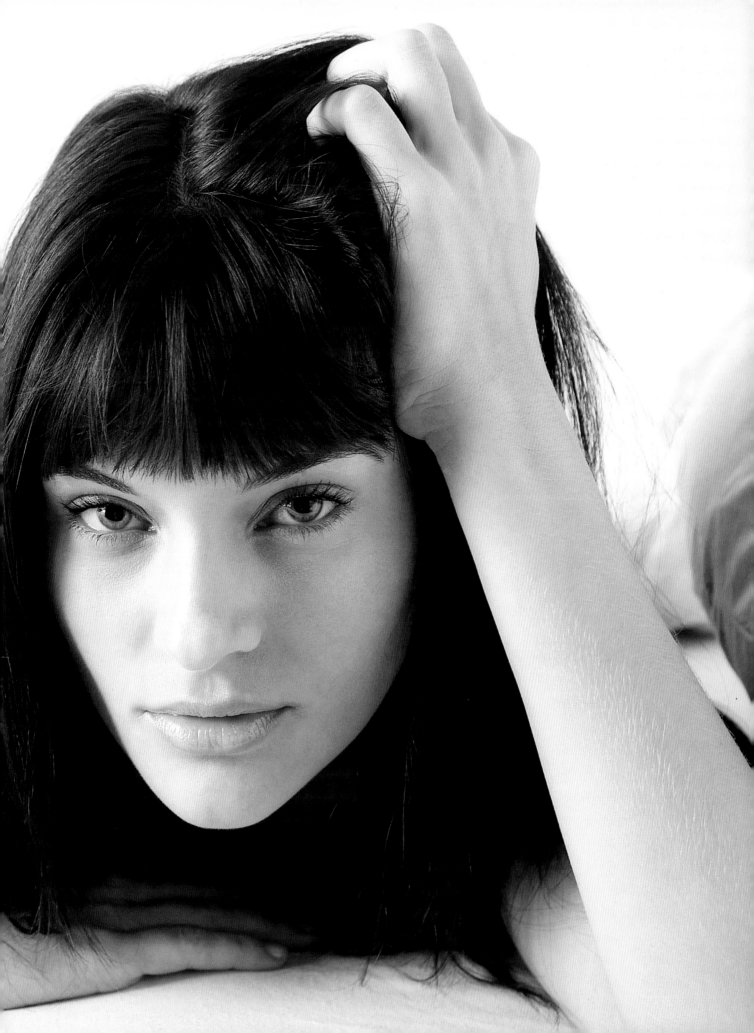

Babies

Very few situations call for a more sensitive approach than when photographing babies. Consider: you have just been born or are just a few days old, and some dark, foreboding shape casts its shadow over you. This is accompanied by a great flash of light as the picture is taken. It's not the sort of approach that gives the baby fond memories of you or endears you to its mother, who has just gone through what is probably the most intense experience of her life. In a situation like this, it would be advisable to use available light.

If the birth takes place in a hospital, the chances are that the light will be fluorescent. If you are using colour film, this gives a green cast and you will have to use a filter to correct it. Alternatively, you could scan your shot into your computer and correct it at a later stage. With a digital camera, either have the camera's white balance set on auto, or adjust it to the fluorescent light setting. If you are shooting in black and white, you will not have to worry about a colour cast.

Where the light is low, you can increase the ISO of the film and push-process it later; if using digital, you can choose a higher ISO rating on the camera itself. With all this, remember that at the birth your photography is the least important part of the proceedings, and the safety and health of the mother and baby are paramount.

By using a moderate telephoto lens or adjusting your zoom lens to its furthest extent, you can get in close while keeping a physical distance from the mother and nursing staff. Once the baby has been born and everything is OK, you can move in close.

After the baby has been born, you may want to shoot a more formal picture of the baby, with or without its mother. Again, available light is still the most favoured type of lighting. Be on the lookout for that special expression, and try new angles. Babies become children far faster than children become adults, so always have your camera at the ready.

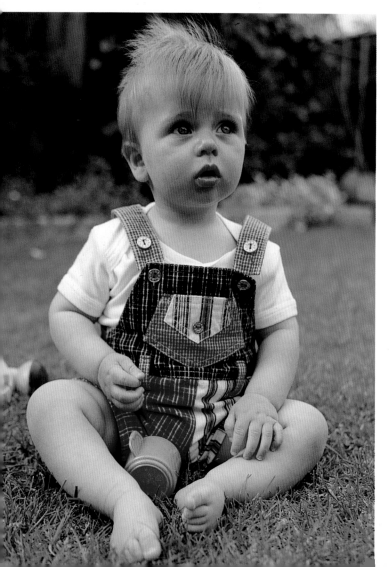

Left: Often it is best to get down to their level when photographing babies. I took this shot lying on the grass and looking very slightly upwards. This viewpoint means that I filled the frame and prevented any problems with my own shadow falling on him, which might have been the case if I had been standing.

Opposite: This portrait of a baby girl was taken within minutes of her being born. I shot it in available light, and because it was low I chose the 800 ISO setting on my digital camera. This has resulted in a slightly grainy picture that adds to the atmosphere of the occasion.

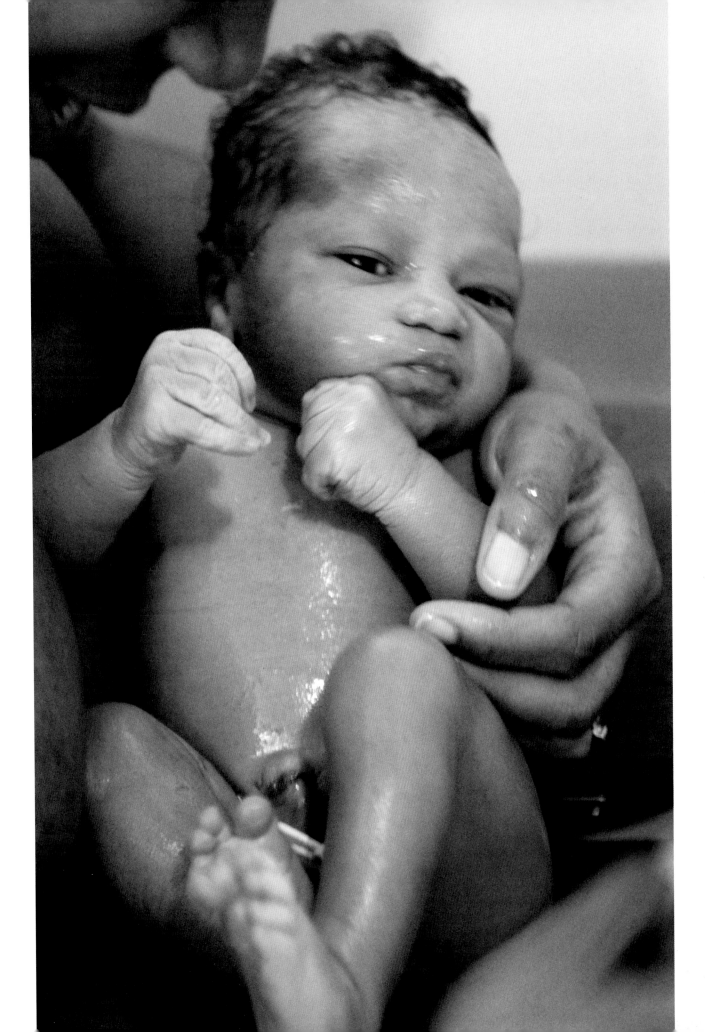

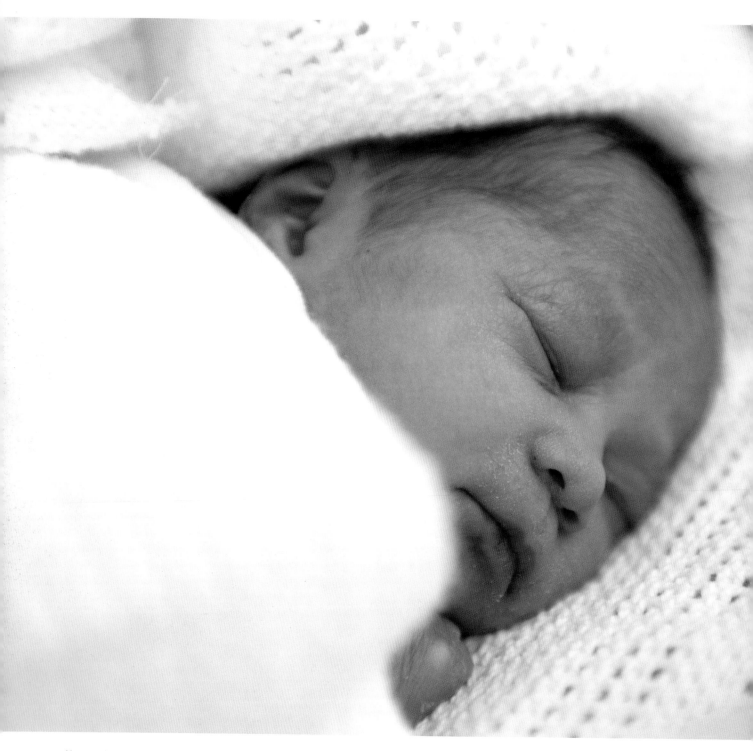

Above: After the trauma of the birth, the baby has been bathed and is now sleeping soundly. Even so, I still chose to shoot in available light, as flash might have disturbed her sleep. Photographing a baby this young is important, as the changes babies go through after birth are so rapid you might miss vital developments if you do not start as soon as they are born.

Above: Some babies can spend a surprising amount of time occupying themselves; there always seems to be a tendency to put things in their mouths, as here. The toy makes a good colour contrast against his white top, and the expression is one of preoccupation. A medium telephoto lens put the background out of focus and produced a mottled effect.

Children

Children are ideal subjects for portrait photography. This is because, as parents or relations, we think of our children as special, and also because children change so rapidly that a lasting record can be built up over the years. With this in mind, it is worth considering taking pictures at specific intervals. These could be the obvious ones, such as birthdays and religious festivals, but you could also make a note to take a shot, in the same position, every six months or so. In this way you can record developments in height as well as facial characteristics, together with fashion changes in clothing.

Think about your viewpoint when photographing children. Try and take some of your shots from their level, otherwise your record of them will always be looking down on them. Few young children can keep still for very long, so you have to work quickly to get your shots. A zoom lens in the range of 28 or 35mm through to 70 or 105mm should enable you to get some good low-angle pictures, while at the same time getting you in close to the action if the need arises.

Try to think ahead about the kind of shots that you want to shoot so that you know exactly what equipment to use. The last thing you want is to start dithering with the controls of your camera or different lenses while a child or a group of children get irritable. If this happens, you will probably have to wait for another time. If you lose your temper and start shouting, you lose the opportunity, not only now but perhaps in the future, as children have an uncanny knack of associating objects, in this case you and your camera, with bad and unhappy experiences.

Because children are naturally curious it can help to let them see exactly what you are doing. This is one of the great benefits of digital photography, as you can show them your shots instantly. It may also help to break down any inhibitions that they might have if you let them take some pictures themselves – again, a digital camera is useful here.

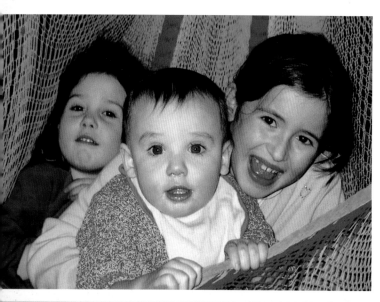

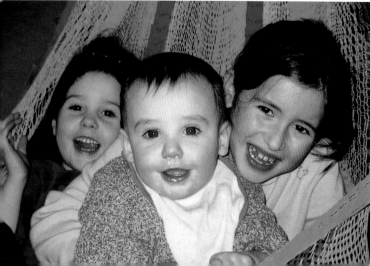

Left and below left: Young children move quickly, and you need to act fast if you are to get spontaneous shots. These children were playing in a colourful hammock, which not only provided a bright backdrop but also kept them tight as a group. The shot was taken using the camera's built-in flash.

Opposite above: Sometimes it pays to stand some distance from where children are playing. Here, I took the shot on a 200mm telephoto lens that enabled me to shoot close up without crowding the children. This has resulted in a picture that reflects their spontaneity in play.

Opposite below left: There are always picture opportunities at events like weddings. Here, I photographed one of the young bridesmaids while she was waiting for the bride to arrive. Always be on the lookout for these types of pictures, as they are often overlooked by the official photographer.

Opposite below right: This child's scarf made a great contrast with his father's T-shirt, which forms the background to this shot. It is a simple, yet effective, portrait that works well primarily due to this colour contrast and the expression of the boy, direct to camera.

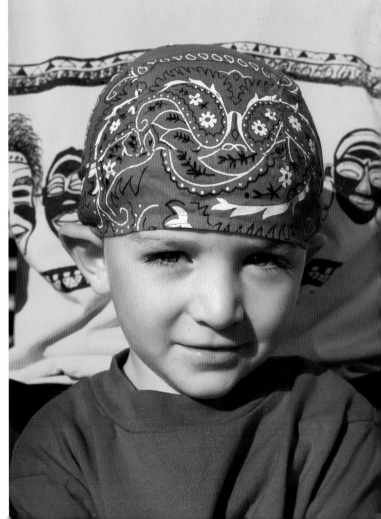

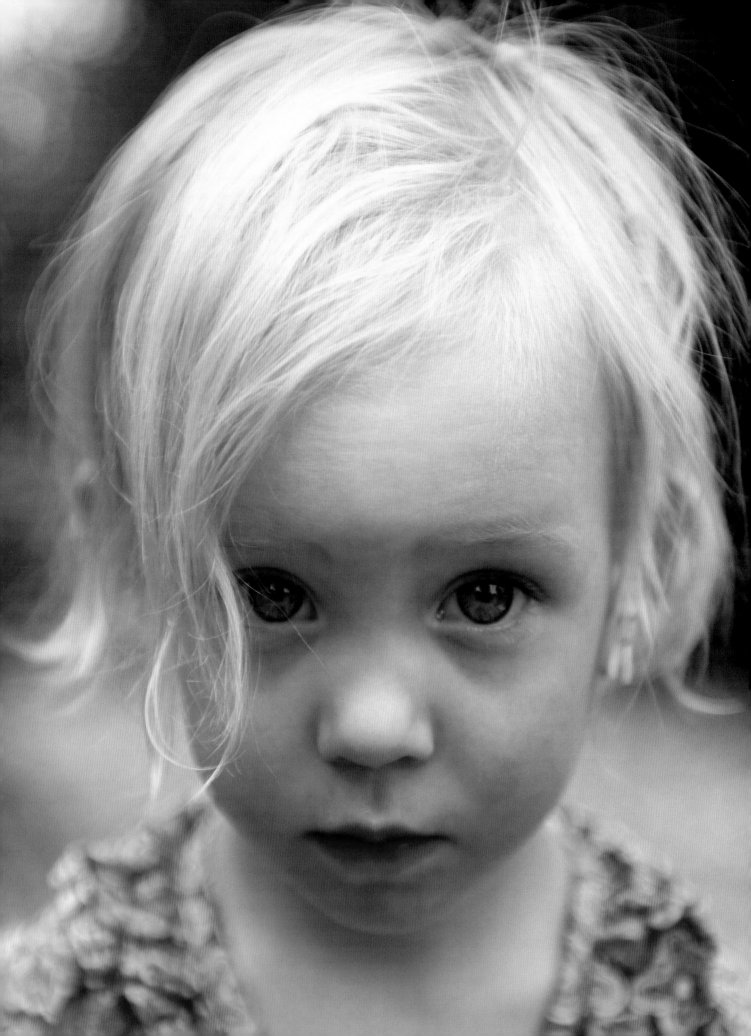

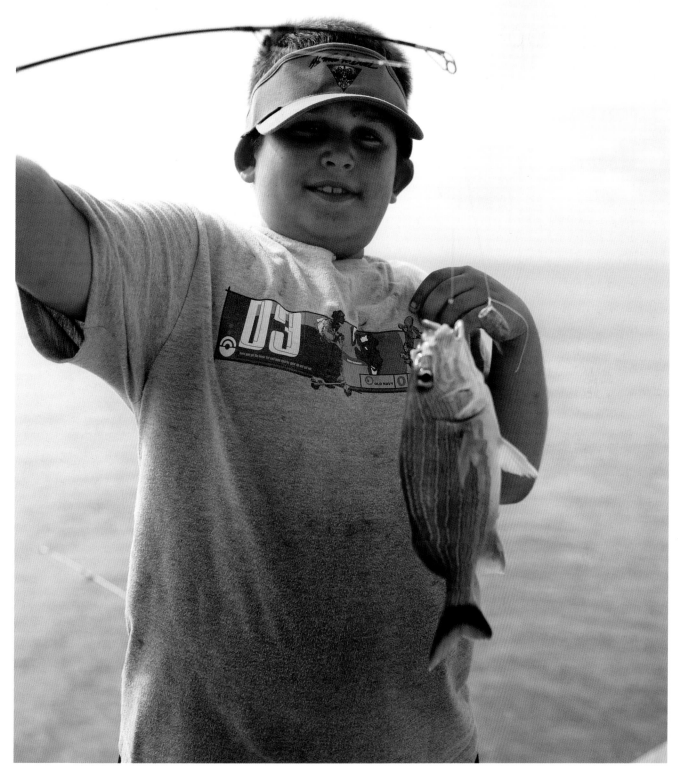

Opposite: The intensity of this child's eyes make this such an appealing photograph. The slightly high viewpoint gives her a sense of innocence and vulnerability. The shot was taken with a normal lens set to an aperture of f2.8; the focusing point was set to her eyes.

Above: As with fishing, you need to have patience when photographing children, because sometimes, just like fish if they don't take the bait, children just don't co-operate with the camera.This young boy had just caught a fish and held it up proudly to be photographed. Care needed to be taken that his cap didn't cast any shadows.

Older People

The difficulty with photographing many older people is that they seem to intensely dislike having their picture taken. This is a great pity, because just as everyone seems to find pictures of babies and children appealing, the same can be true of older people, albeit for different reasons. A human face that has become lined and weatherbeaten can have an attractiveness that is expressive and telling – and bringing out these facial characteristics is the art of shooting an effective picture of an older person.

As with babies, many older people have a shorter attention span and can easily tire if you take an inordinately long time to get the picture you want. Of course, there are exceptions to this rule, and there are many people I have photographed who have astonished me with their energy and vitality, especially when I have discovered that they are well into their eighties.

If you know the person you are photographing, try to think ahead about the kind of shot you want to do and the emphasis you want to put on it. This means that when you come to do your shots you have an idea of how you are going to light it and whether it will be a head shot or full-length. This saves time and gives you longer to concentrate on the shot. This doesn't mean that your shots have to be formulaic: the art of any good portrait is that as the session goes on, you begin to see a characteristic in the person that you are photographing, and you work to bring it out in your shot.

Available light or daylight are probably the best types of light when it comes to shooting older people. If you use flash they may be concerned with the brightness of the light and its afterlight in their vision. Remember, if you want to bring out the lines in a person's face, you can do so more effectively with side light, rather than full-on light.

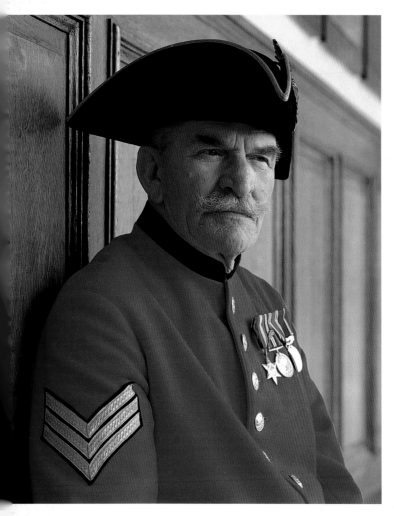

Left: The vibrant red of this old soldier's uniform makes a great splash of colour against the wood-panelled background. His stripes and medals show up well, and the strength of his physical features makes this an interesting study of a person whose life has been spent in the military.

Opposite: Sometimes it pays to take a series of shots, such as these of a Cuban man playing dominoes. Any one of them would stand alone, but because he is so involved with the game it seemed logical to put them together to see a range of different expressions and emotions.

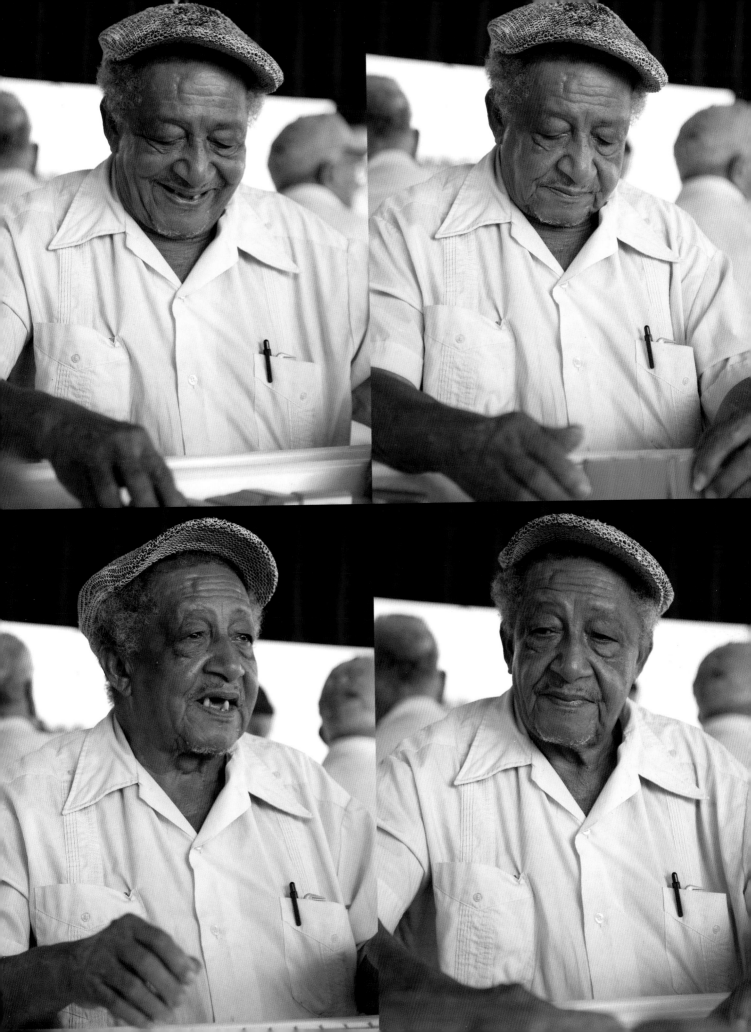

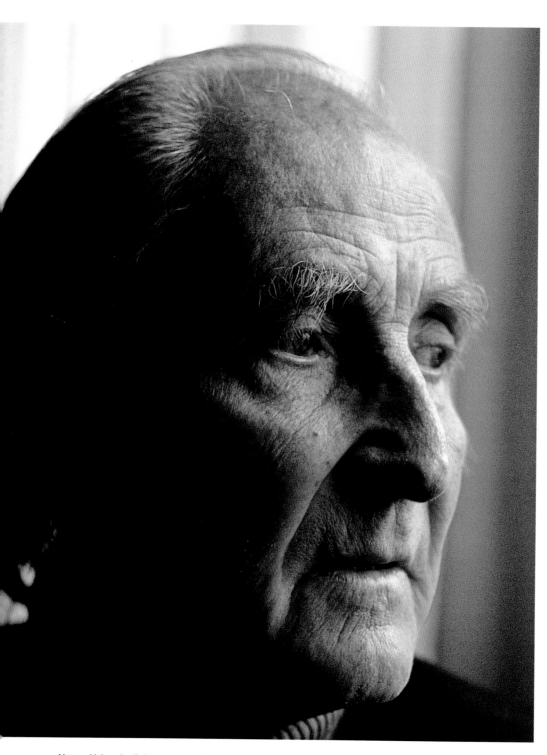

Above: Using the light coming in from a window provided just
the right mood for this portrait of the late photographer, Bill Brandt.
Because it is quite a directional light, it shows up his facial features
well and produces strong shadow detail. This blends well with his
slightly wistful expression.

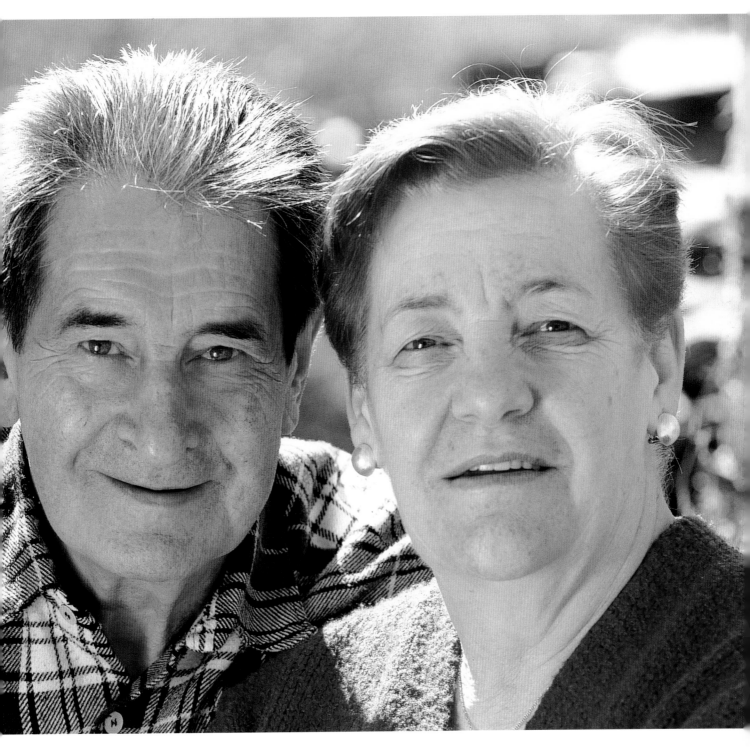

Above: The sun provides an attractive backlight in this portrait of a Spanish couple. I needed to place a reflector in front of them so that light was bounced back into their faces. If I had not used the reflector, I would have had to give the shot more exposure, which would have resulted in flare.

Groups

The biggest problem with photographing groups of people is getting everyone to do what you want at the same time. Even if the group only consists of two people, it is remarkable how one of them invariably looks in the wrong direction when you fire the shutter. Consider how you are going to shoot a group of people before you start, in order to impose a degree of order on the scene and minimize retakes.

Viewpoint is an important consideration. Remember that if you choose a high viewpoint, it foreshortens people's bodies, while a low viewpoint makes them appear taller. When posing a large group, make sure that the people at the front do not cast their shadows over the faces of the people behind – this is also valid when using flash or fill-in flash. Having selected an area to pose the group in, mount the camera on a tripod and use a cable release. This will free you from the camera and allow you to concentrate on posing everyone and adjusting any clothing or props that might need special attention: for a wedding, for example, this could be a bride's train, or for a concert, the instruments held by the musicians. With the camera in a predetermined position, adjustments can be made and then checked through the camera until all the subjects and props are exactly where you want them.

Another good reason for using a tripod is that when you take the shot you can look straight at the group, rather than through the camera's viewfinder or on the LCD screen. This will give you a clearer vision of exactly what everyone is doing and where they are looking. When you are sure that everything is correct and to your liking, then you can take the shot using a cable release to fire the shutter. This ensures a smooth action and helps to reduce camera shake. Always take several frames of the group, to be certain of capturing everyone with the right expression at the same time.

Arranging your group

The problem with photographing any large group is getting everyone to look at the camera at the same time and with an animated expression. Another difficulty in taking these shots was that the only time available was on a late evening in midsummer. This meant that the sun was low, creating long shadows. At first I wanted to shoot into the sun and use fill-in flash, but the background was dark and unattractive. I finally positioned the group with the sun to one side so that the glare of the light was reduced to a minimum (1). It was much easier when it came to shooting the parents (2) and then the smaller groups of their three sons with their wives and children (3–5). Moving them to an area of overall shade created a much more sympathetic light, and it was easier to keep an eye on their expressions.

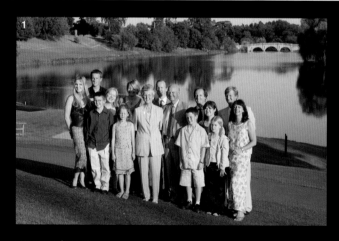

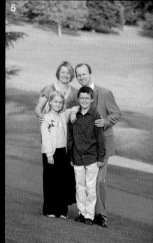

Right: Always be on the lookout for a new angle. An interesting shot was created by lying on the ground and getting these schoolchildren to crowd round me and look down at the camera. Care needed to be taken so that their faces did not come out underexposed, as the camera's meter was taking its reading from the bright sky. The shot worked best with a small amount of fill-in flash (see pages 140–41).

Below: Always be prepared for the unexpected. At the beginning, these children were unaware that I was photographing them. Then one of the group saw me taking pictures through the fence and immediately played to the camera. It was quick thinking that enabled me to get the shot with him isolated in the central square of the fencing mesh, which makes a great framing device and creates foreground interest.

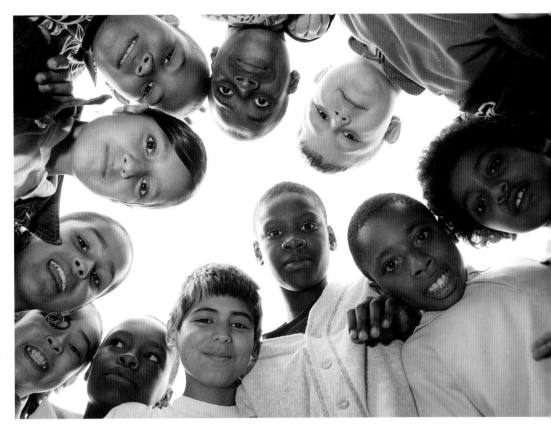

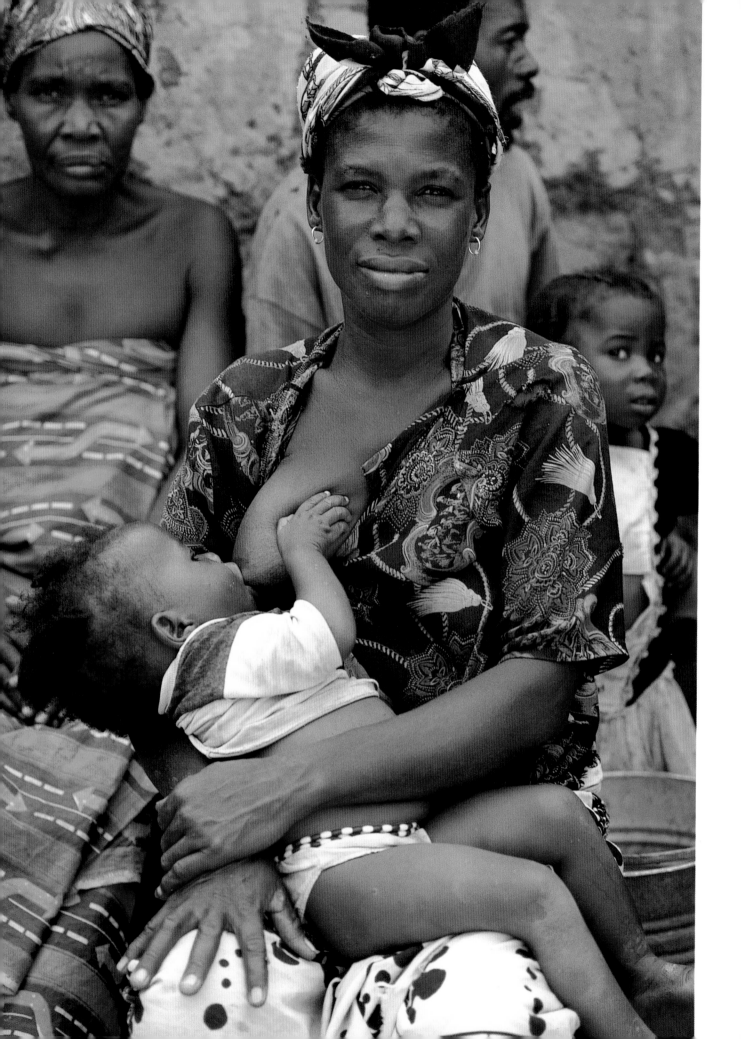

Opposite: Unlike many Western cultures, numerous other countries treat breast-feeding a baby in public as a perfectly normal occurrence. This woman was waiting amongst a group of people when I took this shot. I asked her permission first, and she was at complete ease with being photographed, which is reflected in the shot.

Left: This family group was photographed in the late afternoon, just before the sun was setting. Because they were in shadow against the sky I used a small amount of fill-in flash (see pages 140–41) Many flash units have an automatic fill-in mode but have a tendency to overexpose the flash, so practice to find the right setting.

Below: I met this group in a paint workshop and thought they looked great in their protective clothing and masks. Having got them in a position so that they were all visible I got close in to the front one and took the shot with a 24mm wide-angle lens. With ultra-wide-angle lenses, you need to be careful that the rear members in a group like this do not appear to be a long distance away.

Formal

While candid or spontaneous portraits can look attractive, there are some situations where a more formal approach may be necessary. This could be when you have to photograph someone who has reached a certain position in their work or life – at a graduation ceremony, a wedding or an anniversary. Although you want to reflect the serious or important aspects of the event, you should try to aim for a relaxed pose at the same time.

If your shot is indoors, think about how you are going to light it. Is there enough available light, or will you have to use flash? If the latter, is it going to be powerful enough to give even illumination throughout the area of your chosen field of view?

Nothing looks worse than a portrait of a person who is correctly illuminated, but where the background has gone a murky black, with indistinguishable shapes; or worse, where the background is correctly exposed but your subject appears to be as bright as a turned-on light bulb. Will the light be mixed – i.e. daylight, tungsten and perhaps fluorescent – and if so, are you able to get an evenly illuminated shot without a colour cast? In a situation like this, with mixed lighting, it might be best to move your subject to an area of even illumination.

If you are shooting outdoors, watch for unsightly shadows caused by bright sunlight, and try to move the person to an area of bright shade. Alternatively, a small amount of fill-in flash might be all that is required. If you are shooting a formal group, the problem is always to get everyone looking where you want them to look at the same time. In these cases, it is always best to over-shoot and edit out the bad ones where someone is looking the wrong way or has their mouth open. It is amazing how few will be left to choose from.

Left: Formal does not have to mean rigid. This is a formal portrait, but has a relaxed feel to it. Although he is young, this man is a director and has an air of great confidence. The smart suit is tempered by the open-neck shirt, and the hands in the pockets create a comfortable stance.

Opposite: By contrast, this portrait of a former Lord Mayor of London has all the ingredients of a formal portrait. Much of this is because of the robes of office that he is wearing. The shot was lit by a single flash head fitted with a soft box, positioned to the right of the camera and pointed slightly down to the subject.

Above: These ushers were photographed just before the wedding ceremony. Because the sun was so bright, I positioned them with their backs to the sun and then used fill-in flash with an off-camera unit. I made sure that the flash did not reflect in the glasses of the one on the right.

Right: I photographed the manager of this restaurant at the Oxo Tower in London in available light. It was a bright, sunny day, but as the vast wall of windows faced north there was no direct light coming though to create harsh shadows in the room or, more importantly, on him.

Candid

For really effective candid portraits, your greatest asset is patience. It may take some time for the person or people that you have noticed and want to photograph to move into the right position or have the right facial expression. Taking candid portraits doesn't mean to say that you are setting out to spy on people, but rather to portray them in the most relaxed and revealing way possible.

The photographer most associated with this approach is Henri Cartier-Bresson. His black-and-white photographs, virtually all shot on a 35mm Leica camera, are still revered around the world for their tightly ordered composition and his trademark gift of capturing "the decisive moment". It is not difficult to see why Cartier-Bresson chose a camera like the Leica. Apart from its superb optics and the ruggedness of its construction, it is virtually silent in its operation, which means you can remain as inconspicuous as possible. However, with the advent of digital cameras – including Leicas – features such as swivel LCDs can help to keep you even more inconspicuous.

If your camera takes interchangeable lenses or has a powerful optical zoom, this will be advantageous, as you can then use a long focal length, such as 200mm. This enables you to keep a considerable distance from your subject while still being able to fill the frame. Remember you are not going to be able to move your subject, so if the light is wrong – part of the face or body is in deep shadow, or there appears to be something growing out of their head – it is up to you to find a better viewpoint. On the other hand, if the background is unsightly, it might be simply a case of choosing to shoot at a wide aperture and a fast shutter speed so that the background goes out of focus.

Left: Events such as fairs and carnivals can provide endless opportunities for candid pictures. A zoom lens in the range of 70–210mm is a very good choice. Setting the camera to shutter priority means that you can use a fast shutter speed, while the camera takes care of the aperture.

Opposite above left: In most cases, you need to be extremely alert when taking candid pictures. There's no time to get the camera out – it needs to be at the ready. I was photographing a river boat from the deck above, when I noticed this couple and took the shot as soon as I saw it.

Opposite above right: Sometimes it doesn't matter how quick you are in taking candid pictures. If the subject is aware that they are being photographed, the spontaneity of the situation could be lost. In this case, I balanced the camera on the table in front of me and discreetly pointed it at this young man who was obviously enjoying his doughnut.

Opposite below: This picture of two school friends is another example of being at the ready for when the moment happens. Although we cannot see their faces, the body language is totally expressive of two people very much into one another.

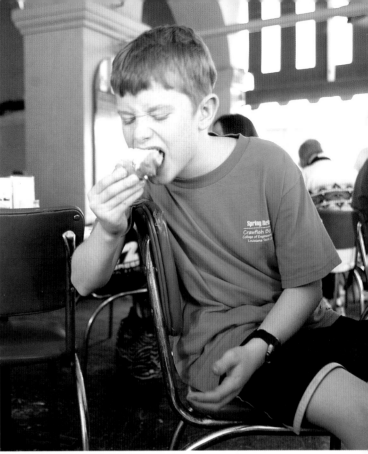

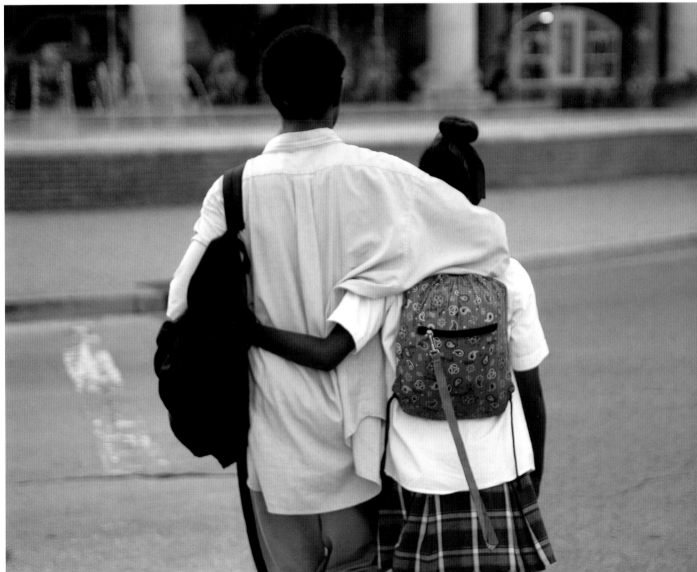

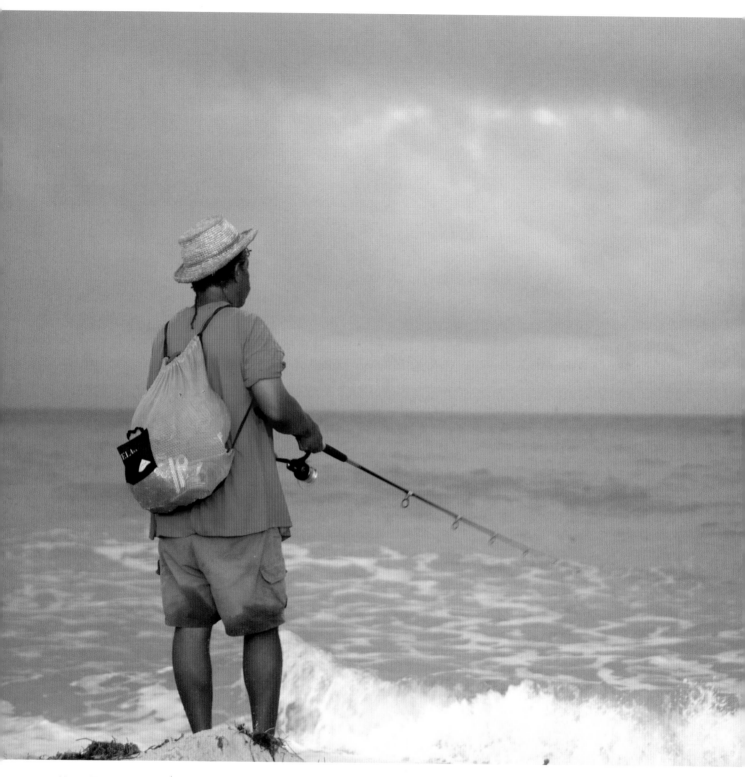

Above: This fisherman was on a beach in Florida and was unaware that I was taking this shot. I liked the way his clothes contrasted with the background: making a strong colour composition. Placing him to one side of the frame created a greater sense of depth.

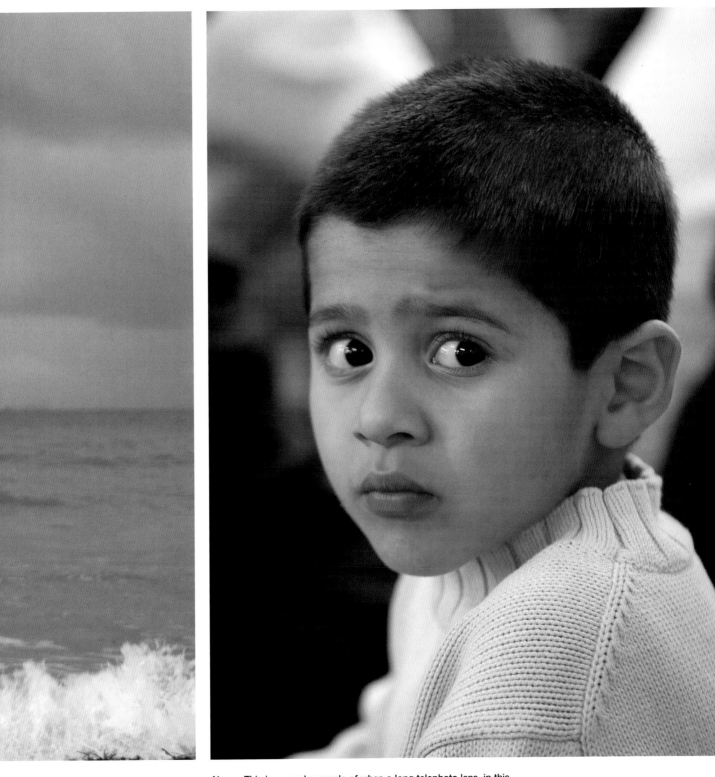

Above: This is a good example of when a long telephoto lens, in this case a 250mm, is essential. This boy had the most alert eyes, and a large aperture, f2.8, means that the background is out of focus, so he stands out even more.

Work

For some people, the workplace can be the place they can't wait to get away from, but for the observant photographer it can provide a rich environment for good portrait possibilities. Whether it's the boardroom or the factory floor, the shop or the farm, there are bound to be a variety of colourful characters and situations just waiting to be captured by your camera.

After you have thought about the expression and the characteristics that you want your subject to portray, it is probably the background that is the most important consideration when taking pictures of people at work. This adds to your shots by not only showing the place of work, but also giving a sense of place and the subject's position in it.

If you are using flash, is it powerful enough, or might it create an ugly shadow behind your subject? If you want to include the whole room with the person in the foreground, can you light the rest of the room without your lights being seen, or is the ambient light enough? When using the main lights and tungsten-balanced film, or when your white balance is set to tungsten, do you still need a small amount of fill-in flash? If this is the case, you need to "gel" the flash to balance it with the tungsten lights, otherwise the person you are photographing will come out with a bluish cast. The gel should be equivalent of an 85B filter, which can be stuck on to the flash head and is easily carried along with your kit, fitting into a small envelope.

When travelling, especially in a foreign country, look out for people involved in what, to you, are unusual occupations. The first thing to do in situations like this is to gain the confidence of the person you want to photograph. Apart from putting them at their ease, you never know what their status might be, or even if they are allowed to pause or take a break so a photograph can be taken.

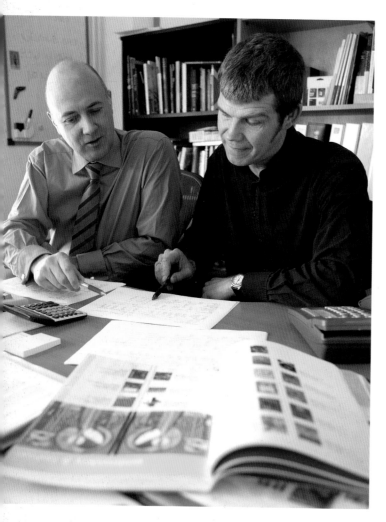

Left: I needed to photograph these directors in a series of different situations; in this one, they are analysing the latest sales figures. Because I wanted the shots to look as natural as possible I used available light and set the ISO to 400 to give me a fast enough speed. A reflector to the right bounced light back into the shadow areas.

Opposite: There are situations where it is not essential that the whole shot is sharp. I was taking pictures in a small Cuban cigar factory and saw this worker pressing the leaves that would be used for the outer casings. He worked rapidly with his hands, and I decided that a certain amount of movement would add to the picture, rather than freezing the action.

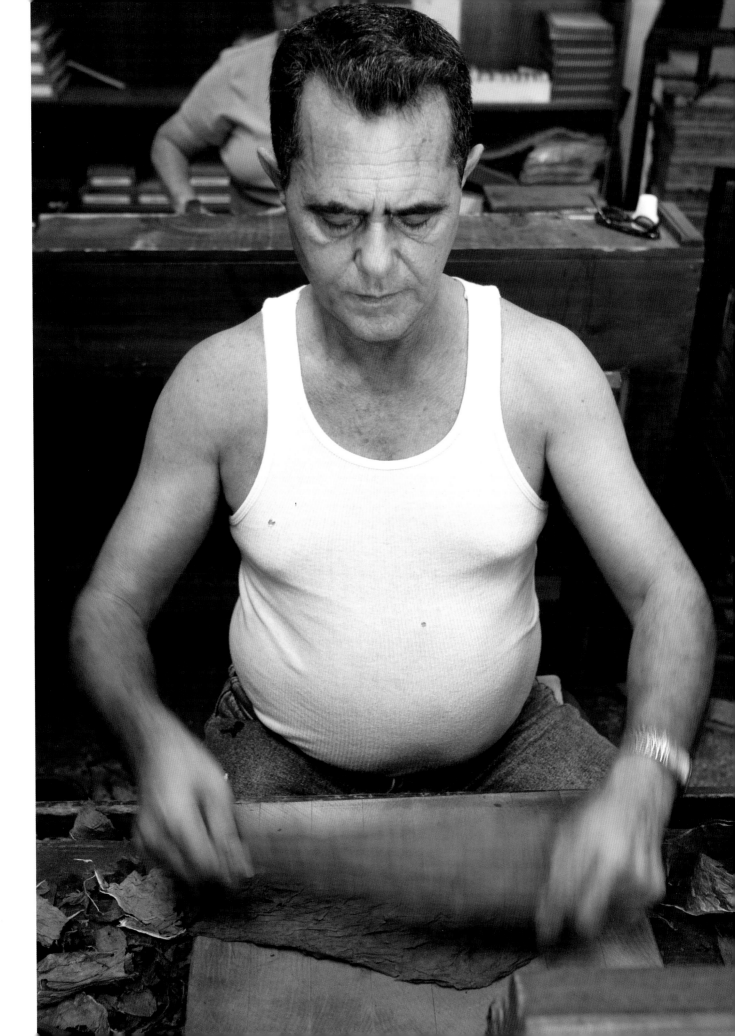

Above: Jean-André Charial is the proprietor-chef at the famous Oustau de Baumaniére in the South of France. I wanted a shot that would portray his status while placing him firmly in his environment. I decided to photograph him in the kitchen, and used various chefs in the background to give a sense of intense activity.

Opposite: By contrast, this tea-picker was shot thousands of miles away in southern India. The sun blazed down, and I had to make sure that I got into a position so that she would not be dazzled by the light. As she could not stop work and pose for me, I had to take several shots until I got the one I wanted.

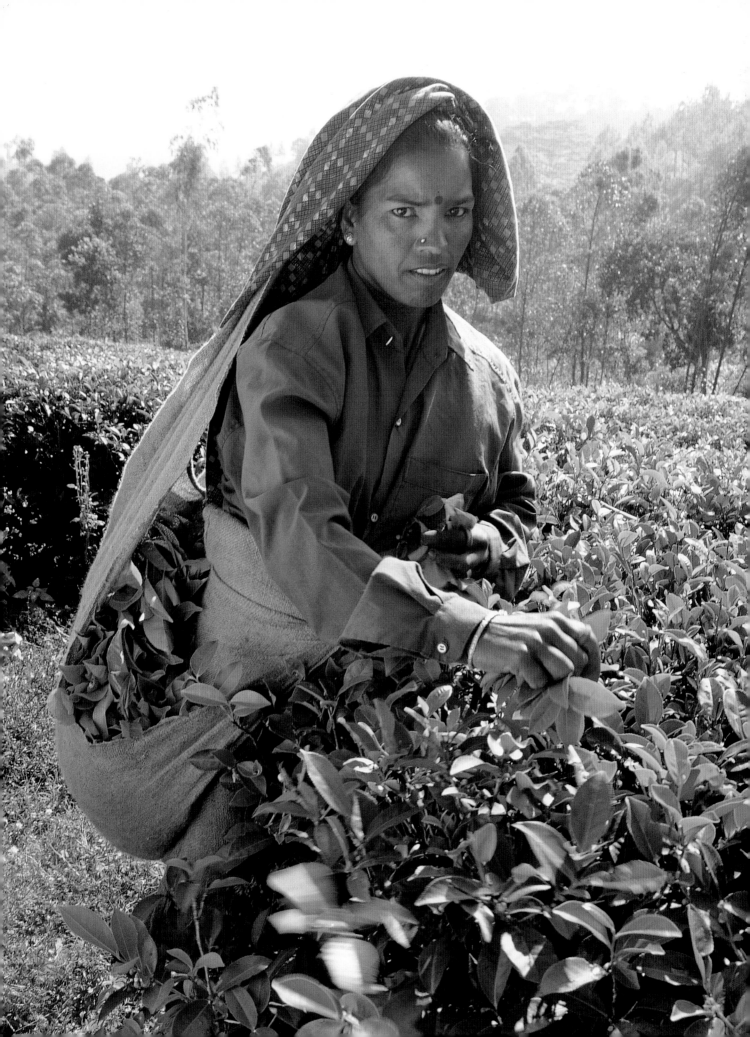

Street Portraits

As with so many aspects of what makes an interesting photograph, it is surprising just how much there is on your own doorstep. Few people bother to take notice of their immediate surroundings, such as when they are on their way to work, and keep their head buried in a newspaper or book. The main reason for this seems to be the attitude of "I've seen it all before". Isn't it therefore somewhat odd that people visiting from abroad appear so fascinated by what they see every day on our streets, and just how much they find to photograph?

Unless the type of street portraits that you intend to shoot are of the candid variety, you need to have confidence to approach people to ask if you can take a shot of them. Apart from the fact that this is just polite – how would you like it if someone suddenly stuck a camera under your nose without saying a word? – you might find that they are more co-operative and move to a position where the light or background is better. It never fails to amaze me how flattered most people are that you have bothered to ask them. Of course, there are certain

countries or situations where it is inadvisable to go around photographing strangers, so a degree of common sense and diplomacy is advisable.

The equipment I always carry for these types of portraits starts with a 28–70mm lens, to give me the option of a wide-angle, low viewpoint shot or a close-in head shot. Depending on the light, I also have a flashgun in case the portrait needs a bit of fill. If I am with a friend, I carry a fold-up reflector, which my companion can hold in position for me. Strangely enough, I also have a tripod. I say "strangely" because so many people find this a cumbersome piece of kit to carry around. However, there are so many situations when a tripod is useful, apart from keeping the camera still when taking long exposures, that I find it worth the hassle – besides, it always provides such an impression of professionalism that strangers are even more likely to pose for you than if you just have the camera hanging round your neck.

Left: This group of American motorcycle cops made a good street portrait. It was a spontaneous shot that needed quick thinking, as they were just about to ride off. It is another illustration of why you always need to have the camera ready to shoot, as you never know what opportunities might arise.

Opposite: I spotted this woman selling garlic from her stall in Marseille in the south of France. I chose a 150mm lens to bring her closer, as I had to take the shot from the other side of the stall. This put the background out of focus, but you can still make out the bustle of the street.

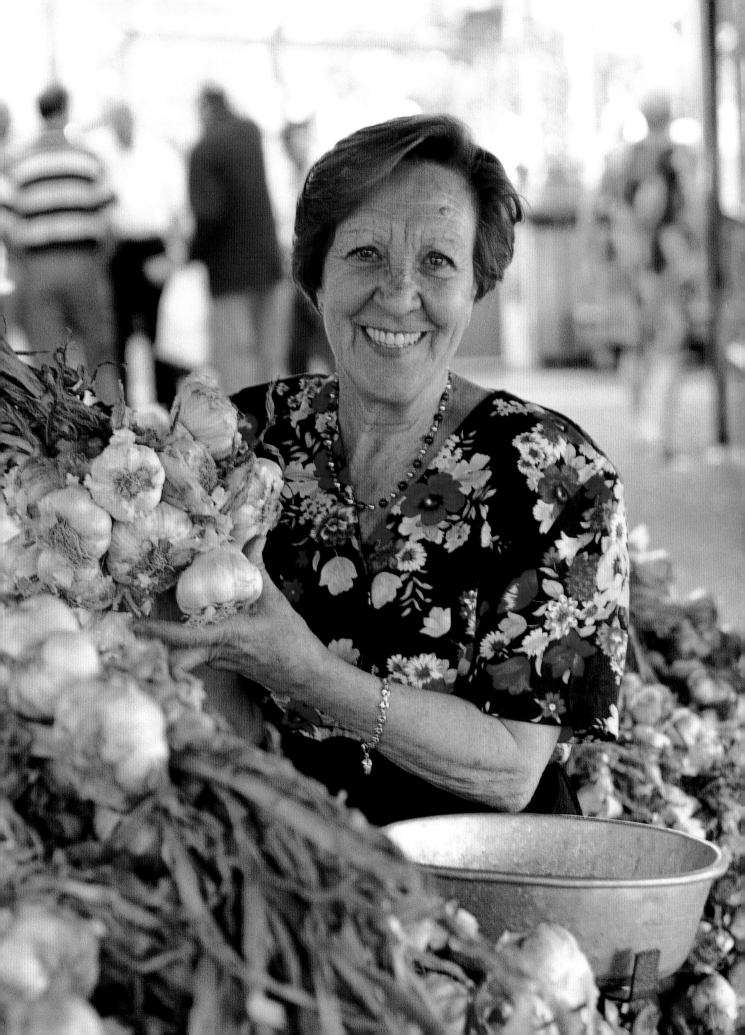

Above: A night out in New Orleans provided the subject for this portrait in the city's famous Bourbon Street. I was already prepared for any spontaneous situations, including having the flash switched on. In a situation like this, it is best to rely on the camera's TTL metering, as to calculate it manually might mean losing the shot.

Left: Often I feel the only way to get to the heart of a portrait is to get in close, and this shot of a homeless person in India is a good example of that approach. Having gained his confidence, I knelt down to his level and used a standard lens, which enabled me to fill the frame.

Opposite: I shot this woman begging outside the entrance to Cologne cathedral. The columns of the building appear to weigh heavily on her and form a fitting backdrop to her situation. The hood of her coat preserves her anonymity and her dignity. As with the portrait left, it's a dilemma for the photographer to decide whether they are exploiting such people. But without the power of the photograph, it would be difficult to portray fully other peoples' impoverished situations.

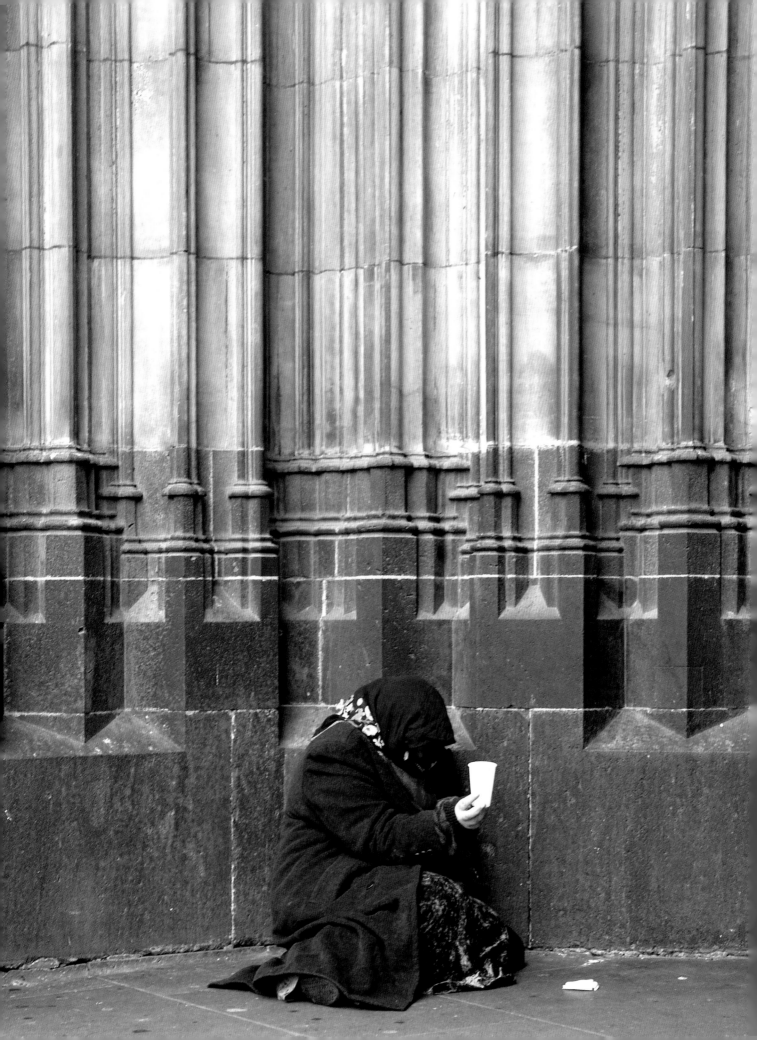

Close-ups

The face is such a fascinating part of the human body that sometimes only going in close can do anything like justice to your subject.

Although some people have faces so striking that all you want to do is shoot them straight-on, others may have one feature that stands out, and therefore different angles are required. For instance, if the person has the most attractive and sensual mouth, can you find a low angle so that the lips are prominent but the rest of the face can still be clearly seen? If it's the eyes, can you take a high viewpoint so that the subject looks up to the camera seductively?

Depending on how close you want to go in, it may be necessary to use extension tubes or bellows. These allow you to go even closer than a macro lens will allow, but the lens will not focus on infinity once one has been fitted, so don't forget to remove it when you have finished. The difference between tubes

and bellows is that extension tubes, which are available in various sizes and can be used individually or coupled together, have a fixed magnification, while extension bellows have a variable range of magnification.

When using extension tubes or bellows you will need to increase the exposure. The reason for this is that light has a greater distance to travel to either the film or the sensor. Most cameras with TTL should compensate for this anomaly. However, if you are using a camera without TTL you will have to make a manual adjustment to the exposure.

When you are shooting this close, every little pore, spot and blemish is going to show up. Even the most seemingly beautiful person is going to suffer from this microscopic scrutiny. Therefore it is essential that a degree of post-production retouching, as described on pages 136–37, is carried out before you can say that your close-up portrait is finished.

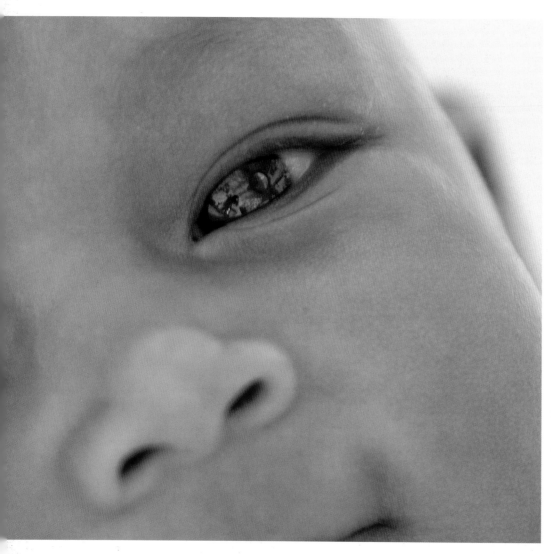

Left: This shot was taken with a macro lens and a No. 1 extension tube, which enabled me to get in close, about 30cm (12in) from the child's face. As she kept moving, it was essential to use the auto-focus mechanism on the camera. The TTL metering system took care of increasing the exposure which is necessary when using extension tubes or bellows.

Opposite: I used a 150mm telephoto lens in this situation so that I could get in close and completely fill the frame with the girl's face. I liked the idea of cropping out the background, as this gave the shot more intensity. It gives her great presence, and the concentration of her gaze is very powerful.

Overleaf: In this shot I went in really close by using two extension tubes mounted together. The front of the lens was only 15cm (6in) away from the lips. I lit the shot with one flash head fitted with a soft box just above the camera and pointing down to her mouth. I then placed a white reflector under her chin to bounce light back up. This created a soft, even light, essential for a shot such as this.

Action Portraits

Not all portraits have to be posed or candid. There are a wealth of situations where people are participating in fast-moving sports or other activities that lend themselves to innovative portrait situations. These do not necessarily need specialist equipment, but they do require the imagination to see an opportunity when it arises.

Perhaps the most important point to consider with this approach is the viewpoint, which is where the photographer's imagination is paramount. For example, if you are photographing a basketball or netball game, it is certainly possible to get some good action shots from the line. However, imagine that you could be immediately above the basket, so that when someone jumps to score you can take your shot looking down on them; using a wide-angle lens, this could be a shot of great drama, as well as being eye-catching. Obviously you can't just climb up behind the basket when a match is in progress, but with a little forward planning you can make arrangements beforehand, or take the shot in a training session.

Another way to get an action portrait is to pan the camera. This is standard practice in sports photography and means moving the camera with the subject, be it a racehorse or racing car. If you use a fast shutter speed to photograph someone in a speed event, the action is "frozen" and everything in the shot is pin-sharp. This means that if a racing car is passing in front of your camera at 100mph and you use a shutter speed of 1/1000th second or faster, the shutter freezes the action and it is difficult to know whether the car is stationary or moving.

On the other hand, if you were to use a slower shutter speed, such as 1/60th second, then follow the car in the camera's viewfinder from one side of its path to the other, taking your shot when it was directly in front of you, the car would still be pin-sharp, but the background would be streaked and blurred, giving a true sensation of speed. There is no reason why you cannot use this technique when photographing people, particularly when they are moving fast.

Selecting the shot

It is unlikely that when you are shooting this kind of portrait that you will get the shot with the first click of the shutter. As can be seen on this page several of the shots did not work because either the player's face is obscured or he looks like he is standing still. When I edited the pictures I looked for a good action movement, where his face is clearly visible and expressive, and he looks as though he is clearly off the ground. This is what I feel I have achieved in the shot opposite.

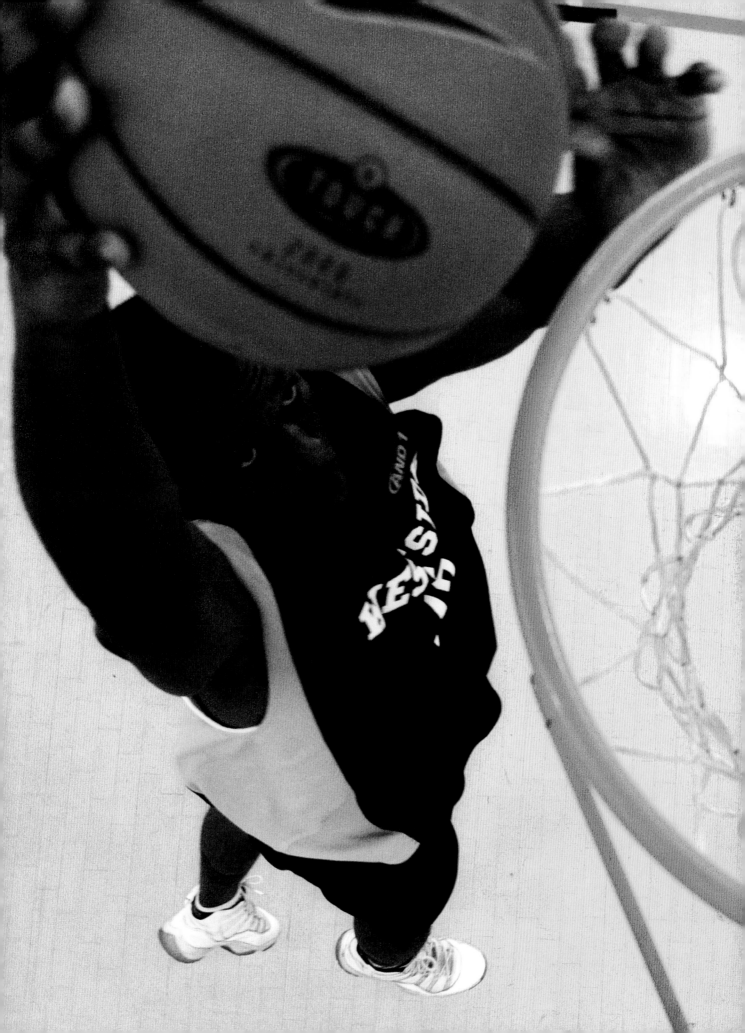

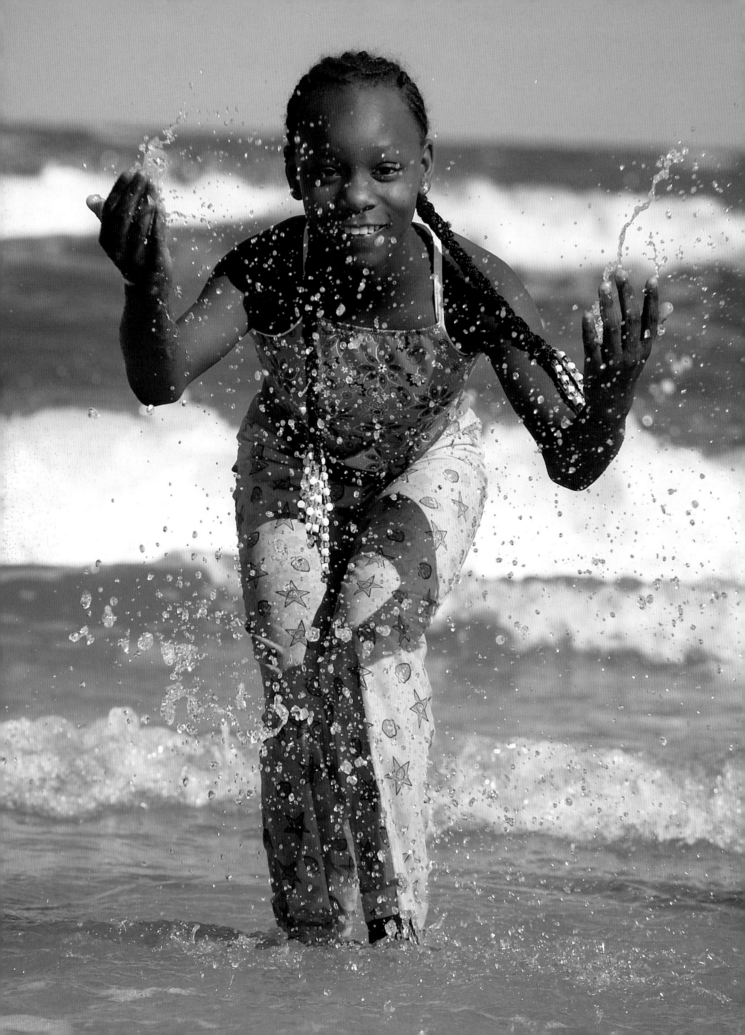

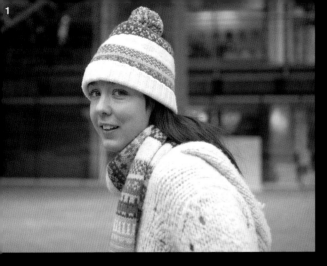

Experimenting with Movement

1 I was photographing this girl on her roller blades and wanted to get a real sense of action. I decided that when she was skating and I was using a fast shutter speed it was difficult to tell whether she was moving at all as the action has been frozen.

2 I then got her to skate towards me. This produced a more realistic shot, as it showed her scarf blowing behind her, but I still felt that the background was too static and that there still wasn't the degree of movement that I wanted in this portrait.

3 In this shot I used a shutter speed of 1/60th second and got her to skate in a circle around me. I panned the camera so that she would be sharp and the background blurred. This created a sense of movement, and I was much happier with the result.

Below: It wasn't until I used a slower shutter speed and had the skater coming towards me that I felt I had got the shot that showed action as well as a pleasing portrait. I used the motor drive and the follow-focus mode on the camera. Although some of the shot is blurred, it gives a real sense of speed and movement.

Opposite: In this shot, I used a shutter speed of 1/1000th second. This froze the water that this young girl was splashing, which gives a real sense of fun. To protect my camera and lens from the sea water, I used a 400mm telephoto so that I could take the picture from dry land.

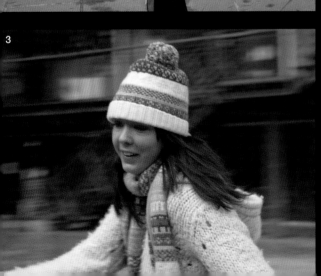

3 Further Techniques

Digital Backgrounds

Digital photography allows you to alter and manipulate an uninteresting background to your advantage. The image you manipulate could be one that was shot digitally, or one that has been scanned from film into the computer. Once in a program like Photoshop, the background can be cut out completely and substituted for one taken from a totally different shot, the colour can be changed, or a sense of movement can be added to the background to emphasize action.

The important point to remember is that you should aim to enhance the existing shot, and not manipulate an image for the sake of it. It is very easy, especially if you are on the cusp of discovering what can be done with your computer, to use every conceivable tool that is available, and end up with something worse than the image you started with. When fitting together a subject and background that have been shot separately, try to achieve the same viewpoint and focal length for each shot so that the two elements do not jar.

The main benefits of creating a background digitally are that you have complete control of all the elements that might otherwise prove disastrous to a photoshoot on location. Imagine that, as a professional, you have been commissioned to fly halfway around the world with a couple of models to do some exotic swimwear shots. When you arrive the models fall sick, the weather is terrible and your equipment gets stolen. Think of what you could save in time and expense if you could choose various exotic background pictures from your photographic archive. You could then shoot the models in different poses in the studio and later combine the two elements.

In addition, you can even digitally manipulate the background of an existing shot to completely change the mood and ambience of the overall photograph. Of course there will always be the need to shoot original material, but the idea of a large cast jetting off to shoots in exotic locations could soon be a thing of the past.

Layers

1 For the original shot, the boy was positioned on his skateboard in a static position. He was posed with the idea in mind of manipulating the background to give the shot more dynamism.

2a/b After duplicating the image on a different layer, you need to extract your subject. Several tools can be used to cut the subject from the background. In Photoshop you can use the pen tool to draw a path around the subject which you can come back to and change, if necessary, at a later date (2a). On non-pro packages, such as Photoshop Elements, you can use the lasso or polygonal lasso. This requires a bit more care, as you can't edit the line after you have drawn it. Whatever method you use, it is a good idea to soften the edge of the selection by feathering.

3 When you have selected the outline, delete the unwanted parts of the image. Now is the time to remove rough edges, especially tricky parts, such as stray hairs.

If you can turn off all the other layers apart from the skateboarder, examine him to make sure that he is cut out properly. Next, hide the skateboarder and turn on the background, which is going to be blurred to give a sense of motion.

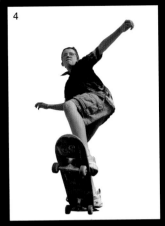
4

If the background is to be blurred, you will need to paint the skateboarder out by sampling a colour and using the paintbrush. Don't worry about being too precise when painting, as it will be blurred anyway.

5

Now use the radial blur filter. Here it was set to the zoom mode and adjusted until the amount of zoom/blur seemed correct. Too little blur, and it will look as if nothing much has happened; too much, and the effect is unnatural.

6

The hue/saturation editor was used to give the colours of the boy a bit more punch. At this stage you can use a variety of tools to perfect the image.

7

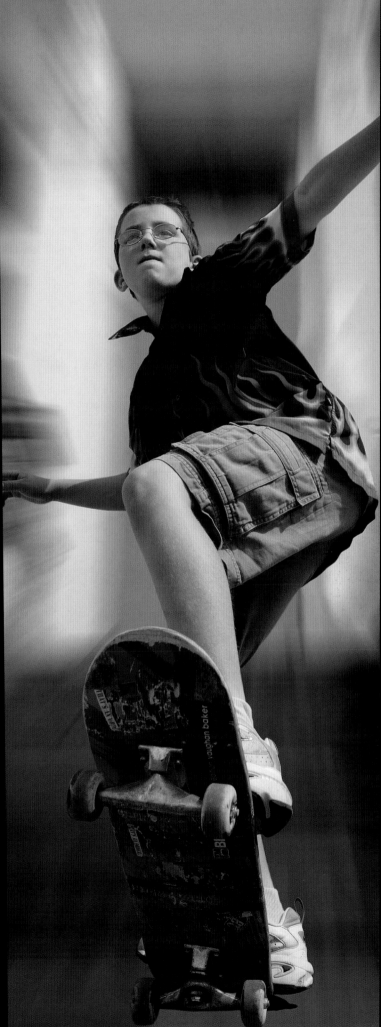

Digital Composites

In digital composites two or more images are blended together using an image manipulation programme such as Photoshop, so that they appear as if they are one picture. The reasons for doing this are many – you might want to insert a different fore- or background into an uninspiring shot or perhaps combine several photographs in order to create a more unusual or far-fetched image. This might mean shooting a background with a particular idea in mind, such as the exterior of a building taken from a strange angle. In the project below I took a circuit board from the inside of a computer and shot it with the intention of combining it with a portrait.

To make the finished image look convincing I had to shoot the circuit board from several different angles before I was satisfied with the overall effect. In the end I used a 21mm wideangle lens together with a No 2 extension tube. This enabled me to get what would be the foreground of the finished image sharp while letting the rest fall out of focus. Because the camera lens was only a couple of inches from the circuit board there was no room for direct lighting so I backlit it and then use small mirrors, placed either side of the lens, to bounce light bac on to the circuit board.

Having shot the background, you next need to shoot your model from a similar angle – this can be quite tricky, as yo are working with two different subjects that may have been sho on different scales, but thorough preparation and attention to th composition of the final image should create a convincing effec When shooting the model I couldn't get the whole of her body in a single shot, so I photographed her face and then the lower part of her body separately and joined them in Photoshop.

The other point that needs to be considered is the lighting. If the finished shot is to look convincing, the light must be harmonious with the background. Lighting can be subtly adjusted by using 3D rendering effects such as the Photoshop lighting effects filter. This filter, although primitive compared to a 3D computer package, sets a light position and plots the cours of the light rays, which then gives the effect of a directional light

Combining Three Images

Opposite above: For this digital composite I used three different elements, one of the background and two of the girl. This was necessary to get the girl in a convincing position on the wall with the correct viewpoint. The images were then combined in Photoshop.

1 I cut out the two separate images of the girl required to make a convincing figure. These were angled and positioned on two separate layers, which enabled me to composite them together.

2 The background was rotated, cropped and flipped until I was satisfied with the perspective. I introduced the girl and rotated her until she was at the right angle on the wall. If the final image is to look convincing it is very important to pay attention to perspective at this stage .

3 Attention to shadow detail adds a sense of realism. I referred to the original picture of the girl and with the Paintbrush tool drew in a black shadow resembling the shadow on a new layer. I set the Layer mode to overlay to let the brighter parts of the background show through as they would in a real shadow.

4 To simulate the dropping off of focus, I used Quick Mask mode and made a gradient mask that I turned into a selection. Then I applied Gaussian Blur, which affects only selected areas.

5 To add greater realism, I darkened the background overall using Curves. Other areas have been selectively darkened, again using Quick Mask.

6 Because the suit is made of shiny latex, it would reflect its surroundings. A feeling that parts of the background were reflected back into the suit was achieved by cutting and pasting sections of the background, mirroring them back into the suit and making them semi-transparent. The final result is a convincing science-fiction-type image that works because of the attention to detail.

Photoshop Filters

Adobe Systems, the creators of the image-editing program Photoshop, have developed a system of "plug-in" filters that allow a library of different filters to be built up and run within Photoshop. Some of these plug-ins are designed and created by companies other than Adobe Systems, and can be bought and downloaded over the Web. The range of filters available is being added to all the time.

The filters include artistic effects, which produce results that look as though they have been drawn or painted with watercolours or oil paints; there is even one filter called "auto Van Gogh". These types of filters can be gimmicky if not used with care, but they can be useful tools to have in your digital toolbox for creating backgrounds and textures.

Filters that are used for retouching, repairing and print finishing include blurring, sharpening and distortion filters. Once you have them, these filters are used time and time again, and can become indispensable to your work.

Filters that do not fall into this range include lighting effects that can simulate spotlighting on textured surfaces, watermarking filters, which protect your images from being used without your permission, and 3D transform filters which, as their name implies, add a third dimension to flat artwork.

As with so much that is innovative in photography, there is always the tendency to use new technology whether it is required or not. This can lead to an already first-class image being ruined for the sake of using what is available – because it is available. A parallel can be drawn with special-effect camera filters: not so long ago, it seemed that every landscape picture had a brownish sky, caused by overuse of the graduated tobacco filter. Hopefully its fall from grace will not be replaced by something equally garish using Photoshop filters.

Left: Many original images lend themselves to being enhanced with Photoshop filters. The trick with any manipulation is not to get carried away with the effect so that your shots end up looking gaudy and gimmicky.

Opposite: 1 Posterize breaks the image into a few tones, producing strong graphic images. 2 Chrome gives the impression of a bright metallic effect. 3 Glass makes the subject look as if they are standing behind a sheet of frosted glass. 4 Graphic Pen emulates a pen-and-ink drawing. The stroke and nib pressure are both adjustable. 5 Ocean Ripple gives the impression that the subject is underwater. 6 Photocopy is achieved using adjustable contrast to produce an effective photocopy appearance. 7 Radial Blur blurs the image around its central axis. Can be used as spin or zoom. 8 Gaussian Blur blurs the image to a specific setting 9 Wave breaks the image into a minimum of five waves, producing a zigzag pattern.

Basic Studio Light

The great thing about taking portraits under studio conditions is that you have complete control of the lighting. There are no worries that the sun will go behind a cloud, or that it will set so there won't be any light at all. Once you turn your lights on, they stay on until you turn them off, no matter what time of day or night it is.

Of all the types of studio lighting available, electronic flash has maintained its popularity amongst professional photographers. One of the great benefits of this type of lighting is that it is far more comfortable to work with than photofloods and spots, which get extremely hot and are expensive to run. However, the advantage that spots and photofloods have over studio flash is that you can see exactly where the light is going and its intensity. Although most studio flashes have a secondary system of modelling lights, these are only useful as a guide and do not give a completely accurate rendition of the final lighting.

If you have never used this type of lighting before, it is best to work with a model who you know can be patient as you experiment and discover exactly what each light does – just a small movement in the position of each light can completely change the ambience of your picture. Always return to your camera position after changing the light, to see what the change looks like from there. If you are working digitally, you can take a shot after each change, which helps you to perfect your lighting to get the shot you want. If you are working with a medium-format film camera, you can check the changes you make by shooting Polaroids.

Don't think that you have to use a whole array of lights – it is surprising what can be done with just one light and a reflector or two. The important point is to study the effect any light or reflector has, so that you can start to perfect your own technique and style.

Lighting a Face

1 Position your main light (a), or key light as it is sometimes called, to the right of the camera, and point it downwards to the model's face. You should be looking for the shadow to fall roughly between her nose and upper lip.

2 When you are satisfied with the position of this light, you can add another light to the other side of the face (b). This is the fill-in light, which is at a lower power than the key light. If they were the same power, you would get a double shadow on the nose.

3 If required, you can now add a hair light (c). This is normally on a boom so it can shine down on the hair but be out of shot. You need to be careful that you do not have this light on too great a power, which would cause the detail in the hair to burn out.

4 If you now place a reflector (d) under the model's chin, you soften the shadow under her eyes and chin.

Finally, two lights (e) are directed towards the white background and adjusted so that they do not cause flare. By this stage you should have a well-lit portrait with the right degree of shadow detail. From a simple set-up you can now experiment with a variety of different lights and effects.

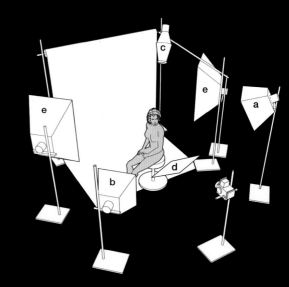

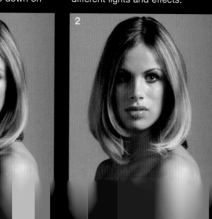

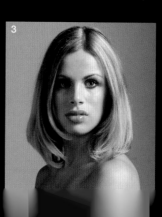

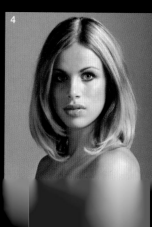

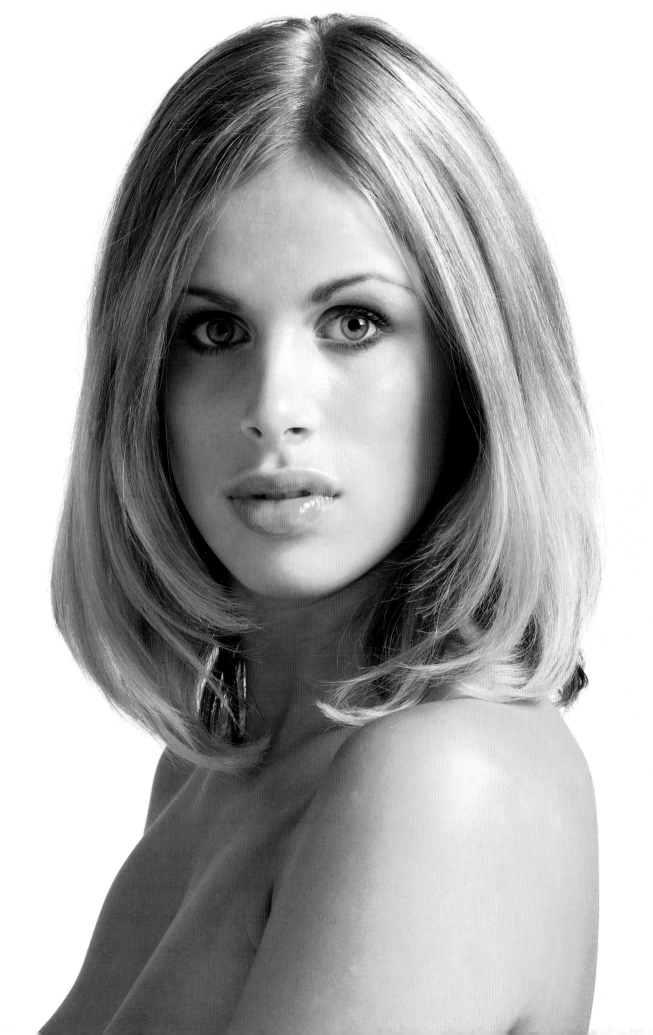

Further Studio Light

Having got to grips with a basic lighting set-up, you can start to get more adventurous with different lighting techniques. This does not mean that you have to buy lots of additional kit, but rather that you experiment with different angles of perhaps just one light. For example, if you start with just a single light and with your model facing the camera, try placing the light down low and quite close to your model. Now point the light upwards to the model's face at quite a steep angle. Return to your camera position and study the effect. It should look quite ghostly, with the shadows running up the face.

Now take a low camera angle so your model is looking down on to you, which should give a menacing, eerie quality. Next, position the light directly over and about 3ft (1m) above the head and point it straight down – the shadows now run downwards, forming dark areas in the eyes and under the nose and chin. Although this also has a haunting quality, the ambience of the light provides a totally different effect.

If you take this single light and move it almost behind your model, you get what is known as "rim" lighting, where the light looks as though it is painted just along the outline of the face. If you then place a bright reflector, such as a mirror or silver foil, to the opposite side but in front of your model, so that the light is bounced back on to him or her, you can create a theatrical effect. Take a careful look at what happens when you tilt or move this reflector; you can direct the light to wherever you want it, creating many different effects quite easily.

This is just a fraction of what you can do using one light and perhaps a reflector. Just think of the possibilities if you had another light or two, honeycomb grids, barn doors, flags, diffusers, soft boxes, beauty lights, spotlights, snoots and so on. However, the final image is only as good as you make it, which is created through the skill you develop with this type of kit.

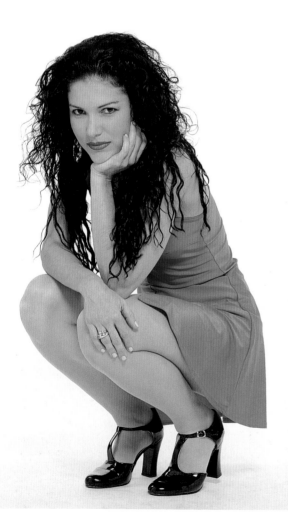

Left: This model was photographed against a white Colorama background that extended along the floor. These backgrounds, when correctly lit, produce a seemless backdrop which can make your subject look as though they are floating in an endless space.

Opposite above: Only one studio flash unit was used to take this portrait. It was fitted with a soft box, which gives a very even light that resembles diffused daylight. A reflector was used to fill in the shadows.

Opposite below: These three shots show the difference that a change of lighting reflector can make. In (1) a beauty dish was positioned in front of and above the model. This creates strong, moody lighting and creates a slightly ghostly effect. Keeping the light in exactly the same position, I placed a diffuser over the beauty dish (2). This created a much softer lighting, and there is far more detail in the eyes and the shadow areas. With the beauty dish and diffuser in the same position, I then placed a white reflector under her chin (3). This has softened the light even more. Experimenting like this is the best way to learn how light works and the way it reacts to diffusers, reflectors and a variety of other devices.

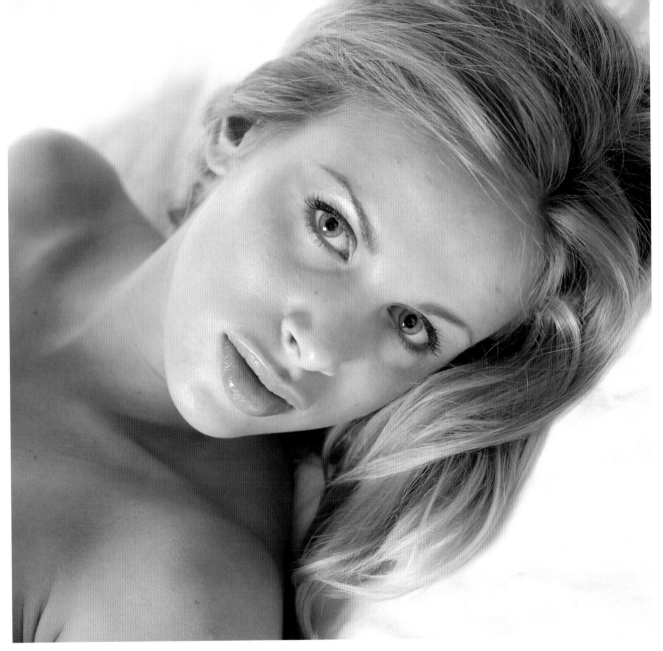

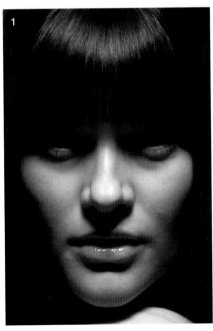

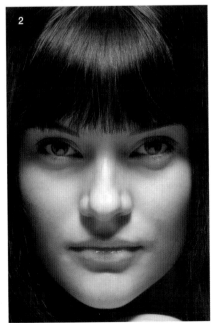

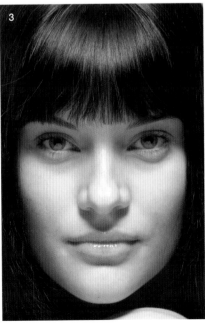

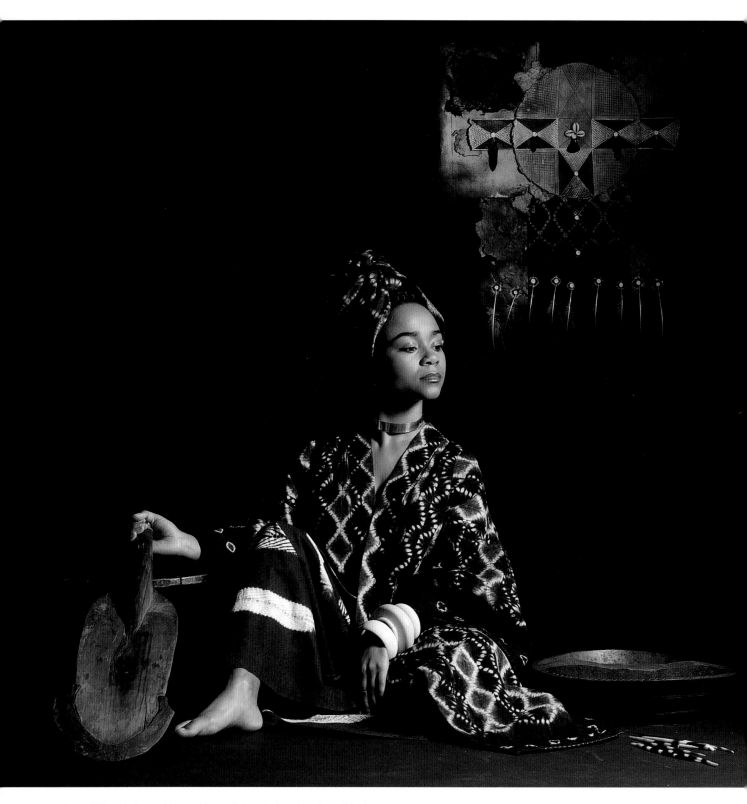

Above: This girl, dressed in an African print, was placed against a black background. The studio flash was placed at right angles to the camera to sidelight the model and artwork. A low camera angle has added to the mood of the picture and a small reflector has added just enough luminosity to the shadow areas.

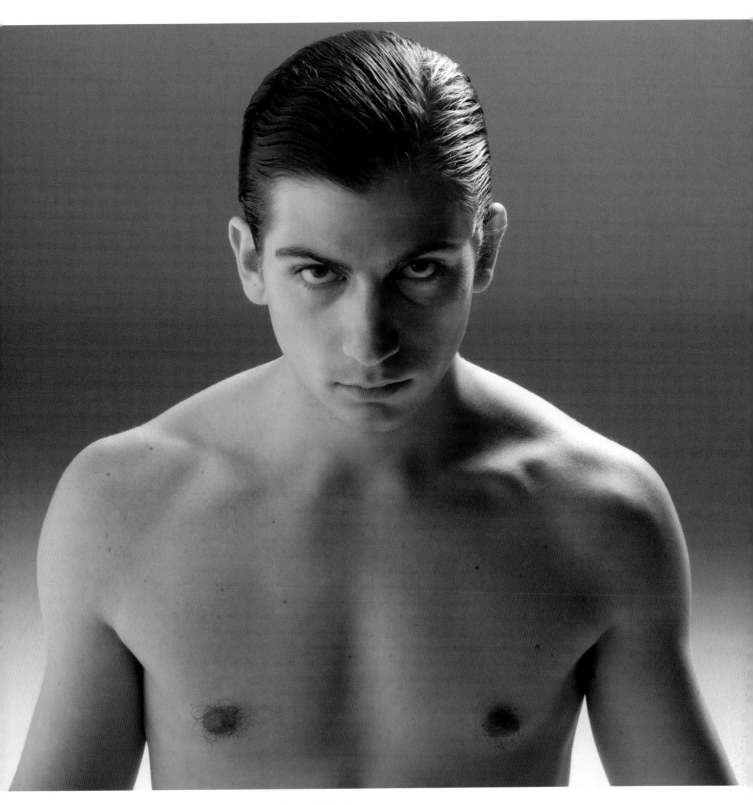

Above: I photographed this man against a white background. Keeping him as far away from it as possible, and using a light on the right hand side, pointing towards the camera so that he is backlit. This creates a graduated light behind the model and makes the background more interesting. I then used two large reflectors to bounce light back on to the model – you can see where the light is coming from by the highlight on his left shoulder.

Make-up

Many photographers have had the experience of seeing a drop-dead-gorgeous person in the street and plucking up the courage to ask if they can take some portrait shots. Once the person is in front of the camera, however, it just doesn't work. Now part of this could be that no matter how good-looking that person might be in the flesh, he or she just doesn't have what the camera loves. On the other hand, it never fails to amaze me that models sometimes arrive at the studio without any make-up on, perhaps a spot on their chin and their head under a scarf, but once you put them in front of the camera – WOW! That said, what can make a difference is hair and make-up and the person applying it.

Leading beauty photographers would never consider taking a shot before a team of make-up artists, hairdressers and stylists, who have probably spent many years perfecting their craft, had got to work. However, there are some basic rules that can help you to achieve a striking look and produce photographs that are far more glamorous than the everyday shot. The most important is that the type of make-up that might look striking in the street, office or home, which a lot of women wear every day, may not translate particularly well in front of the camera – when lit, for instance, it may be shiny and reflect badly.

If you do not know a professional photographic make-up artist or cannot afford to hire one, discuss the type of look that you want your model to achieve. Look at examples in magazines as a reference. Professional models are very adept at doing their own make-up, as they have had the experience of working with make-up artists and will have picked up hints and tips.

All this make-up advice is equally applicable to men: a great portrait of a rugged hunk leaning on his hands is going to look terrible if his fingernails are dirty and broken and his hair is dry and dull.

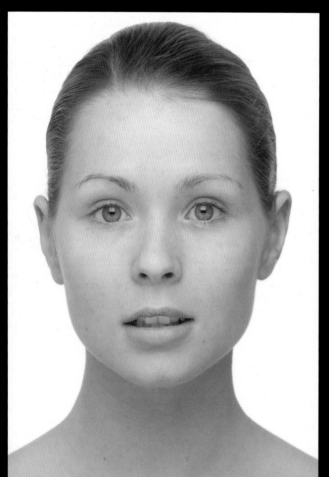

Basic Rules of Make-up

For photographic make-up that will portray a natural look and achieve symmetry (left), start with a base of liquid foundation that is close to the tone of the model's own skin, and powder that will even out skin tones and create a matt canvas.

1 Define the eyebrows to create a frame for the eyes using an eyebrow brush.

2 If the eyebrows need extra definition, darken them using an eyebrow pencil.

3 Apply eye shadow to emphasize contours, remembering that light tones will highlight an area, whereas darker shades will make them recede.

4 The next step is to apply mascara to the eyelashes. If you want a more natural look, apply the mascara to the top lashes only. After applying the mascara, comb the lashes through with a clean mascara brush to prevent clogging.

5 Use eyeliner on the bottom lash line.

6 Define the lips by using a lip pencil as close to the natural colour of the lips as possible to even out and to enhance the mouth shape. This procedure is made easier if a light smear of lip balm is applied first.

7 Fill in the lip area with the chosen colour, blot with tissue and reapply for a denser and longer-lasting colouration.

8 Using a brush apply blusher to the apples of the cheeks to create a healthy, natural glow to the complexion.

Right: The final shot shows a clean and natural effect that will photograph well under studio lighting. Compare this look to the beginning picture on the opposite page.

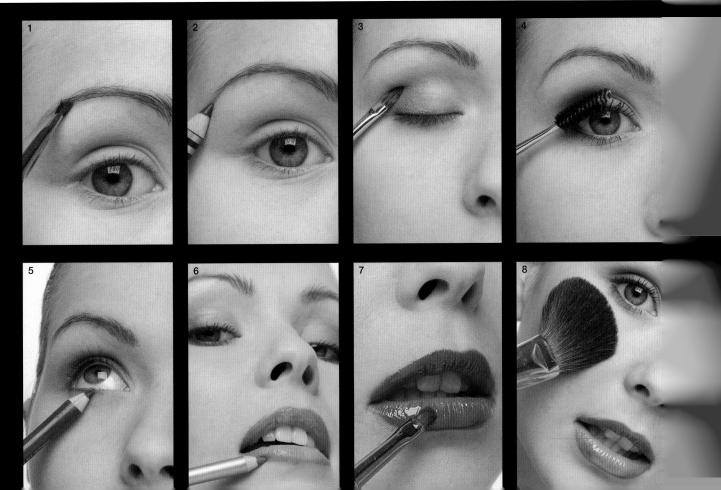

Beauty Retouching

Even when you have had complete control over the lighting and posing of your model, and perhaps the benefit of working with a hair and make-up artist, it might still be necessary to retouch your final image to get it exactly to your liking. This used to be done with brush and inks, but now it is more likely to be done digitally, using a program such as Photoshop.

For many photographers, the digital age is one of manipulated images where there is little left of the original shot. They see people's body shapes being altered and enhanced, their hair colour and eyes changed and the lines of age being removed with the click of a mouse. They complain that the increasing use of digital retouching is deceiving the viewer by creating unreailstic images.

However, along with so much that purists overlook is the fact that photography, as with painting, has always been a medium of manipulation. Take a look at the work of a great portrait painter, such as Gainsborough, and try to find the blemishes in his subject's skin. They are remarkable by their absence. So if painters can use poetic licence, it can be used to the same effect with photography. Look at the work of the great Hollywood portrait photographers, such as George Hurrell, or fashion photographers such as Norman Parkinson or Irvine Penn. A close inspection of their negatives and prints shows a mass of retouching. This in itself can be considered an art, and on no account should it be dismissed as mere trickery; the work of these photographers is now sought after by collectors the world over.

The important point to remember when you retouch a portrait photograph is that the aim is to enhance the overall image, not to change it out of all recognition. Fundamentally changing a picture is image manipulation.

Curves

The Curves control is a powerful tool for adding contrast. Take a picture you want to manipulate (1a) and with careful use of contrast you can emphasise muscle bulk on men (1b) or subtle curves on women. By using the dodge and burn tool, you can also "paint in" or emphasize existing contours.

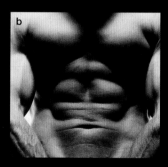

Selective Colour

A healthy tan makes everyone look more attractive. Here, I masked out the background and clothing and used the Selective Colour command to tan the flesh by removing cyan, and adding magenta and yellow to the pale neutral skin tones. I also used the Healing brush to remove a scar.

Liquefy Tool

The most useful tools in Photoshop for retouching the body are the Warp, Push Left and Freeze tools. The Warp tool moves groups of pixels with the cursor, while the Warp Push Left tool moves the pixels sideways as you drag in any direction.

1 Here we wanted to slim the model's waist. To do this we dragged the cursor up to shift the pixels to the right (to move pixels to the left, move the cursor down).

2 We've started to remove bulk from the waist by gently brushing with the Push Left tool. The Freeze tool is a mask that stops any movement of selected pixels.

3 The new waistline. Both the Warp and Push Left tools are destructive to the pixel and can leave nasty distortions if not used correctly.

Transform Tool

The Transform tool stretches pixels and allows you to apply a number of distortions.

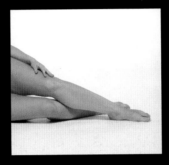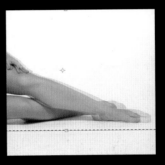

1 I decided to lengthen the model's legs. When selecting the area to lengthen, think carefully about the proportions of the body to find the most suitable area to change.

2 I highlighted the legs and stretched them using the Transform tool to make them appear more slender.

3 The new legs. You have to be very careful when stretching body parts – it would be very easy here to make the model's feet resemble diver's flippers.

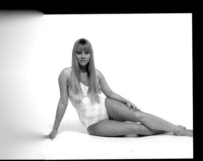

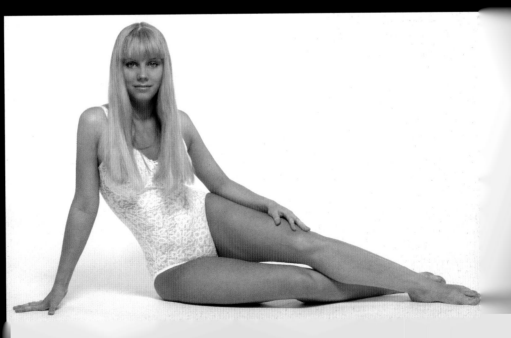

Above: Before
Right: The retouched model

Reflectors

Although most people tend to think that the best pictures are taken on a bright sunny day, these conditions can present problems when taking portrait photographs. If the person you are photographing is facing the sun, it is inevitable that they will screw up their eyes and squint into the camera. On the other hand, if they are wearing a hat or cap to protect their eyes from the sun, this in turn creates a dark shadow across the face. The obvious thing to do is to turn them around so that the sun is behind them. However, this means that the face will be in shadow. The problem is if you expose for this shadow the background will be burnt out and you might lose some of the important detail. You can get over these problems by using a reflector or fill-in flash.

A reflector can be improvised using any reflective material, such as a piece of white card, a white towel, silver foil or even a newspaper or book. You can buy custom-made reflectors that fold up into a small package, which makes them easy pieces of kit to carry around. This type of reflector comes in a variety of sizes and shapes: circular, square or rectangular. Some are double-sided, with one side white and the other gold, while others take a variety of different reflective surfaces.

The important point to remember is that the quality of the light reflected is determined by the colour of the reflector. For instance, a white reflector bounces a reasonably neutral light back on to your subject's face, while a silver one produces a much colder light, and a gold or bronze one a much warmer light. What you should be aiming for is to make the light look as natural as possible and not have the reflected light so bright that it has the same effect as bright sun or gives the subject what amounts to an awful fake tan!

1 I took this picture from a low viewpoint with the sky behind the model's head. It's a pleasing enough picture, but it looked on the cool side and I decided that it would be better if I reflected some light back into her face.

2 I chose a gold reflector and got the model to hold it with her free hand, which is just out of camera. This added a certain degree of warmth to the shot, and the skin tones definitely benefited from this approach.

Opposite: I then tried the white side of the reflector and decided that this was the optimum one to use. It gives an even light and looks completely natural. It has made all the difference to the sparkle in her eyes, and has taken the cold appearance that was in (1) away.

Fill-in Flash

One of the benefits of using reflectors is that you can see the effect that they are having on the subject immediately. With fill-in flash, you have to look at the LCD screen on your camera or wait until you have had your film processed. This is not necessarily a problem, as once you have become familiar with this technique you should be able to use it with confidence on every occasion.

Many people can't understand why you need to use flash on a day when there appears to be plenty of sunlight around. The reason comes down to that difference between what we see and how the camera sees it. When you are talking to someone, maybe over a coffee on the terrace of a café, the last thing on your mind is to take notice of those dark shadows under their eyes, nose and chin. However, if you take a shot of them in these conditions and then look at the finished print, these are the first things you notice. By using fill-in flash these dark areas can be softened, and the effect is to give your finished shot a much more natural appearance.

The art of using fill-in flash is to use it at a slightly different setting to the one that the flash thinks it should be. For example, imagine that you are photographing a person and the ambient or daylight reading is 1/60th second at f11. However, your subject has the dark shadow problem. Set the camera to the above exposure, but set the flash to give half (1:2 ratio) of this exposure or even a quarter (1:4 ratio). This means that the flash is set to give an exposure of 1/60th at f8 or f5.6 respectively – in other words, less flash output than the daylight. The shot is then taken at 1/60th second at f11. With this combination, the background is perfectly exposed and the amount of flash falling on the subject's face should be just enough to soften the shadows and thus make a more flattering portrait. If you are using a camera with built-in flash, it may not be possible to do this, and you will have to rely on the camera's fill-in flash mode if it has one. This might emit too much flash power and make the shot overlit.

Far left and left: In these shots, the sun is coming from behind, causing the bride to be in shadow as she gets out of the car. By using fill-in flash the shot is now more evenly balanced and the overall effect is far more pleasing.

Below and opposite: Often, in bright sun, it is easy to assume that everything is evenly balanced. However, in the shot below, the girl is underexposed compared to the background. A small amount of fill-in flash was used and has lifted the foreground exposure.

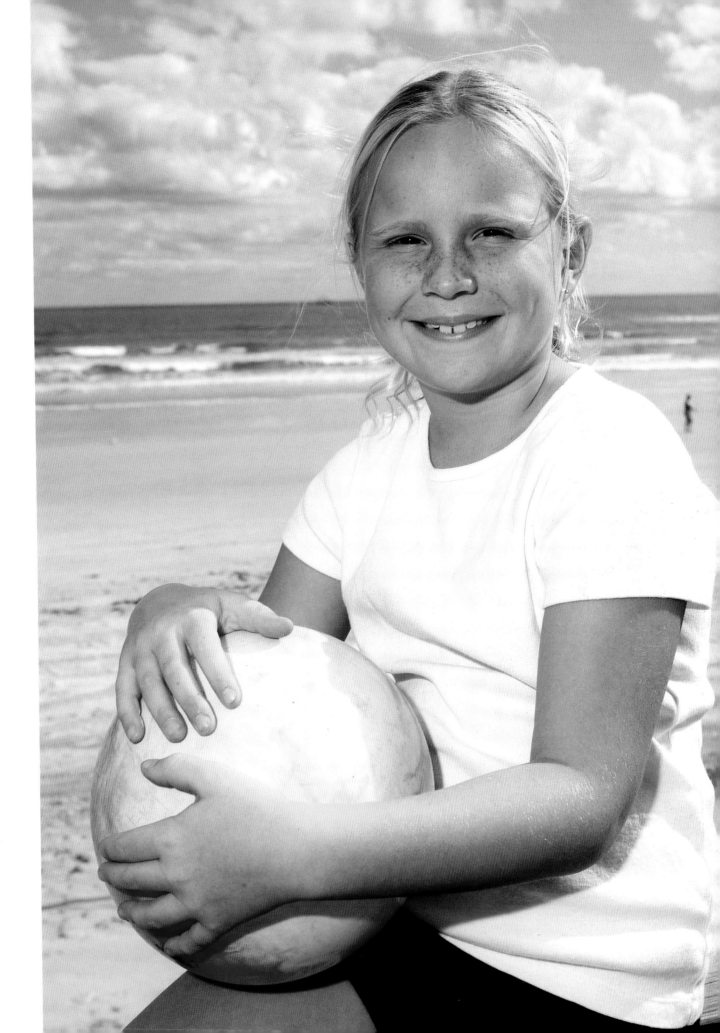

Slow Sync Flash

Most cameras synchronize flash at a shutter speed of 1/60th or 1/125th second. Any higher than this, and the result can be that only part of the frame comes out: the camera does not "sync" to a faster shutter speed.

However, with all cameras any shutter speed you choose that is slower than the manufacturer's recommended one will "sync" the flash. By using this slower speed you can produce shots with the effect known as slow sync flash.

If you combine a situation where there is a certain amount of ambient light with a shutter speed of 1/15th or 1/8th second, your subject will be mainly sharp, with perhaps a feathered edge. This can look very effective, and in certain cases very sensual. However, if at the same time that you take your shot you move the camera, the background will have a degree of "movement" in it. This can look particularly effective if you are shooting in a street where there are lots of streetlights or illuminated shop windows: the subject is virtually frozen, but the background lights "streak", creating interesting lighting patterns.

When using this technique outdoors in daylight, the best method is to underexpose the daylight by a stop or two. A subject photographed against the sky – a skater or skateboarder jumping, for instance – appears to cast a shadow onto the sky itself. However, when using a slow shutter speed in daylight, you may have to use a small aperture – f16 or f22 – otherwise the background can become completely overexposed, and the effect can be lost. Imagine that you want the sky slightly underexposed. If the normal reading is 1/125th at f5.6, set the aperture to f8, which slightly underexposes the sky. For the slow sync flash technique to work, you need to use a shutter speed of 1/15th second. This means that you need to set the aperture at f22, then set the flash dial to this aperture or work out the flash-to-subject ratio that requires an aperture of f22.

Left: An excellent example of slow sync flash. The use of a slow shutter speed has caused the street lighting to blur, while the flash has illuminated these three characters so that they stand out from the background.

Opposite: This shot was taken indoors and is a mixture of ambient tungsten light and flash. The slow shutter speed, 1/8th second, has caused blurring to some of the girl's features, but is much more controlled than the street scene.

High Key and Low Key

In most cases, a good photograph is judged on its tonal range across the scale. In black-and-white photography this ranges from a rich black through to a bright white, with a range of greys in between. However, striking pictures can be produced without this tonal range; indeed, pictures where the tones are taken from just one end of the scale can produce very effective results.

Pictures such as these, where the tonal range is taken from the predominantly white end of the scale, are known as "high-key" pictures; pictures whose tonal range is predominantly from the black end of the scale are called "low-key" pictures.

High-key pictures work best when the light is bright but soft. To get this effect, you need to diffuse your light source. If you are using studio flash, you should use a soft box. This, as its name implies, is a large, white-lined box, with a diffuser at the front, which fits on the flash head. It produces a soft, even light which can be made softer still by being projected through a layer or layers of tracing paper or muslin. If you are using available light, from a window for instance, you can create the same effect by placing muslin or tracing paper over it in layers until you have achieved the desired effect.

With low-key pictures, the best background is black velvet, which gives a rich black. Directional lighting gives a far better effect. To achieve this you need to fit a honeycomb to the front of the flash head to control the degree of spill; you can also use barn doors or a simple flag. Start with one light, which might be enough, and use reflectors: white boards for a soft effect, or mirrors for a harsher one. The idea is to put just enough light into the shadow areas without making them appear flat.

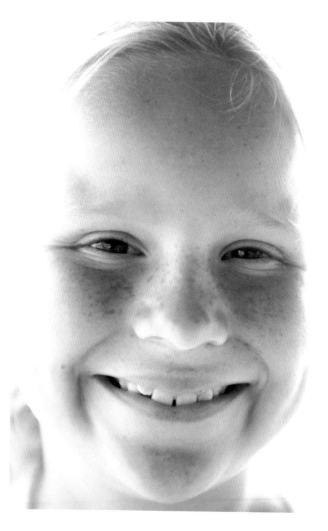

Left: This shot was taken against bright sunlight, which caused the background to burn out completely. I placed two white reflectors on each side of the head to get light back into the shadows. The result is a high-key shot of a young girl with a very attractive and photogenic smile.

Opposite: I wanted this shot to give the feel of a cold winter day. The girl's make-up was kept on the pale side, and her white fur hood was pulled up to further reinforce the idea of cold weather. Shooting against a white background, I cropped in closely so that the hood and hands fill the frame tightly.

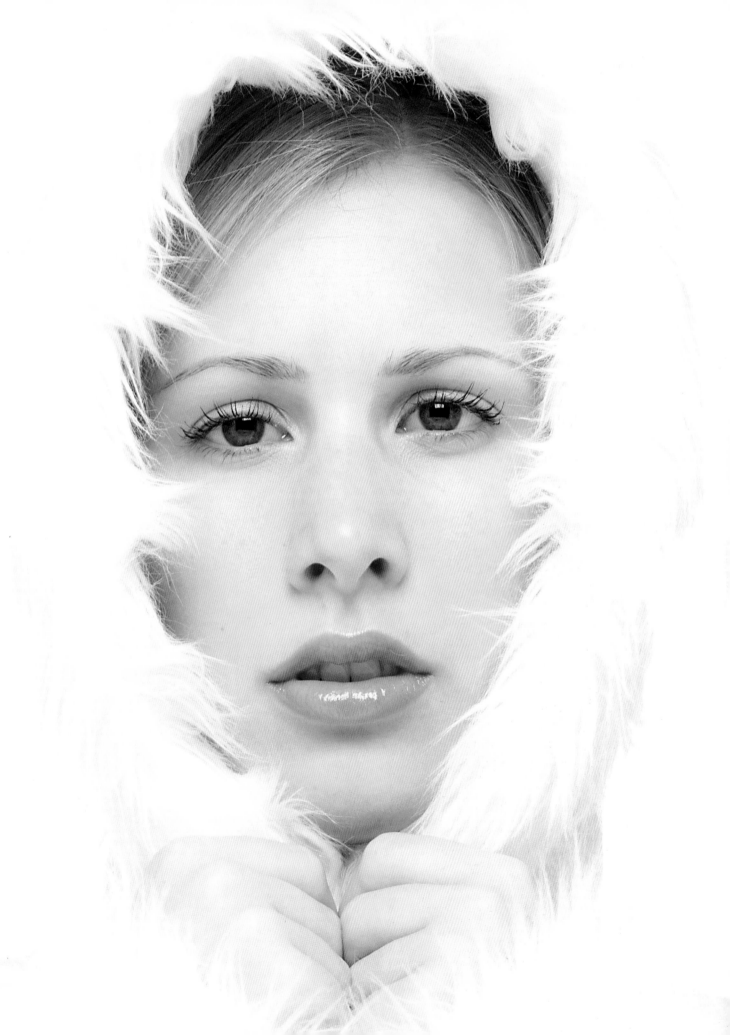

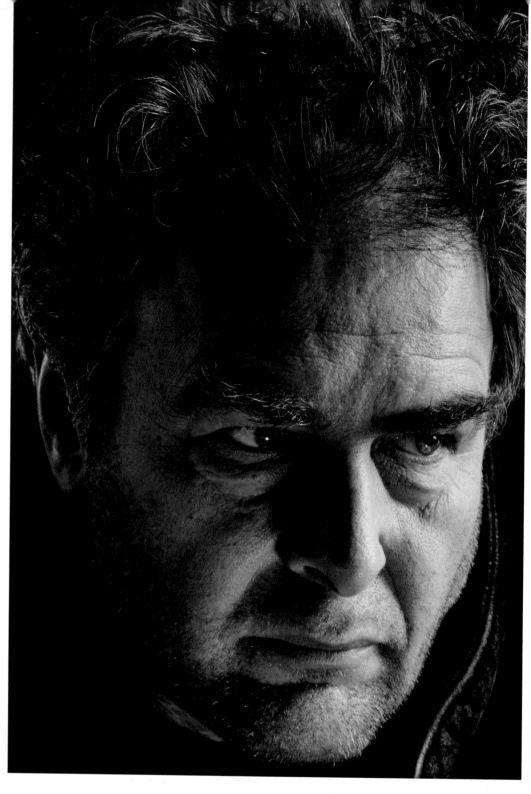

Above: I wanted to show a range of different styles when I photographed this man, and in this shot I kept the light deliberately low key. It was taken in a studio with just one flash head and a beauty dish with a honeycomb. This gives a directional light with very little spill. A small reflector was used to add just a little light in the shadow areas.

Opposite: This portrait was taken in the studio and is one of a series I am shooting on African art. The model is lit from one flash head, which was placed at right angles to the camera. A polystyrene reflector was placed just to the right of the camera, and another slightly behind her left shoulder but out of shot. Another was added under the mask to reflect light upwards.

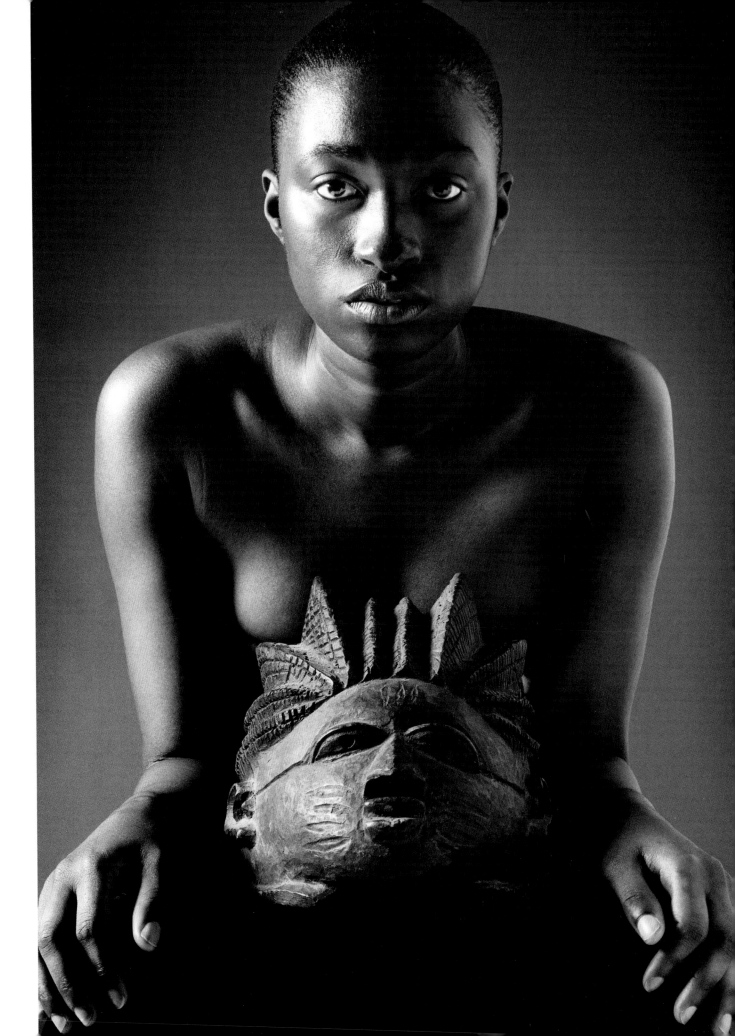

Toning

Colouring or toning photographs is a technique that has been used by photographers for almost as long as photography has been in existence. Originally it was used as a technique to preserve photographs and stop them fading, and it was only later that photographers started to use toners as a way of adding another dimension to their work.

Sepia is probably the most familiar colour for toning photographs and was very popular in the Victorian era, but there is a whole range of different toners that colour or preserve images. Selenium toner, for instance, is very subtle in its effect, but is superb at adding permanence to your prints.

It is possible to buy all the chemicals that you require to make up the different types of toner, but if you have never done this process, it is probably best to buy one of the ready-made ones that are available from all good photography shops. As you become more confident with the process there are specialist books that give you various formulae for making your own.

What is particularly good about toning your own photographs is that there is no need to have a darkroom, as each step of the process can be done in the light. All that is required are some dishes to immerse your prints in, and a supply of running water. A well-ventilated room to work in is advisable, as some of the chemicals used for toning have a rather pungent odour.

Having mixed your toner as recommended by the manufacturer, immerse your print in the solution for the advised amount of time; with experience you can vary this, together with the ratio of toner to water. Each of these elements changes the intensity of the finished print, and you can experiment with each one in turn. Once the print has been toned, it appears to be bleached and needs to be washed before being re-fixed. When in the fix, the print comes back to life and the tone becomes clearly visible. It then needs to be fixed for the correct amount of time before being thoroughly washed and dried.

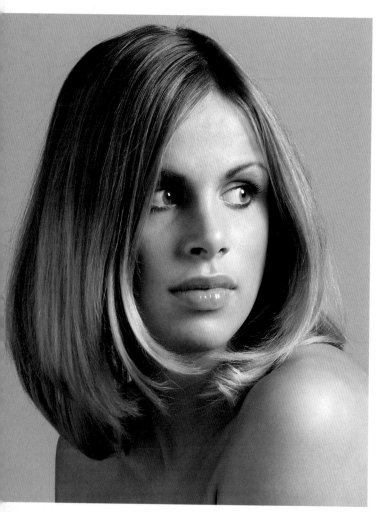

Left: The portrait that is going to be toned. Many toners are used to give the original print archival permanence, for instance selenium toning. This particular toner is quite subtle but does give the finished print a rich quality of tones.

Opposite: All toners give a variety of intensities, depending on how long you tone them for or the strength you mix the solution to. The temperature of the toner is another factor. These illustrations are just a guide to the different effects that can be obtained. With practice you will be able to control the effect of any of them.
1 Copper toner
2 Green toner
3 Iron toner
4 Nickel toner
5 Sepia toner
6 Selenium toner

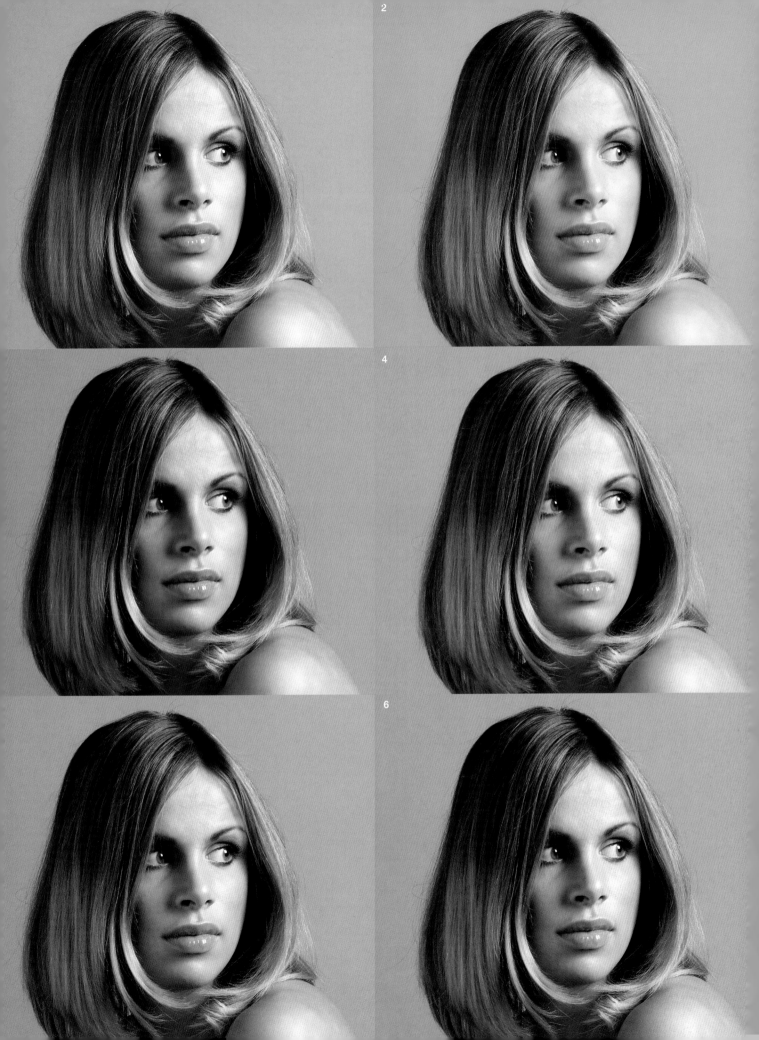

Digital Toning

As computer technology progresses at an astonishing rate, it is now possible for a modern desktop or laptop computer, combined with the latest inkjet printers, to perform as a digital darkroom, capable of producing prints that are equal to, if not better than, anything that can be produced in a traditional wet darkroom.

All modern displays, whether CRT (cathode-ray tube) or TFT (flat-screen), can be calibrated by the user to get reasonably accurate colour. Hardware calibrators that allow you to preview the image before it is printed can now be purchased relatively inexpensively and are available widely.

Every day more and more paper varieties are being introduced, ranging from cotton rag papers, which are more often associated with fine-art reproductions, to the high-gloss papers associated with commercial processing labs. Printers are now capable of extremely high resolution: over 2880 droplets of ink per inch (DPI) can be achieved using archival pigment inks, which have a comparable lifespan to conventional bromide

prints, if not better. With traditional darkroom imaging there have always been limitations, as there are a finite number of processes that involve one or more chemicals reacting with the print. These can take a lifetime to master and require a good knowledge of chemistry; in addition, each finished print is unique and therefore difficult to replicate.

Digital image processing gives far more scope and is only limited by your imagination. You can preview each image to ensure that it is exactly how you want it before making the final print. This does not mean that a digital print is inferior or should have less value placed on it. Results that a few years ago would have been hazardous to health, due to exposure to chemicals in a wet darkroom, or simply impossible to create, are now possible. Many of the images now produced on computers mimic established darkroom techniques, probably because this is what we are used to seeing, but as more people discover and experiment with digital imaging, new standards are bound to evolve and become part of the repertoire.

Converting the Image

It is not necessary to start with a black-and-white picture when producing monochrome images on a computer. This original colour photograph (1) has very little impact, and I felt a lot more could be achieved if it were converted to black and white. I used Photoshop Curves to adjust the tones and colour. The curve is plotted on a grid; by default it is a straight line. The bottom left point represents the brightest part of the image and is known as D-min or the point of minimum density. The top right point is the darkest part of the image or D-max. Any point between these can be clicked on and dragged with a mouse. The image will become brighter if pulled down, and darker if pushed up. By default the curve dialog box opens with all the colours (RGB) selected. This means that you alter all the colours together, and only the brightness is adjusted.

2 The image has been converted to black and white but looks very flat because it lacks contrast. You can increase the contrast by clicking and dragging the Curve tool until the desired effect has been achieved.

3 To tone the print using Curves means working on the separate colour channels (see opposite, top). I selected the red channel and pulled up the top right (dark) part of the curve, introducing a red tone in the shadows. I then switched to the blue channel and pulled down the bottom left (brighter) part of the curve, to introduce a blue tone into the highlights. The final RGB curve is shown below.

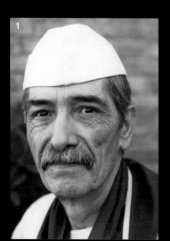
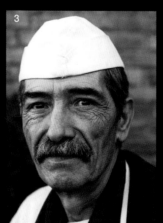

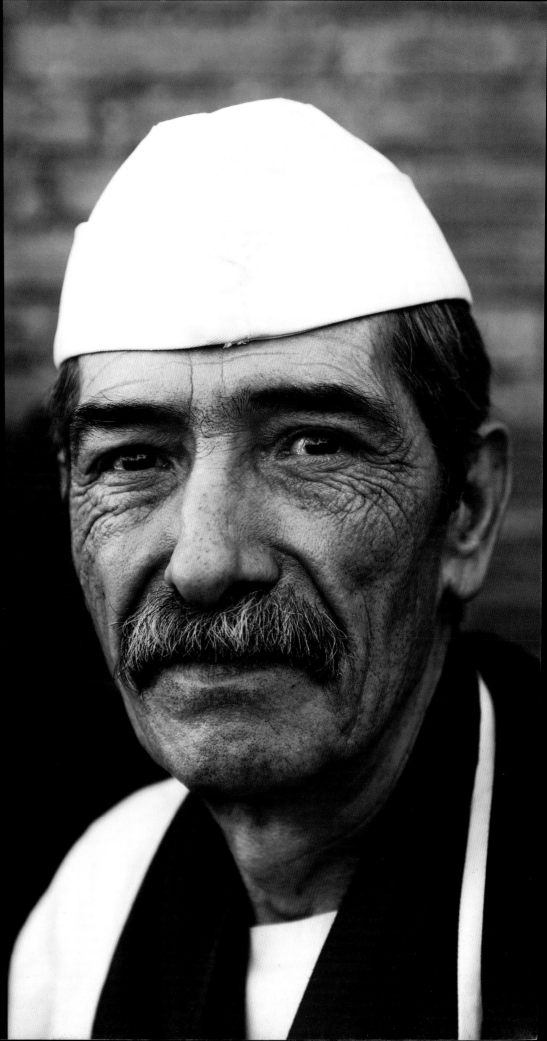

Right: The final version is a split-toned red-and-blue image. I also darkened the background and intensified the eyes by contrasting them with the Lasso tool and applying the Curves command to each one.

4 To introduce a sepia tone I used the Hue/Saturation control. The hue slider selects the colour (or chroma), and the saturation controls the intensity of colour. For a toned print it is best to keep the saturation low.

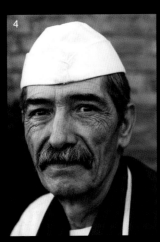

Digital Archival Retouching

For all the criticism that some photographers level at the inroads digital photography is making, there are certain areas that are undeniably beneficial. One of these is the ability to retouch and revive old and archival photographs and reprint them so that they are as good as – if not better than – the original. This is particularly true of old pictures of people. There can hardly be a home that does not have a box or album of old family photographs. Although some of these may only be a few years old, there may also be some that could be 100 or 120 years old. The chances that these have been filed away with their negatives allowing you to produce fresh prints, is as likely as digital photography being a passing fad!

Even if the surviving print is creased, torn or has a corner missing, it is still possible to reproduce a good-quality version. It seems amazing to think that only a few years ago the only way to restore a photograph in this state would have been to re-photograph it and produce a new print. This would then have to be retouched by hand with any missing parts built up. If you did not have the skill to do this yourself, it would cost a fortune – perhaps prohibitively so – to get a professional to do it for you. Then it would have to be re-photographed again (further reducing the quality) so that prints could be made and distributed around the family or other interested parties.

Now the print can be scanned on an inexpensive desktop scanner. If you have a transparency or lantern slide, it is probably best to give this to a professional bureau. Once scanned, the image can be retouched in a program such as Photoshop. When you are satisfied with the result, it can be printed on one of a variety of papers and even toned to completely restore it to its original glory.

Besides framing your restored picture or emailing it around the world to friends and relations, you might like to think of other ways of presenting it. This could be in an album, or you might want to create a family tree. In the latter case, you will be able to put a portrait next to each member of the family.

Retouching the Image

This is a good example of an archival family photograph. We can see how it has been torn, creased and discoloured over the years. However it is not beyond repair and with practice even the most worn image can be bought back to life.

1 I scanned the original print on a desktop scanner, and although the image has been damaged, it has retained good detail, even though it has been softened by the scanning process.

2 Using Hue/Saturation I neutralized the colour cast. This gave a neutral image, and I could add a colour tint, in this case orange/yellow.

3 Using Levels I set the black-and-white points. The histogram tells me where the tones in the image are located.

4 I used Curves to add contrast to the image. Although the effect is similar to Levels, it allows greater control.

5 To repair the damage, such as this crease, I used the Patch/Healing brush, drawing a selection around the area that need patching and then moving to an area of undamaged texture. The computer blends the new area into the old area.

6 The Clone tool allows you to select an area of texture and paint that over the spots or cracks. This is a much more controllable tool than the Healing brush.

7 By drawing a selection around the faded light patch in the centre of the print and softening the edges (feathering), I used Curves to raise the value to match the rest of the picture.

1

2

3

4

5a

5b

6a

6b

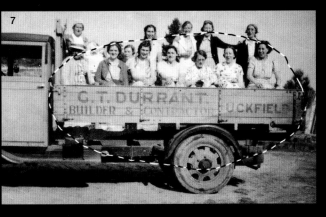

7

Glossary

Alpha channel
Extra 8-bit greyscale channel in an image, used for creating masks to isolate part of the image.

Analogue
Continuously variable.

Aperture
A variable opening in the lens determining how much light can pass through the lens on to the film.

Aperture priority
Camera metering mode that allows you to select the aperture, while the camera automatically selects the shutter speed.

Apo lens
Apochromatic. Reduces flare and gives greater accuracy in colour rendition.

APS
Advanced photo system.

ASA
American Standards Association. A series of numbers denoting the speed of a film. Now super-seded by ISO numbers, which are identical.

Auto-focus
Lenses that focus on the chosen subject automatically.

B setting
Setting on the camera's shutter speed dial that will allow the shutter to remain open for as long as the shutter release is depressed.

Back light
Light that is behind your subject and falling on to the front of the camera.

Barn doors
Movable metal plates that can be attached to the front of a studio light to flag unwanted light.

Between the lens shutter
A shutter built into the lens to allow flash synchronization at all shutter speeds.

Bit
A binary digit, either 1 or 0.

Blooming
Halos or streaks visible around bright reflections or light sources in digital pictures.

BMP
A file format for bitmapped files used in Windows.

Boom
An attachment for a studio light that allows the light to be be suspended at a variable distance from the studio stand.

Bracketing
Method of exposing one or more frames either side of the predicted exposure and at slightly different exposures.

Buffer ram
Fast memory chip on a digital camera.

Byte
Computer file size measurement.
1024 bits=1 byte
1024 bytes=1 kilobyte
1024 kilobytes=1 megabyte
1024 megabytes=1 gigabyte

C41
Process primarily for developing colour negative film.

Cable release
An attachment that allows for the smooth operation of the camera's shutter.

Calibration
Means of adjusting screen, scanner, etc, for accurate colour output.

Cassette
A light-tight container that 35mm film comes in.

CC filter
Colour correction filter.

CCD
Charged coupled device. The light sensor found in most digital cameras.

CDR
Recordable CD.

CDS
Cadmium sulphide cell, used in electronic exposure meters.

Centre-weighted
TTL metering system that is biased towards the centre of the frame.

Clip test
Method of cutting off a piece of exposed film and having it processed to judge what the development time should be for the remainder.

CMYK
Cyan, magenta, yellow and black: colour printing method used in inkjet printers.

Colour bit depth
The number of bits used to represent each pixel in an image.

Colour negative film
Colour film that produces a negative from which positive prints can be made.

Colour reversal film
Colour film that produces positive images called transparencies or slides.

Colour temperature
A way of expressing the colour content of a white light source, measured in degrees Kelvin.

Compact flash card
Removable storage media used in digital cameras.

Compression
Various methods used to reduce file size. Often achieved by removing colour data (see JPEG).

Contact sheet
A positive printed sheet of a whole processed film, enabling negatives to be selected for enlargement.

Contrast
Range of tones in an image.

Cross-processing
Method of processing colour film in different developers, i.e. colour reversal film in C41 and colour negative in E6.

Cyan
Blue-green light whose complementary colour is red.

Dark slide
A holder for sheet film used in large-format cameras.

Data
Information used in computing.

Daylight-balanced film
Colour film that is balanced for use in daylight at 5400 degrees Kelvin.

Dedicated flash
Method by which the camera assesses the amount of light required and adjusts flash output accordingly.

Depth of field
The distance in front of the point of focus and beyond that is acceptably sharp.

Dialog box
Window in a computer application where the user can change settings.

Diaphragm
Adjustable blades in the lens determining the aperture size.

Diffuser
Material such as tracing paper placed over the light source to soften the light.

Digital zoom
Digital camera feature that enlarges the central part of the image at the expense of quality.

DIN
Deutsche Industrie Norm. German method of numbering film speed, now superseded by ISO number.

Download
Transfer of information from one piece of computer equipment to another.

DPI
Dots per inch. Describes the resolution of a printed image (see PPI).

DPOF
Digital print order format.

Driver
Software that operates an external device or peripheral device.

DX
Code marking on 35mm film cassettes that tells the camera the film speed, etc.

E6
Process for developing colour reversal film.

Emulsion
The light-sensitive side of film.

EV
Exposure value.

EVF
Electronic viewfinder found in top-quality digital cameras.

Exposure meter
Instrument that measures the amount of light falling on the subject.

Extension bellows
Attachment that enables the lens to focus at a closer distance than normal.

Extension tubes
Attachments that fit between the camera and the lens that allow close-up photography.

F numbers
Also known as stops. They refer to the aperture setting of the lens.

File format
Method of storing information in a computer file, such as JPEG, TIFF, etc.

Film Speed
See ISO.

Filter
Device fitted over or behind the camera lens to correct or enhance the final photograph.

Filter factor
The amount of exposure increase required to compensate for a particular filter.

Firewire™
High-speed data transfer device up to 800 mbps (mega bits per second), also known as IEEE 1394.

Fish-eye lens
A lens that has an angle of view of 180 degrees.

Fixed focus
A lens whose focusing cannot be adjusted.

Flag
A piece of material used to stop light spill.

Flare
Effect of light entering the lens and ruining the photograph.

Flash memory
Fast memory chip that retains all its data, even when the power supply is switched off.

Focal plane shutter
Shutter system that uses blinds close to the focal plane.

Fresnel lens
Condenser lens that aids focusing.

Fringe
Unwanted border of extra pixels around a selection caused by the lack of a hard edge.

Gel
Coloured material that can be placed over lights either for a special effect or to colour correct or balance.

Gobo
A card used in front of a spotlight to create different patterns of light.

Grain
Exposed and developed silver halides that form grains of black metallic silver.

Greyscale
Image that comprises 256 shades of grey.

Hard drive
Computer's internal permanent storage system.

High key
Photographs in which most of the tones are taken from the light end of the scale.

Histogram
Diagram in which columns represent frequencies of various ranges of values of a quantity.

HMI
Continuous flicker-free light source balanced to daylight.

Hot shoe
Device usually mounted on the top of the camera for attaching accessories such as flashguns.

Incident light reading
Method of reading the exposure required by measuring the light falling on the subject.

Internal storage
Built-in memory found on some digital cameras.

Interpolation
Increasing the number of pixels in an image.

Invercone
Attachment placed over the exposure meter for taking incident light readings.

ISO
International Standards Organization. Rating used for film speed.

Jaggies
Images where individual pixels are visible due to low resolution.

JPEG
A file format for storing digital photographs where the original image is compressed to a fraction of its original size.

Kelvin
Unit of absolute temperature used in photography to express colour temperature.

Latitude
Usable film tolerance that is greater with negative film than reversal film.

LCD
Liquid crystal display screen.

Light box
A light with a diffused screen used for viewing colour transparencies.

Low key
Photographs in which most of the tones are taken from the dark end of the scale.

Macro lens
A lens that enables you to take close-up photographs.

Magenta
Complementary colour to green, formed by a mixture of red and blue light.

Megapixel
1,000,000 pixels.

Mirror lock
A device available on some SLR cameras that allows you to lock the mirror in the up position before taking your shot to minimize vibration.

Moiré
An interference pattern similar to the clouded appearance of watered silk.

Monobloc
Flash unit with the power pack built into the head.

Montage
Image formed from a number of different photographs.

Morphing
Special effect where one image changes into another.

Network
Group of computers linked by cable or wireless system so they can share files. The most common form is ethernet. The Web is a huge network.

Neutral density filter
A filter that can be placed over the lens or light source to reduce the required exposure.

Noise
In digital photography, an effect that occurs in low light that looks like grain.

Pan tilt head
Accessory placed on the top of a tripod that allows smooth camera movements in a variety of directions.

Panning
Method of moving the camera in line with a fast-moving subject to create the feeling of speed.

Parallax correction
Movement necessary to eliminate the difference between what the viewfinder sees and what the camera lens sees.

PC card
Removable memory cards that have been superseded by flash cards.

PC lens
Perspective control or shift lens used to correct distortion, mainly in architectural photography.

Photoshop
Image manipulation package that is the industry standard.

Pixel
The element that a digitized image is made up from.

Polarizing filter
A filter that darkens blue skies and cuts out unwanted reflections.

PPI
Pixels per inch. A measurement of image resolution that defines the size the image can be printed.

Predictive focus
Method of auto-focus that tracks a chosen subject, keeping it continuously sharp.

Prop
An item included in a photograph that enhances the final composition.

Pulling
Decreasing the development of the film.

Pushing
Rating the film at a higher ISO and then increasing the development time.

RAM
Random access memory.

Rangefinder Camera
A camera that uses a system that allows sharp focusing of a subject by aligning two images in the camera's viewfinder.

Reciprocity failure
The condition where, at slow shutter speeds, the given ISO does not relate to the increase in shutter speed.

Resolution
The measure of the amount of pixels in an image.

RGB
Red, green and blue, which digital cameras use to represent the colour spectrum.

Ring flash
A flash unit in which the tube fits around the camera lens, giving almost shadowless lighting.

ROM
Read-only memory.

Shift and tilt lens
Lens that allows you to shift its axis to control perspective and tilt to control the plane of sharp focus.

Shutter
Means of controlling the amount of time that light is allowed to pass through the lens onto the film.

Shutter priority
Metering system in the camera that allows the photographer to set the shutter speed while the camera sets the aperture automatically.

Slave unit
Device for synchronizing one flash unit with another.

SLR
Single lens reflex camera.

SmartMedia
Type of removable memory used by some digital camera manufacturers.

Snoot
Lighting attachment that enables a beam of light to be concentrated in a small circle.

Spill
Lighting attachment for controlling the spread of light.

Spot meter
A reflected-light exposure meter that gives a reading over a very small area.

Step wedge
A greyscale that ranges from white to black through various shades of grey.

Stop
Aperture setting on a lens.

T setting
Used for long time exposures to save draining the camera's battery.

Teleconverter
Device that fits between the camera and lens to extend the lens' focal length.

TIFF
Tagged inventory file format. The standard way to store digital images.

TLR
Twin lens reflex camera.

TTL
Through-the-lens exposure metering system.

Tungsten-balanced film
Film balanced for tungsten light to give correct colour rendition.

TWAIN
Industry standard for image acquisition devices.

USB
Universal serial bus. Industry standard connector for attaching peripherals with data transfer rates up to 450 mbps (mega bits per second).

Vignetting
A darkening of the corners of the frame if a device such as a lens hood or filter is used that is too small for the angle of view of the lens.

White balance
Method used in digital cameras for accurately recording the correct colours in different light sources.

ZIP
An external storage device that accepts files between 100 and 750 megabytes.

Zoom lens
Lens whose focal length is variable.

Index

Acknowledgements

John Freeman and Chrysalis Books would like to thank Calumet Photographic UK for their assistance in the production of this book, Hasselblad UK for supplying equipment, and Harvey Nichols Restaurant at the Oxo Tower.

This book would not have been possible without the help of many people. In particular I would like to thank Alex Dow, without whom there would be no book! His dedication to the project and technical expertise, especially in the area of digital photography, cannot be spoken of highly enough. I would like to thank Serena Webb and Emma Baxter who kept everything going and made it happen on time, and Ian Kearey for editing my text; Peter Dawson and Paul Palmer-Edwards at Grade Design for the design concept; Jon Anderson and Brenda Lally for organizing the loan and purchase of equipment from Calumet Photographic; Teresa Neenan for faultless travel arrangements through Trailfinders; Bettina Graham for hair and make-up. I would also like to thank Nick Beak; Anne and Floor Blom; Graham and Hannah Brooke-Ball; William Cook; Daz Crawford; Silke Davies; Jack Denham; Jeune, Sophia and Wesley Ephson; John Fawdry; Debbie Frankham; Allegra; Katie, Luke and Teresa Freeman; Dorothy Freeman; Gaia and Thibaud Friedman; Manolo, Maite and Nekane Garcia; Brittany Gibbs, Kelly Grant; Frank Lamptie; Patrick Omigie and Serena Sperioni at the Harrow Club; Innes and Isabella Harvey; Susana Wilson-Hawken; Roz Houchin; Helen Colt Hychka; Patricia Jones; the staff and pupils at Jubilee Primary School; Etienne Lamarch; Adela Lana; Katie Lawrie; Nathan Long; Simon Lycett; Jane Mahida; Dario, Elsa and Thomasina Marainelli; Nicola McLean; the three Meakin families; Natalie Miller; Helen Moody; Lisa Moore; Kate Miller; Mika; Vania Neves; Martha and Oscar North; Patrick O'Reilly; the staff at Paintworks; Tiphaine and Thomas Popesco; Djakoly Sangare; Aisha Sidibeh; Abigail Toyne; Jody Trew; Danialle Tweebeeke; Fam Van de Heyning; Hank Wangford; Billie Jean Wilde; Patrick Wiseman; Caroline Wooton; Jennifer Young; Tomasz Zaleski; and a special thank you to Vanessa Freeman, for being there when it mattered most.

The Calumet John Freeman Photography Prize

Here is a fantastic opportunity to win £500 of photography equipment, courtesy of Calumet, plus the complete *The Photographer's Guide to...* series by John Freeman. Applications are welcome from amateur or semi-professional photographers. The winner will be chosen by John Freeman.

First Prize: £500 worth of photography equipment plus a complete set of *The Photographer's Guide to...* series by John Freeman.

10 Runner-up Prizes: Signed copy of *The Photographer's Guide to Composition* by John Freeman.

For more information and to download the application form please visit:

www.chrysalisbooks.co.uk
www.calumetphoto.com

Only print photographs will be accepted, accompanied by a completed application form. The closing date for entries is 1st March 2005.